WORLD PRESS PHOTO 11

D1270652

Thames & Hudson

Contents >

Jodi Bieber was born in South Africa and began her professional career at The Star *newspaper in Johannesburg in 1993. In 1996 she was a participant in the Joop Swart Masterclass, which for her proved a turning point. Assignments for such publications as* The New York Times Magazine *followed. Bieber has published a number of books focusing on aspects of South African life. Bieber's first solo exhibition was at Visa pour l'Image in 2002, and she has since exhibited widely around the world. She has won eight World Press Photo awards, as well as numerous other accolades. In 2009, Bieber was awarded the Prix de l'Union Européenne at the Rencontres de Bamako Biennale Africaine de la Photographie.*

How did you become interested in photography?
It didn't come naturally. At school in South Africa we were encouraged either in an academic or a sports direction. The creative side didn't come into it. After school I went straight into a job in marketing—working during the day and studying at night. I got to quite a responsible position at a young age, but then decided I really needed some time off, so I took a ten-month break traveling around Turkey, Egypt, and Europe. My father gave me his old camera, and instead of writing a diary I took very bad photographs. But the camera became my vehicle for expression. When I returned home, it became the means for me to explore a South Africa outside of my previous experience, the way for me to really discover the country I was living in, and its people.

How did you make the move into photojournalism?
At first, after I came back to South Africa, I worked in advertising, and then one day I saw a leaflet for a photography workshop at the Market Theatre in Johannesburg. I thought, perfect! I'll work during the day and after hours I can pursue what I'm really excited about. This was at a very historical time for the country, in the early 1990s. Every free moment I had, I would go to a township or cover a march or demonstration. I took a portfolio to Ken Oosterbroek, chief photographer at *The Star* newspaper, and he offered me a place in a training program. I gave up the advertising career for just three months guaranteed at *The Star*. I got a front-page on day three. From that moment, there was no turning back.

What inspires you as a photographer?
Many things. The history of my country; a moment in that history; fragments from my own personal life. The motivation behind each of my books has been different. These days I move between the editorial and the gallery worlds. There is an artistic as well as the journalistic side, but I am a storyteller—even a project like *Real Beauty* (photos of women who are beautiful, though not necessarily in conventional way) has a consciousness behind it. It's talking about serious issues.

Can you describe the circumstances behind the winning photo?
I was sent to Afghanistan on an assignment from *Time* magazine to take photographic portraits of different women. The journalist Aryn Baker had found and interviewed the women already, and set up a meeting at the Women for Afghan Women shelter in Kabul, where Aisha was at the time. I knew her story from Aryn, so made the decision not to interview her again. I didn't want to put her through the trauma of reliving her experience. She was in a small room, with just a carpet on the floor and cushions around the walls. I had just my camera, tripod, and a reflector. First I tried small talk, to help her to relax, but I could see I wasn't achieving anything, so put down the camera for a while. While we had been talking, I'd noticed how beautiful she was, but also shy and sad. But when she released a little of something inside her, there really was a beauty, so I said: "You are really very beautiful. I want to capture that, your power and inner beauty. Think of something that makes you feel good, that gives you your power." That was the photo. I could never have created those eyes, that look she gave me.

What issues does the photo raise for you?
For me it is 100% about violence against women. Maybe it works because you see Aisha as a woman first, before you see her disfigurement. If I had photographed her in a vulnerable or distressing position, I think people would have just turned the page, and not responded in the way they have. I think that twenty, even ten years ago, I might not have taken a photo like that, but I have changed as a photographer. These days I enjoy collaborating with the person I'm photographing, which means talking in the way I did with Aisha, bringing myself and my beliefs in slightly, rather than being invisible.

Bibi Aisha (18), was disfigured as retribution for fleeing her husband's house in Oruzgan province, in the center of Afghanistan. At the age of 12, Aisha and her younger sister had been given to the family of a Taliban fighter under a Pashtun tribal custom for settling disputes. When she reached puberty she was married to him, but she later returned to her parents' home, complaining of violent treatment by her in-laws. Men arrived there one night demanding that she be handed over to be punished for running away. Aisha was taken to a mountain clearing, where, at the orders of a Taliban commander, she was held down and had first her ears sliced off, then her nose. In local culture, a man who has been shamed by his wife is said to have lost his nose, and this is seen as punishment in return. Aisha was abandoned, but later rescued and taken to a shelter in Kabul run by the aid organization Women for Afghan Women, where she was given treatment and psychological help. After time in the refuge, she was taken to America to receive further counseling and reconstructive surgery.

Portraits > **Jodi Bieber** > South Africa, Institute for Artist Management/
Goodman Gallery for Time > 1st Prize Singles

World Press Photo of the Year 2010 >

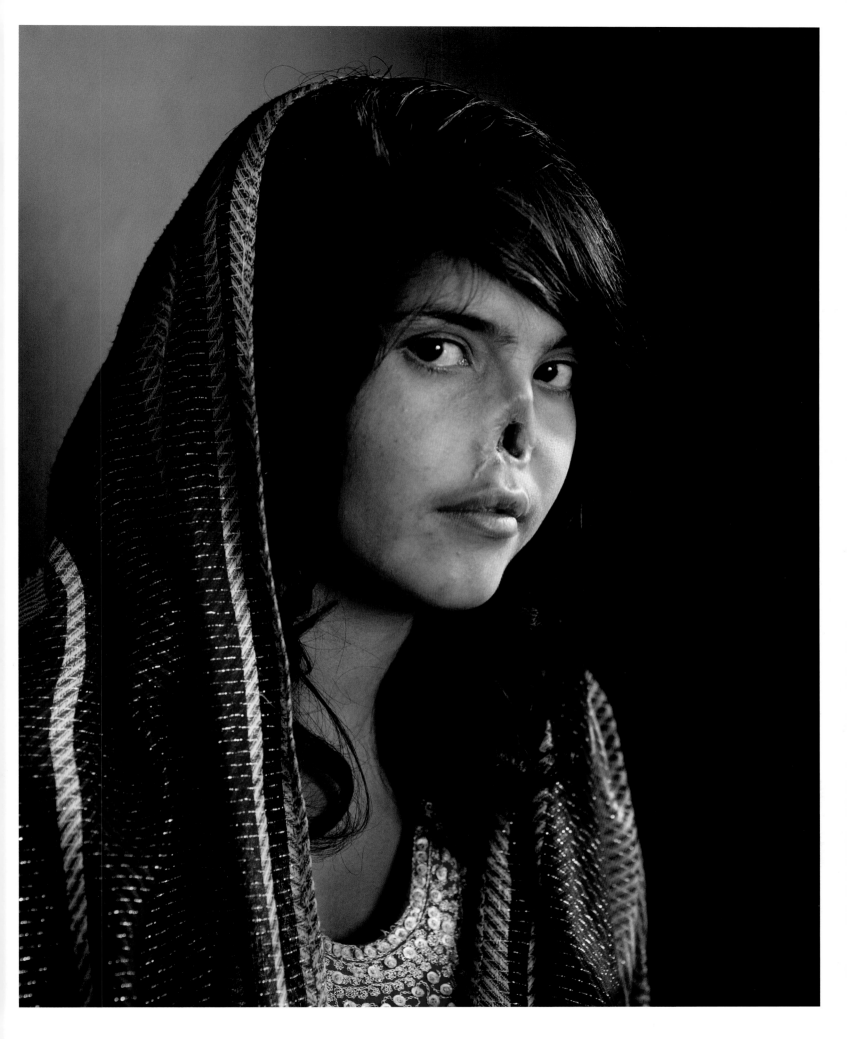

Every December, as the year draws to a close, photojournalists around the world take a few minutes—or hours—to ponder the photographs they have produced that year. There is a desire to evaluate our work, to see what we have created and how we have helped tell the story of yet another year. Like our reporter colleagues, whose job it is to write the "first draft" of history—the history of the times we live in—we seek to make sense of those events. The difference is, of course, that reporters can always file after the fact. But without our photographs there is no evidence. Photographs become our world's collective memory.

There are moments that are imagined ahead of time, but many which defy our ability to see into the future. Life happens. It can be with ruthless force, or a tender hand. But as the world moves ahead, photographers react, and create those bodies of work that eventually become part of the 108,000 images which World Press Photo received this year. The jury was presented with a broad scope of work touching on the major news events of 2010, including the Haitian and Chilean earthquakes, street battles in Bangkok, death squads in Mexico, and dozens of others, less headline-grabbing, but no less compelling. Additionally, there were stories which were reflective of the times we live in: refugees escaping at night in Somalia; oil and chemical spills in China, the United States and Europe; and volcanic eruptions in Indonesia and Iceland.

With more than 108,000 images to look at (looking at one every second, it would take 30 hours, with no breaks, to see them all) it remains an amazing tribute to the power of the still image that "the pictures of the year" rise to the top. And there remain surprises. A man carries a shark in Mogadishu. Trains and traffic in Asia swirl into buttery patterns, demonstrating the coexistence of people and machinery. Sheer delight is reflected in the faces of villagers watching an outdoor movie. And in the portrait category, too, there are images that haunt and surprise. It was a year in which great photography matched the challenge of unfolding events.

Jodi Bieber's evocative portrait of Bibi Aisha is that combination of horrific and beautiful: the power of the picture lies in the dignity of its subject and in the thoughtful treatment by the photographer. It speaks not only of Aisha's own case, but also to that of women in many places around the world, whose lives remain in jeopardy. Yet the jury chose this picture not because of any political agenda, but simply because we felt it made a strong statement photographically, and did what all photographers strive for: to challenge the viewer not only to contemplate this moment for what it is, but also to desire more. More information. More understanding.

This year the jury met in Amsterdam, while half a world away the streets of Cairo were filled with demonstrators demanding change. We know that next year some of those photographic moments will be the ones the jury will see. The visual circle of life never stops.

David Burnett
Photojournalist and founding member
Contact Press Images

Portraits

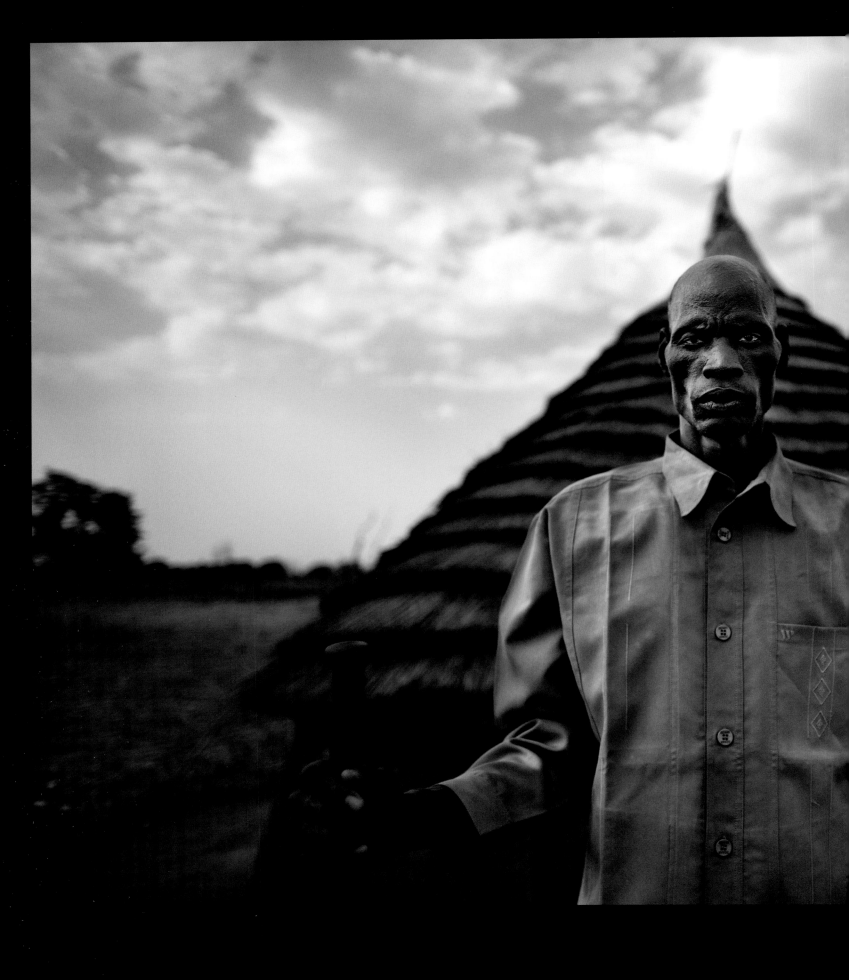

A Dinka man stands in front of
his house in Akkach, South
Sudan. The Dinka, the largest
ethnic group in Southern
Sudan, are an agro-pastoral
people who migrate according
to season. At the onset of the
rainy season in May or June,
they move to settlements of
huts built from mud and
thatch above the flood level,
where they plant crops. During
the dry months, beginning
around December, they leave
for better grazing regions in
the lowlands, living in semi-
permanent shelters. Between
1983 and 2005, the people of
South Sudan were embroiled
in a bitter civil war with the
largely Muslim government in
the north, which cost some
1.5 million lives. In January of
2011, a referendum among
southerners, promised as part
of a peace deal, resulted in a
nearly unanimous vote for
independence.

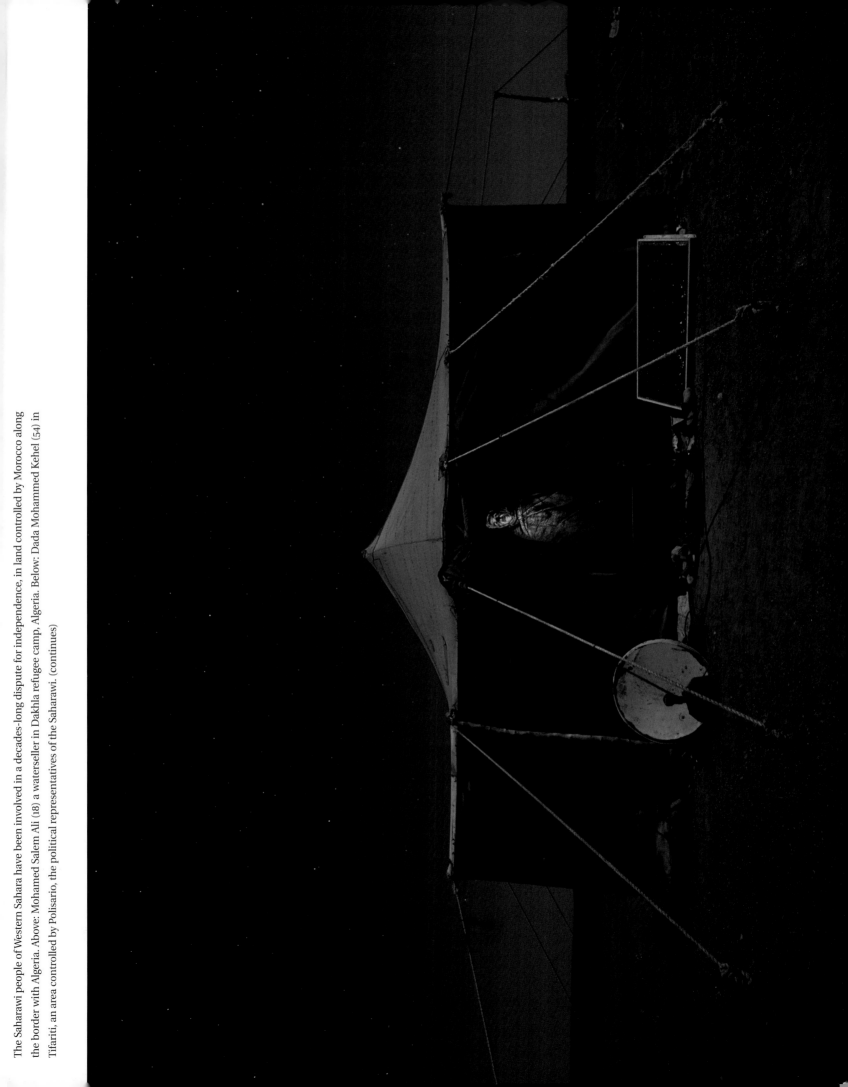

The Saharawi people of Western Sahara have been involved in a decades-long dispute for independence, in land controlled by Morocco along the border with Algeria. Above: Mohamed Salem Ali (18) a waterseller in Dakhla refugee camp, Algeria. Below: Dada Mohammed Kehel (54) in Tifariti, an area controlled by Polisario, the political representatives of the Saharawi. (continues)

(continued) In the 1980s, Morocco built a 2,700-kilometer-long sand barrier and planted it with mines, dividing Western Sahara in two. Most Saharawi live in the inland desert behind this barrier, or in refugee camps in Algeria. A former Spanish colony, Western Sahara is Africa's last open file of the United Nations Decolonization Committee. Below: Nagla Mohamed Lamin (20) on a bus near Smara refugee camp, Algeria. (continues)

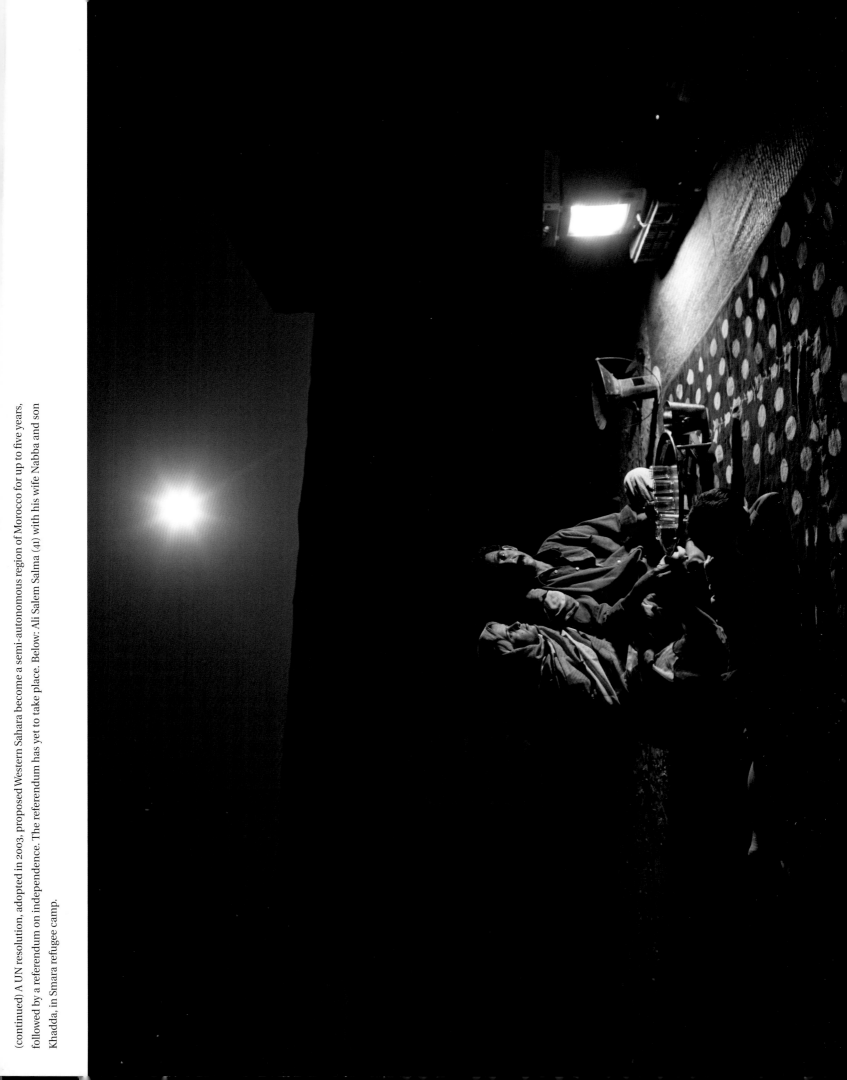

(continued) A UN resolution, adopted in 2003, proposed Western Sahara become a semi-autonomous region of Morocco for up to five years, followed by a referendum on independence. The referendum has yet to take place. Below: Ali Salem Salma (41) with his wife Nabba and son Khadda, in Smara refugee camp.

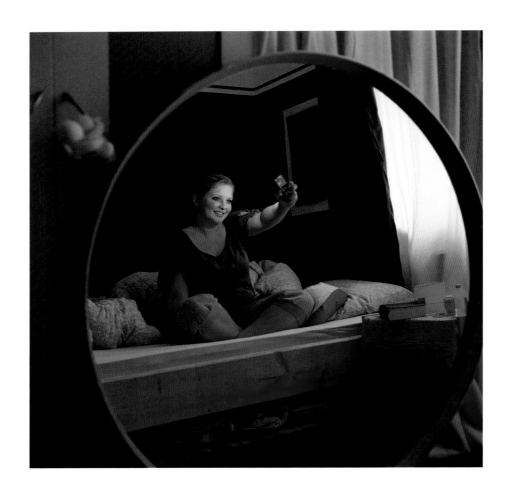

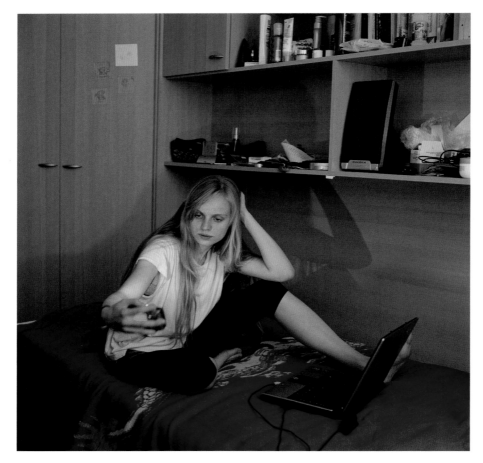

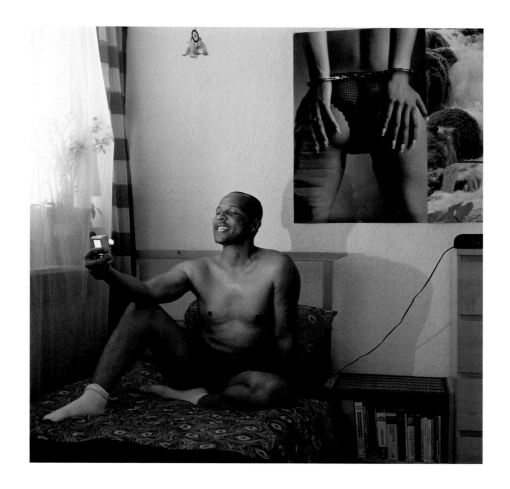

People re-enact the self-portraits they took for the social networking site MySpace. The photographer contacted fellow Berliners, asking them to remake the photos in the place they had originally been taken. He captured the exact moment at which the flash went off.

Kirill Lewerski, (16), a cadet on the Russian ship *Kruzenshtern*. The traditionally rigged, four-masted bark was built in 1926, and is the second largest tall ship still in operation.

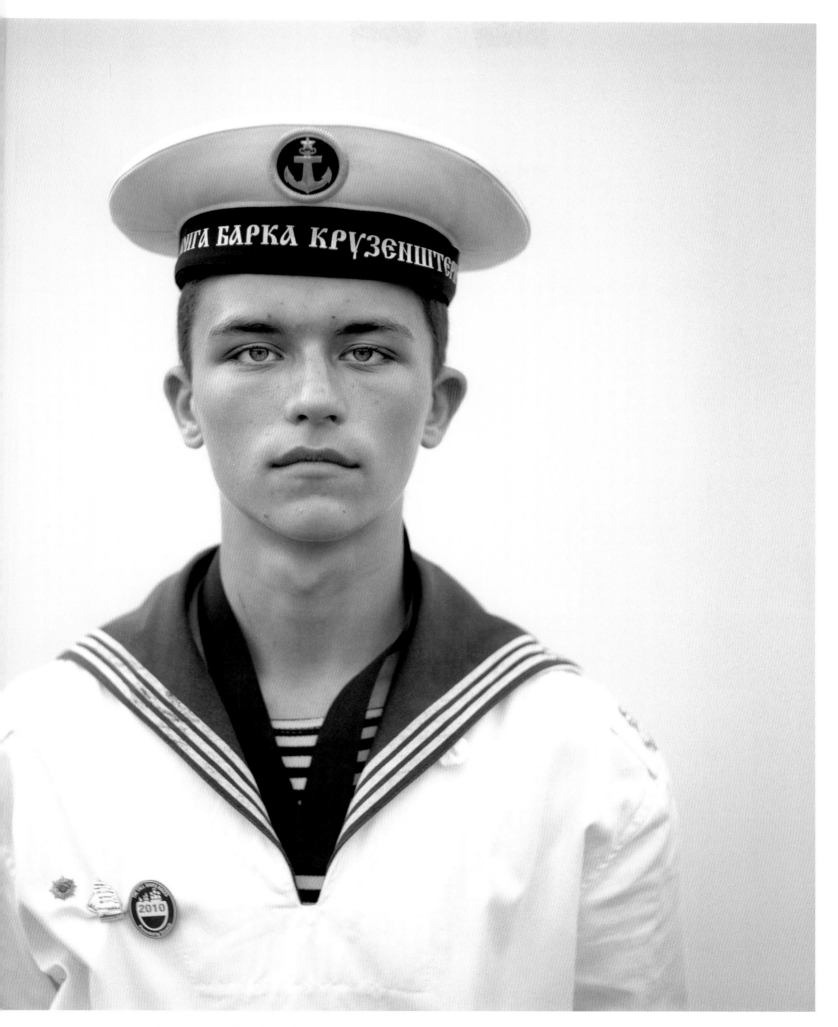

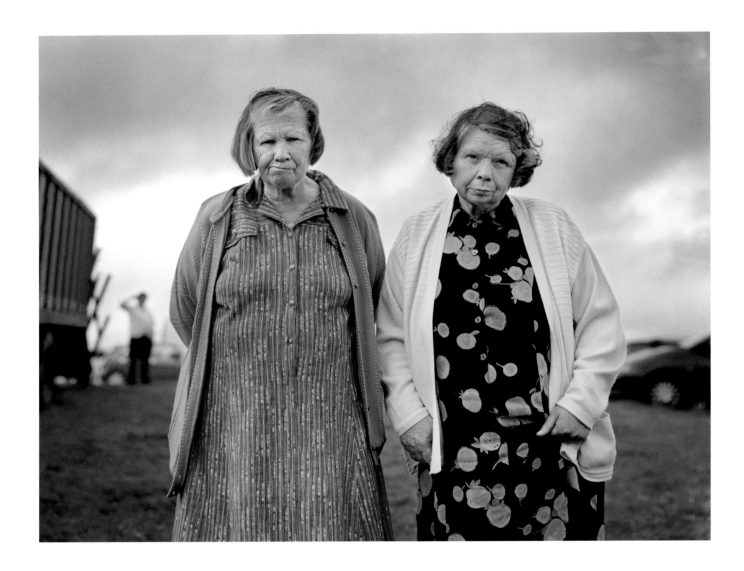

Fairs in Ireland are more than places of trade, often forming an important social and cultural event in the county calendar. Women regard them as occasions worth dressing up for. Many fairs focus on horse-trading, carried out to a large extent by traveling people, who belong to an ancient Gaelic nomadic tradition. Above: Muff Fair, County Cavan, dates back to the 12th century. Facing page, top: Cahirmee Fair, County Cork, held each year on 12 July. Smithfield Fair, Dublin. Below: Ballinasloe Fair, Galway, one of the oldest fairs in Ireland. Puck Fair, Killorgan, County Kerry, was granted a royal charter in 1603.

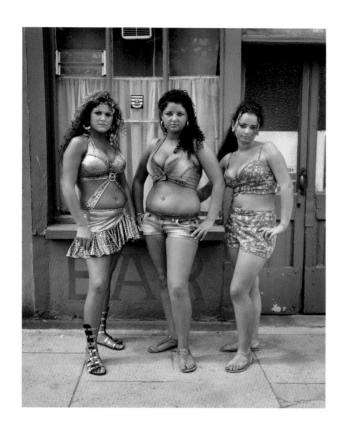
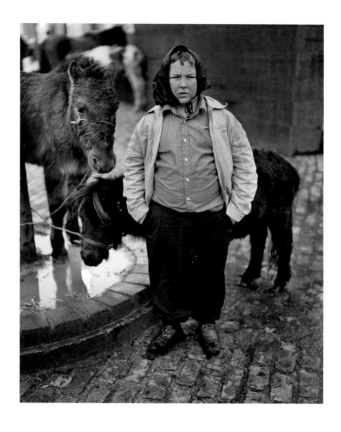
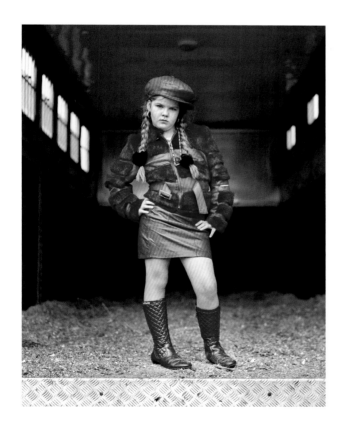
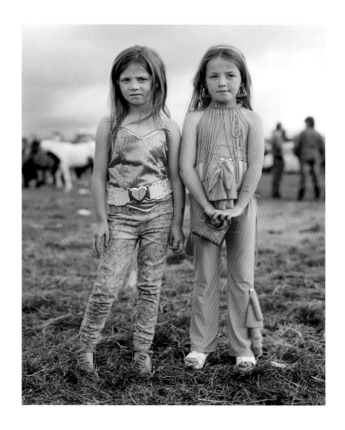

People in the News

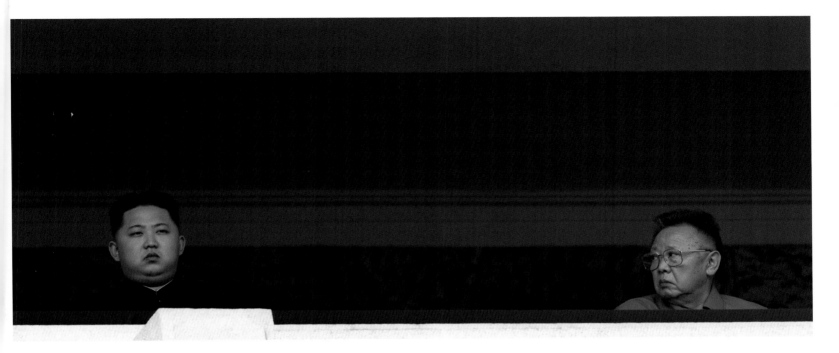

North Korean leader Kim Jong-il attends a military parade, together with his youngest son and designated successor Kim Jong-un, in Pyongyang on 10 October. Until then, Kim Jong-un had rarely appeared in public or been photographed. The elder Kim, said to be in poor health after apparently suffering a stroke in 2008, had hurried his youngest son's steps to succession in previous weeks. In September, Kim Jong-un, believed to be in his late twenties, was appointed a four-star general and given two significant positions in the party. It appeared that his elder brothers were either uninterested or deemed unsuitable for the position.

Julian Assange, founder of the whistle-blowing website WikiLeaks, emerges from a panel discussion at the University of London, on 30 September. During the year, WikiLeaks had made public a large batch of classified US military documents on Iraq and Afghanistan. It went on to release sensitive correspondence between American, Middle-Eastern, and other international diplomats, including revelations on the stance taken by Palestinian negotiators in connection with Israel. At the beginning of September, the Swedish Director of Prosecutions re-opened a previously dropped case against Assange on allegations of sexual assault. The following month an international warrant was issued for his arrest, sparking accusations of a smear campaign.

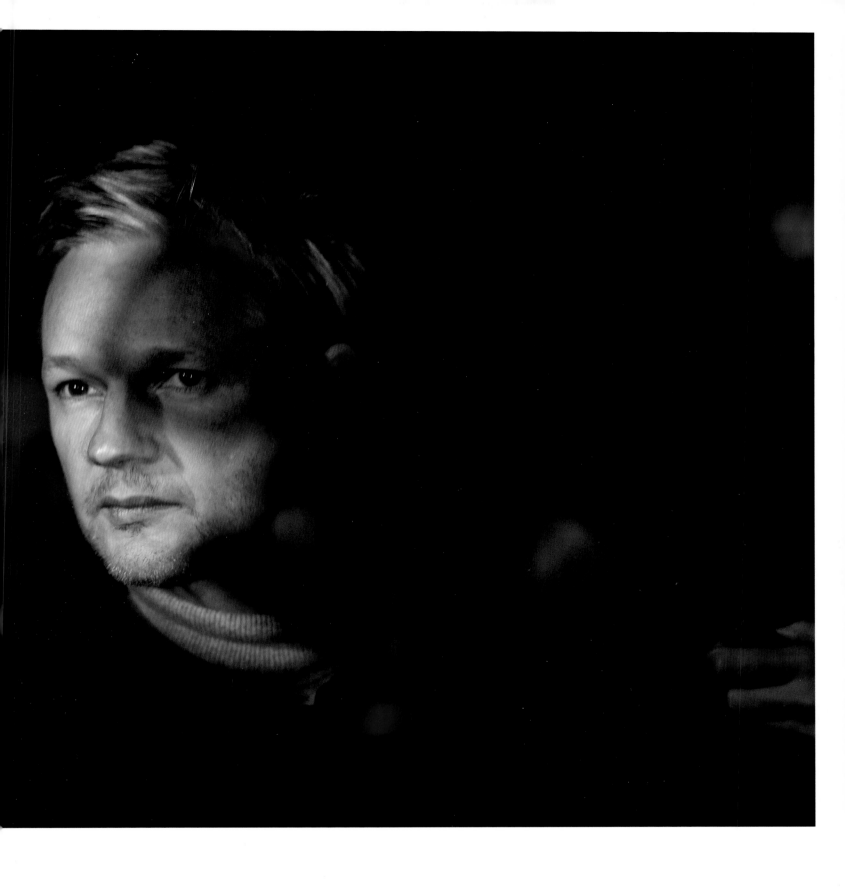

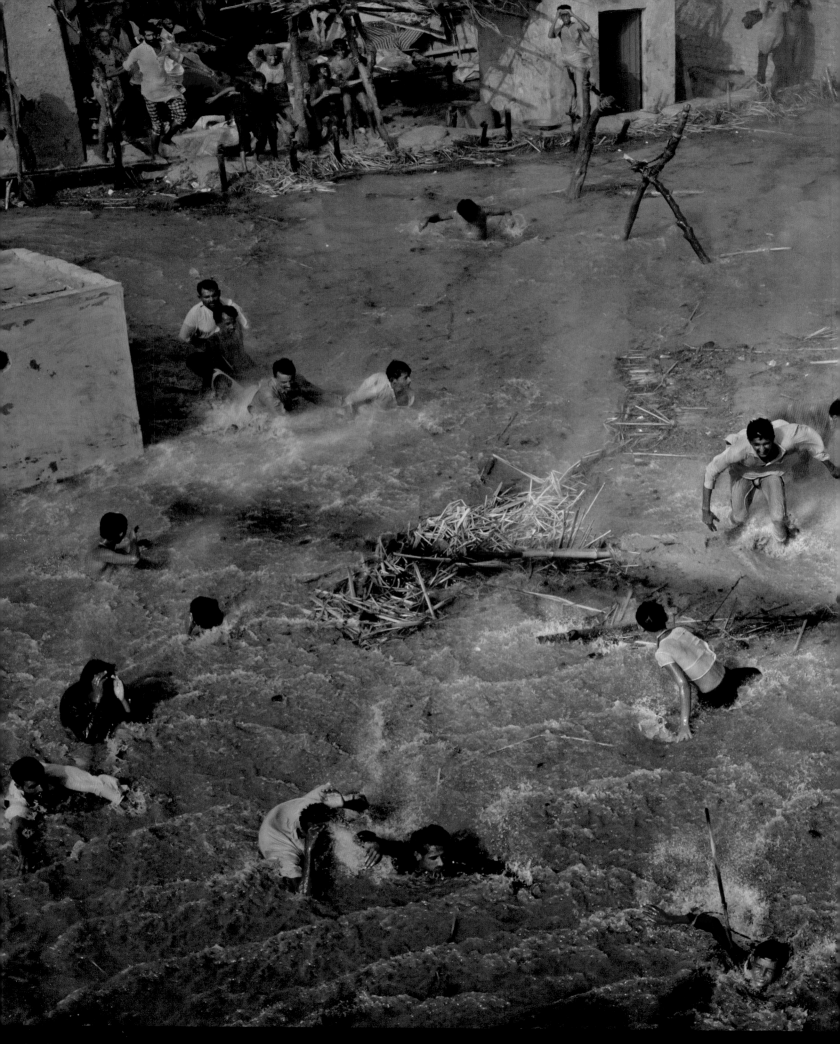

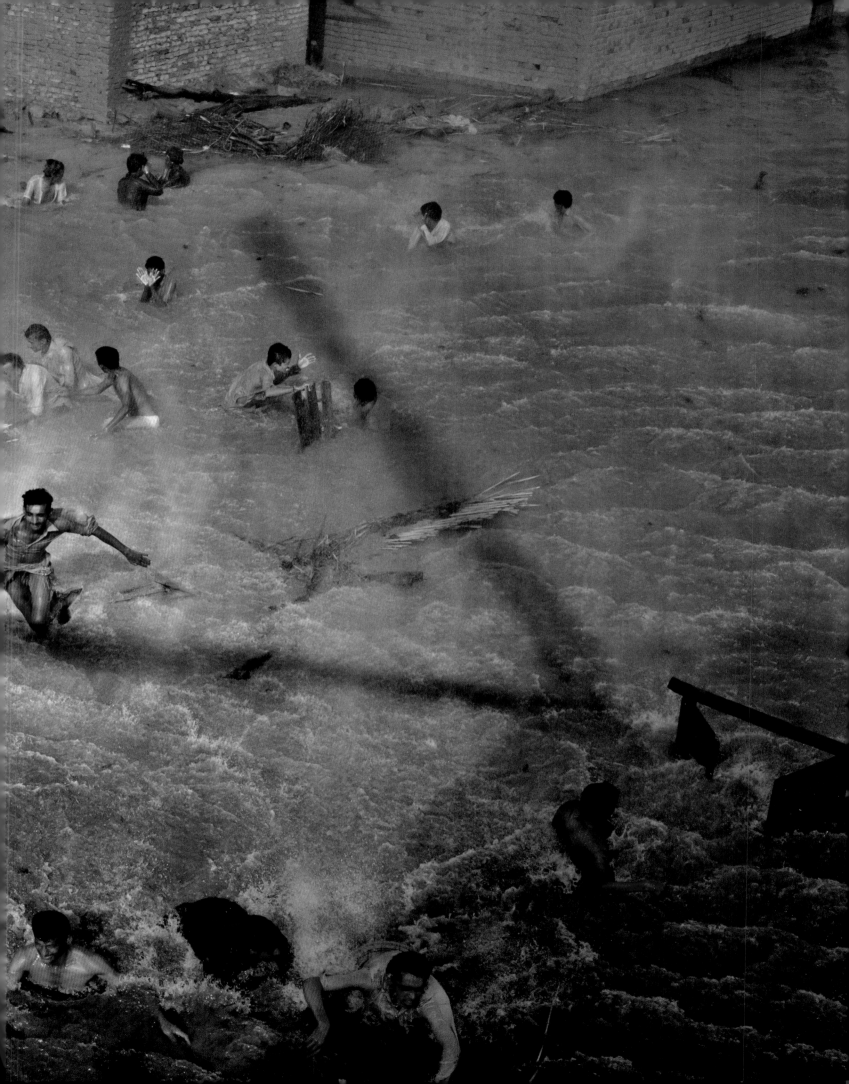

Unusually heavy monsoon rains in July triggered the worst flood in Pakistan's history. Beginning in the northern province of Baluchistan, the flood spread throughout the Indus River Basin to Punjab and Sindh in the south. At one point, around one fifth of the country's total land mass was under water. Over 20 million people were directly affected by the floods with up to 1,600 killed, as homes were destroyed and crops and livestock were washed away. The country's infrastructure was devastated as thousands of kilometers of roads and railways were destroyed, in addition to some 7,000 schools and 400 health facilities. The Pakistan government, overwhelmed by the disaster, was accused of being slow to respond. Months after the flood, many Pakistanis were still suffering its effects. The loss of seed for the next planting season, and the vast areas left uninhabitable meant even longer-lasting consequences. Previous spread: Flood victims scramble for food rations in the downwash of a Pakistan army helicopter, during relief operations in Sindh, the worst-hit province, on 13 September. Facing page top: Displaced villagers travel through flood waters in Punjab, on 11 August. Below: A girl sleeps, covered in flies on a makeshift bed, on a patch of land accessible only from the air. Next spread, from top left: Girls whose families have been made homeless by the floods take shelter on high ground. A man and boy walk through flood waters in the Punjab village of Baseera, on 22 August. A boy carries water through a flooded yard, near Muzaffargarh in Punjab, one of the hardest hit cities. Villagers offer prayers on the roof of a madrasa, on 21 August, during the month of Ramadan.

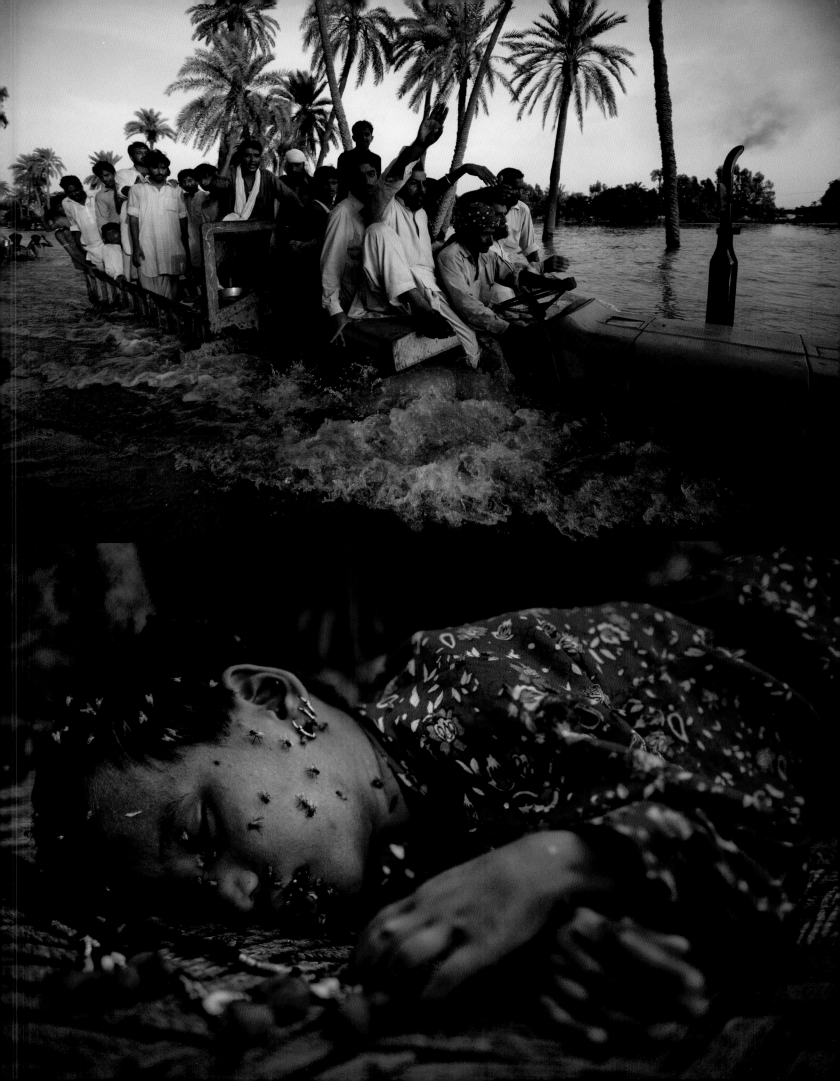

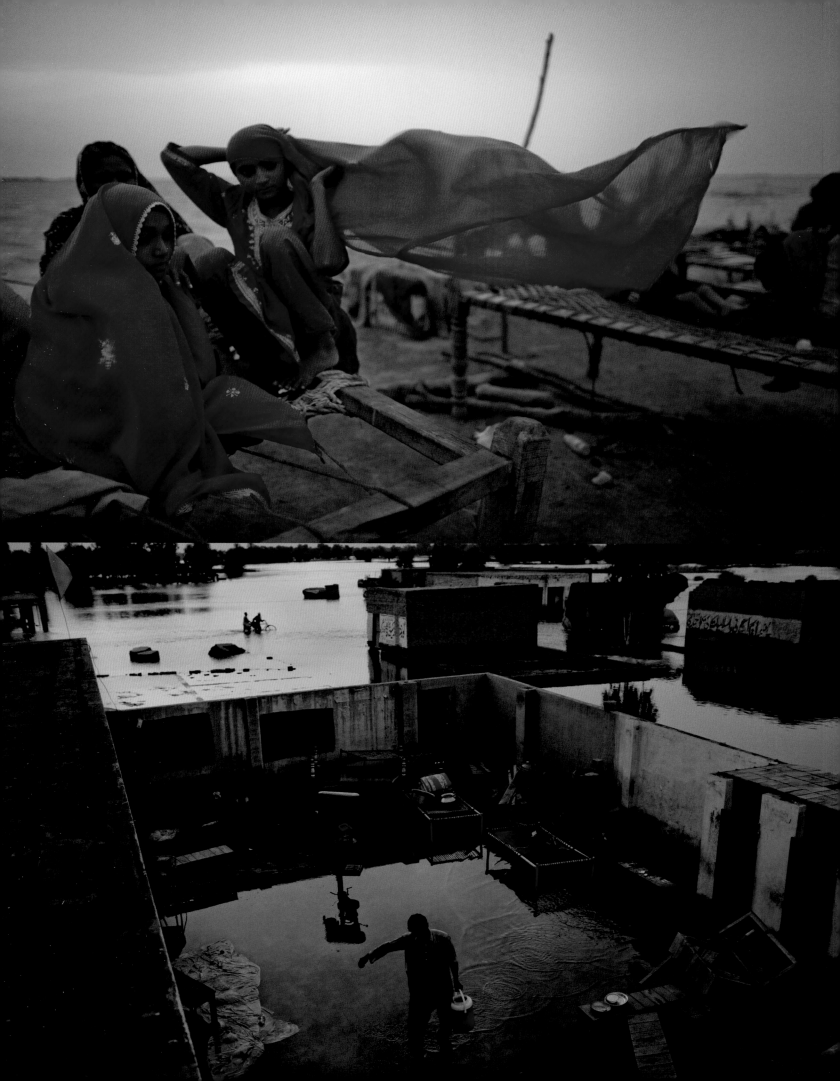

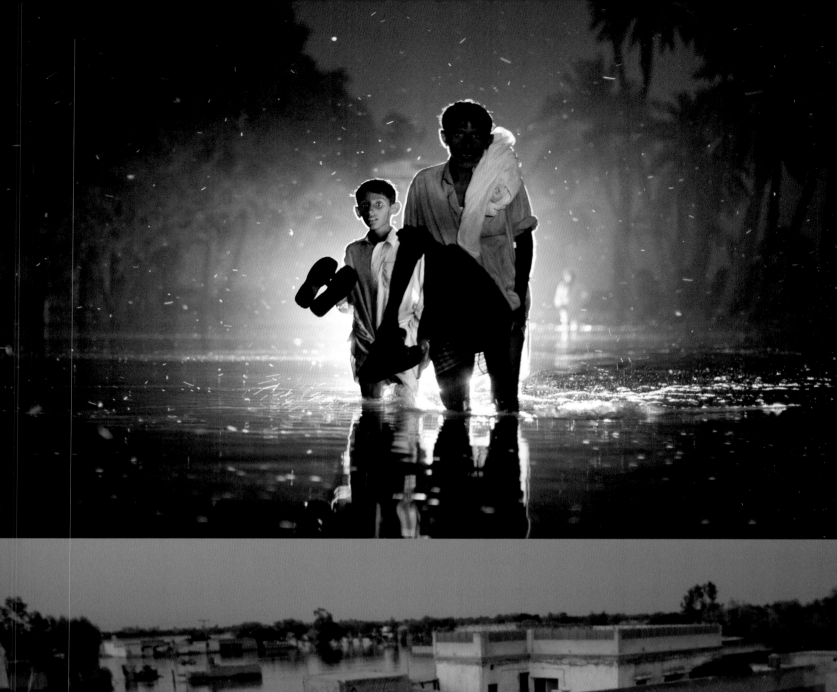
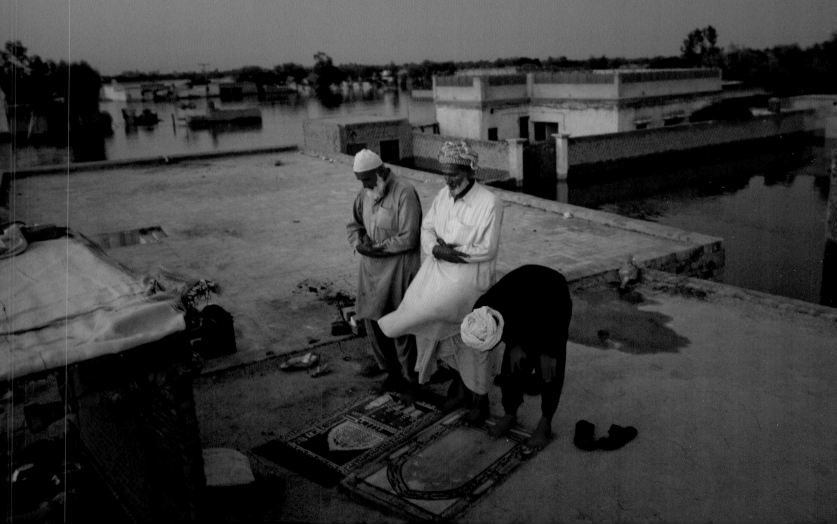

The sister of Feroz Ahmad Malik wails as she clings to the bed carrying his body, at his funeral in Palhalan, near the city of Srinagar, in Indian-administered Kashmir. Feroz was one of two people killed when Indian police and para-military fired at random in the town marketplace on 6 September. The incident led to massive protests in the town, during which a further two people were killed. Separatist unrest across the region had lasted since July, resulting in more than 60 deaths. Kashmir, which is over 60 percent Muslim, has been disputed by India and Pakistan since the partition of the subcontinent in 1947. From 1989 onwards, a growing Muslim separatist movement against Indian control has led to frequent clashes with government forces.

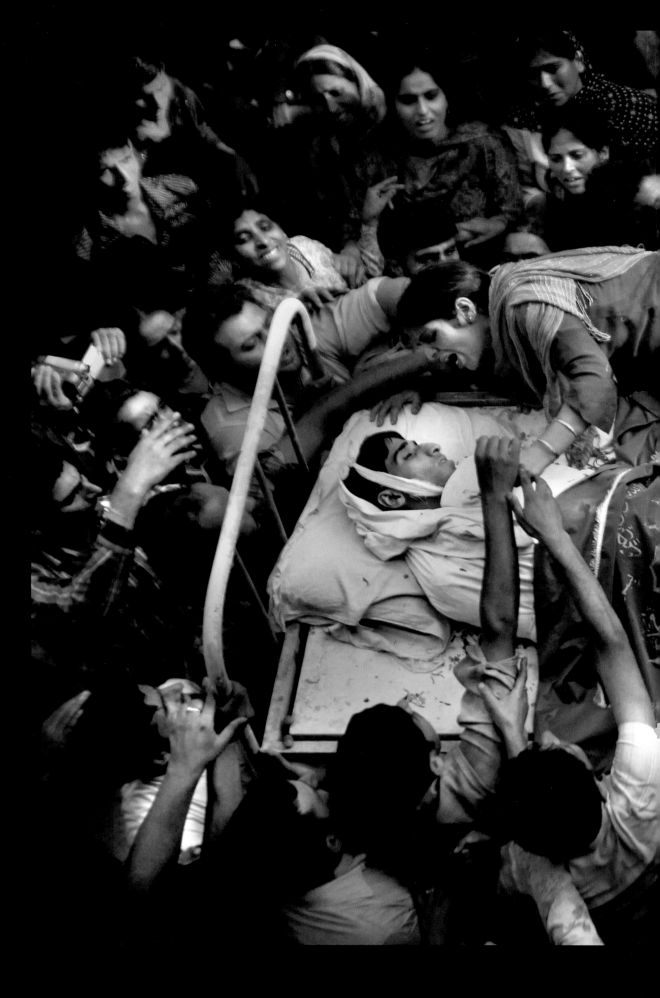

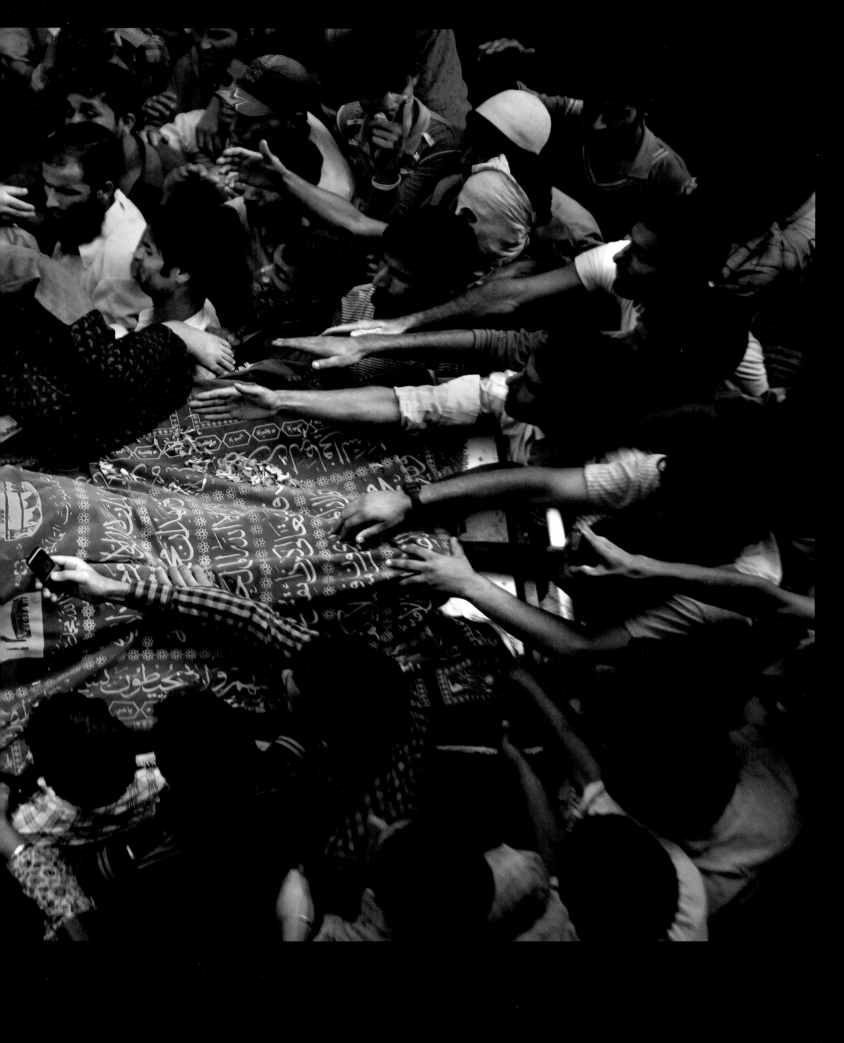

Poles mourn President Lech Kaczynski and dozens of the country's top political and military leaders, killed in an air crash near Smolensk airport in Russia on 10 April. The plane was transporting the official party to a reconciliation ceremony at a site where Soviet secret police had massacred some 20,000 members of Poland's elite officer corps during the Second World War, an incident the Russians had for decades blamed on the Nazis. The crash happened in thick fog and killed all on board, including the president and his wife, the chiefs of the army and the navy, Poland's deputy foreign minister, the president of the national bank, and a number of members of parliament. A national week of mourning was declared, culminating in an open-air memorial service attended by hundreds of thousands in the capital Warsaw, on Saturday 17 April. A state funeral for the president and his wife was held in Krakow the following day.

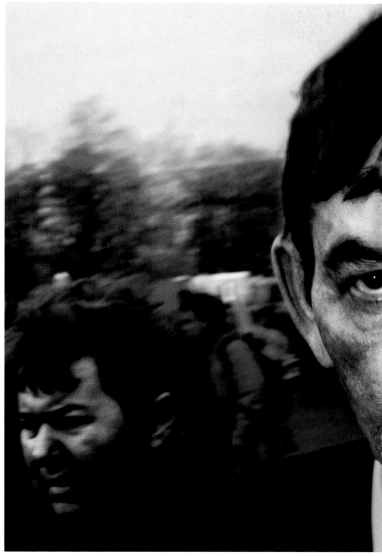

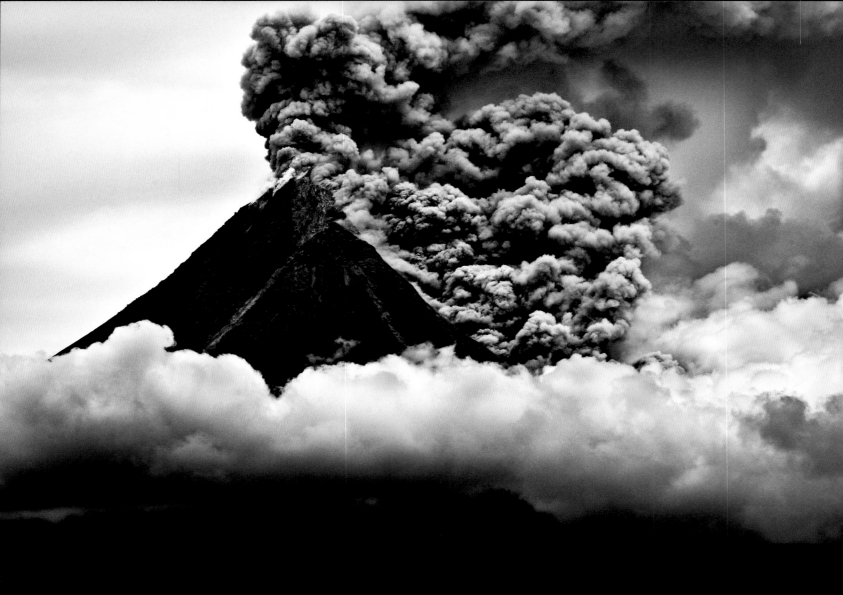

Mount Merapi, in Central Java, Indonesia, erupted in late October, blasting hot rock and volcanic ash a kilometer and a half into the air, in what was said to be its largest eruption since the 1870s. Merapi is one of the most active of over 100 volcanoes in the archipelago, but is known usually for non-explosive, slow eruptions. Over 350,000 people were evacuated from the area around Merapi, and 353 people were killed in a spate of volcanic activity that lasted over a month. Above: The volcano spews out an ash plume on 1 November. Facing page, top: Bodies of victims lie covered in volcanic ash in a house in the village of Argomulyo, in early November. Below: Masked in protection against the ash, people wait for public transport in the town of Muntilan, on the western slopes of Mount Merapi.

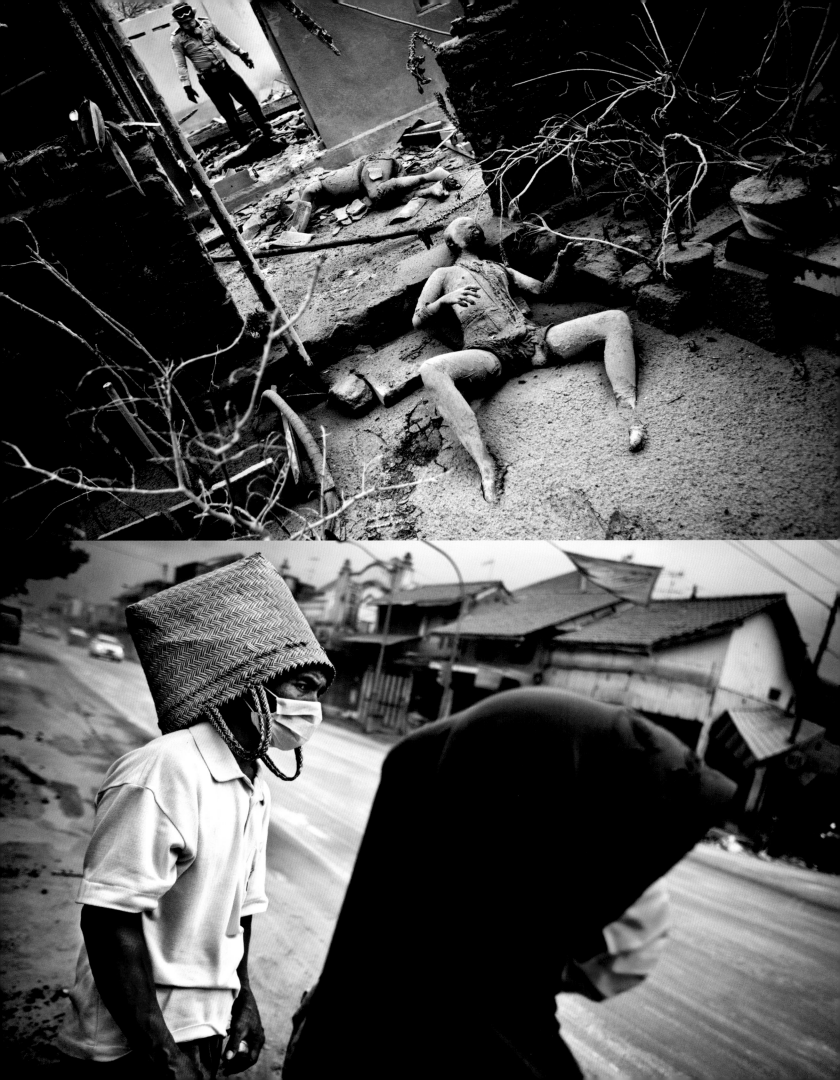

General News

SINGLES
1st Prize
Riccardo Venturi
2nd Prize
Guang Niu
3rd Prize
Javier Manzano
STORIES
1st Prize
Olivier Laban-Mattei
2nd Prize
Massimo Berruti
3rd Prize
Fernando Brito

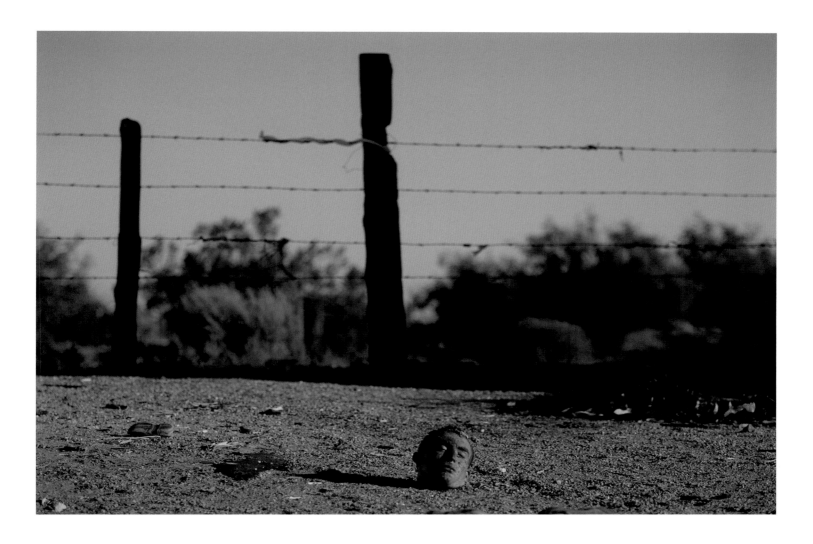

The head of a man who was ambushed while driving with his family, lies beside the road on the outskirts of Ciudad Juárez, in northern Mexico. The city, on the border with the USA, is a smuggling crossroads and a battleground in the drug wars that afflict the region, with thousands killed each year. The man's wife was fatally wounded by gunfire during the attack, and he was forced from the vehicle and abducted, leaving behind his children aged three and four. Police later found his body some 20 kilometers away.

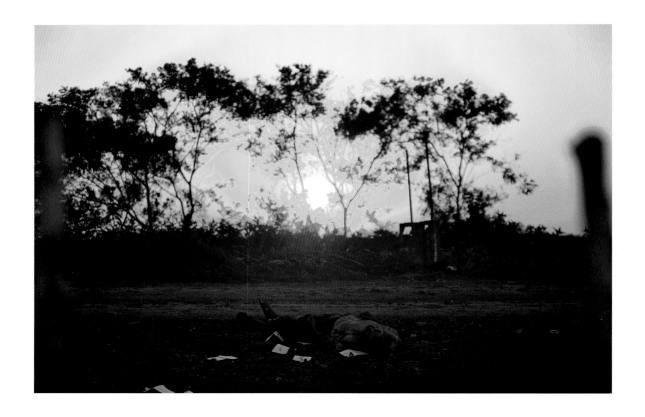

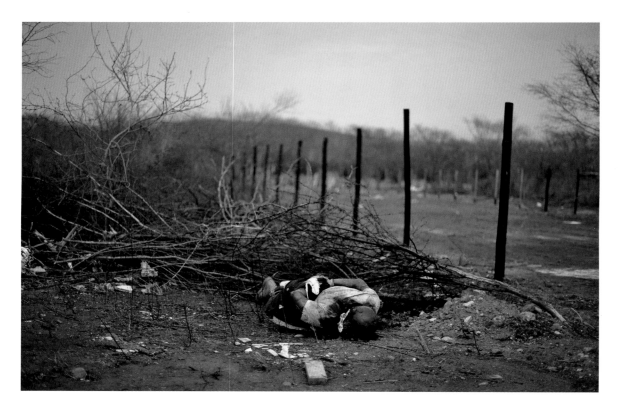

Areas of northern Mexico are racked by violence, involving turf wars between powerful drug cartels vying for control of trafficking routes. The death toll for 2010 was 15,237, the heaviest yet. This page, top: The body of an unidentified youth lies by the roadside near the town of La Higuerita, northwestern Mexico. He had multiple bullet wounds in his body and head. Below: A decomposing body discovered near the town of La Primavera, northwestern Mexico. One hand held a piece of card bearing the message: "Look what happened to a thief like me."

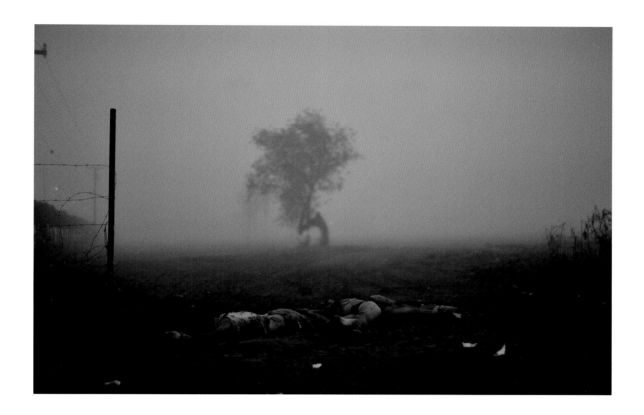

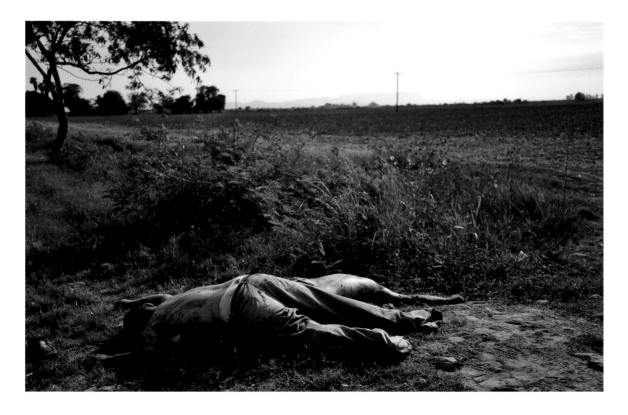

For generations Mexico has been a producer of, and transit route for, drugs. Powerful drug cartels have developed strong financial bases, and in some regions exert almost autonomous control, creating "zones of impunity" for their activities. This page, top: The bodies of three youths, discovered bound hand and foot and executed. Investigating officials found over 80 cases from three different guns in the vicinity. Below: Two victims of an apparent assassination lie outside the town of Caimancito, northwestern Mexico.

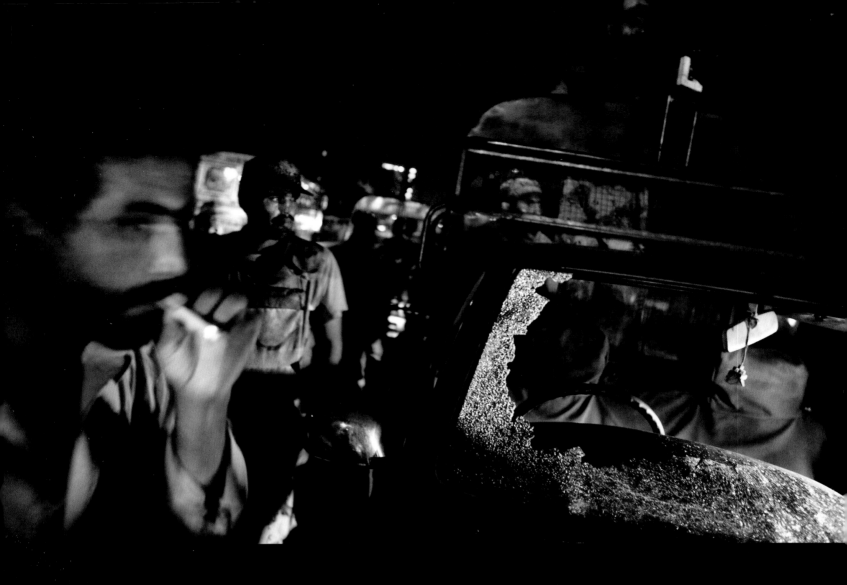

The number of targeted shootings in the Karachi area of Pakistan escalated in 2010, with over 1,100 violent deaths recorded by October. The cause of the killings remains obscure, but it appears to be a mix of political, religious, and criminal violence. Some observers blame rivalry between parties that have their electoral bases in different ethnic groups in the city. Others say the violence is linked to criminal gangs, allegedly controlled by major political parties. Some killings appear directly politically motivated, reactions to the assassination of political figures. Sectarian conflict between Shia and Sunni Muslim communities has also been blamed. Above: Rangers (government paramilitaries) respond after unknown men opened fire on a Shi'ite procession at the Empress Market shopping area in Saddar, in Karachi. Facing page, top: A worker washes the floor at a mortuary run by an NGO in a suburb of Karachi. Bodies not claimed immediately after shootings are transported here to await collection by families. Below: A passer-by lies injured after being caught in the fire when gunmen targeted two journalists, in Saddar, Karachi.

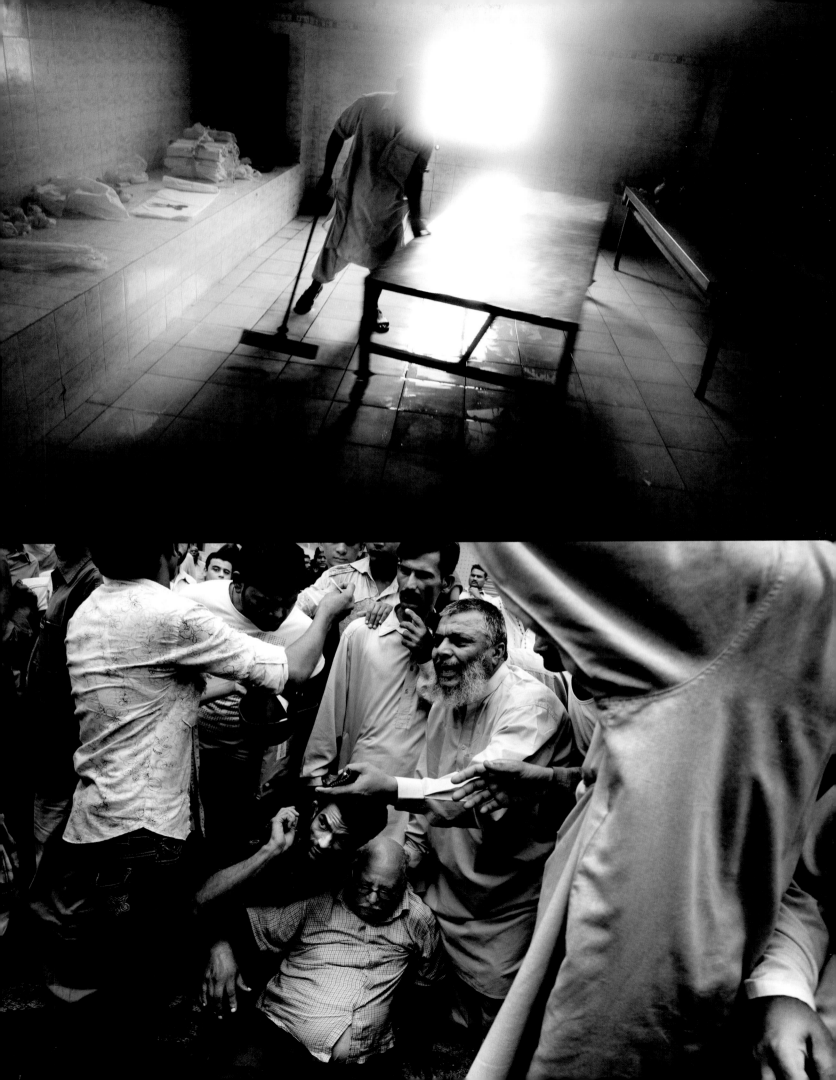

Tibetan monks prepare for the mass cremation of earthquake victims on a mountaintop in Yushu county, Qinghai province, China. A 6.9 magnitude earthquake struck the province on 14 April, killing over 2,600 people and injuring some 12,000 more. Tibetans usually practice "sky burial", leaving corpses out for vultures, but the sheer numbers of dead in this case forced the monks to abandon tradition.

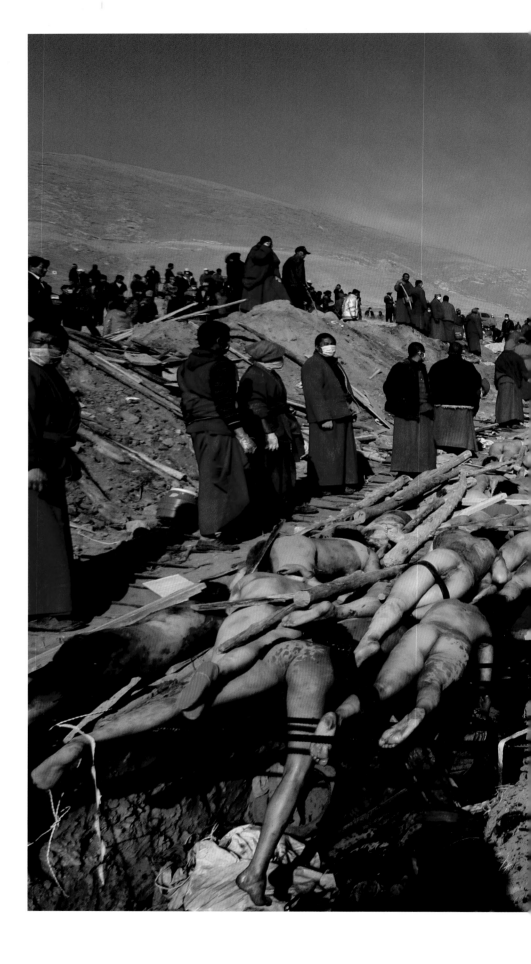

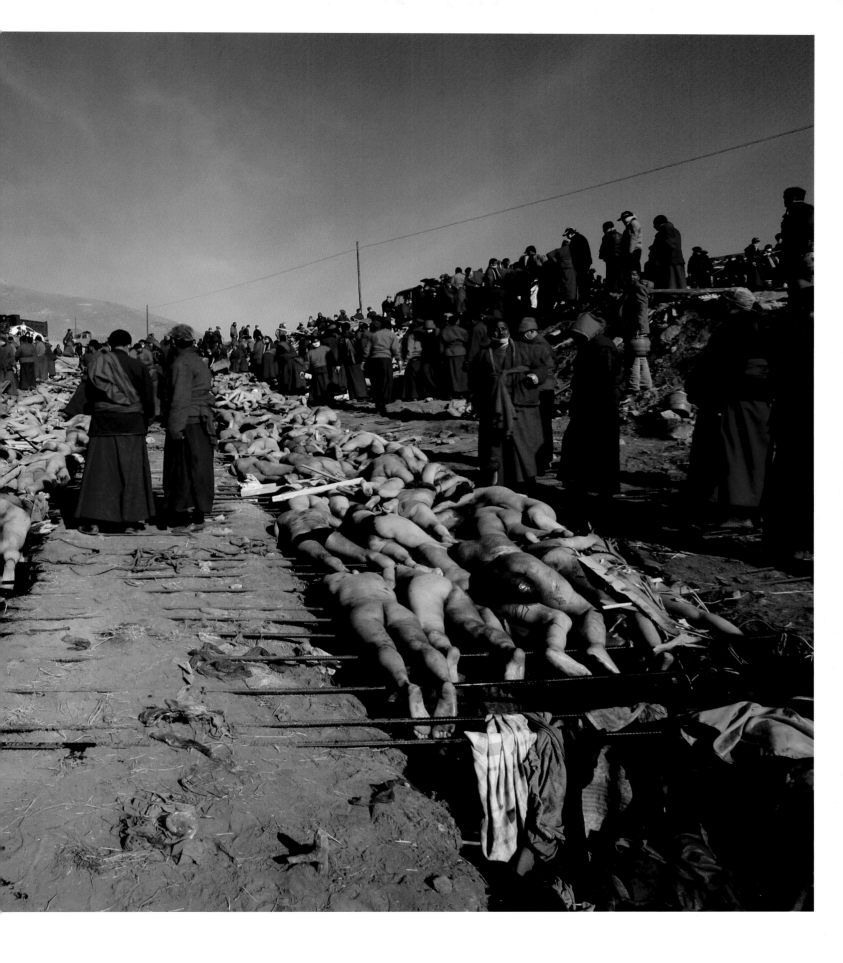

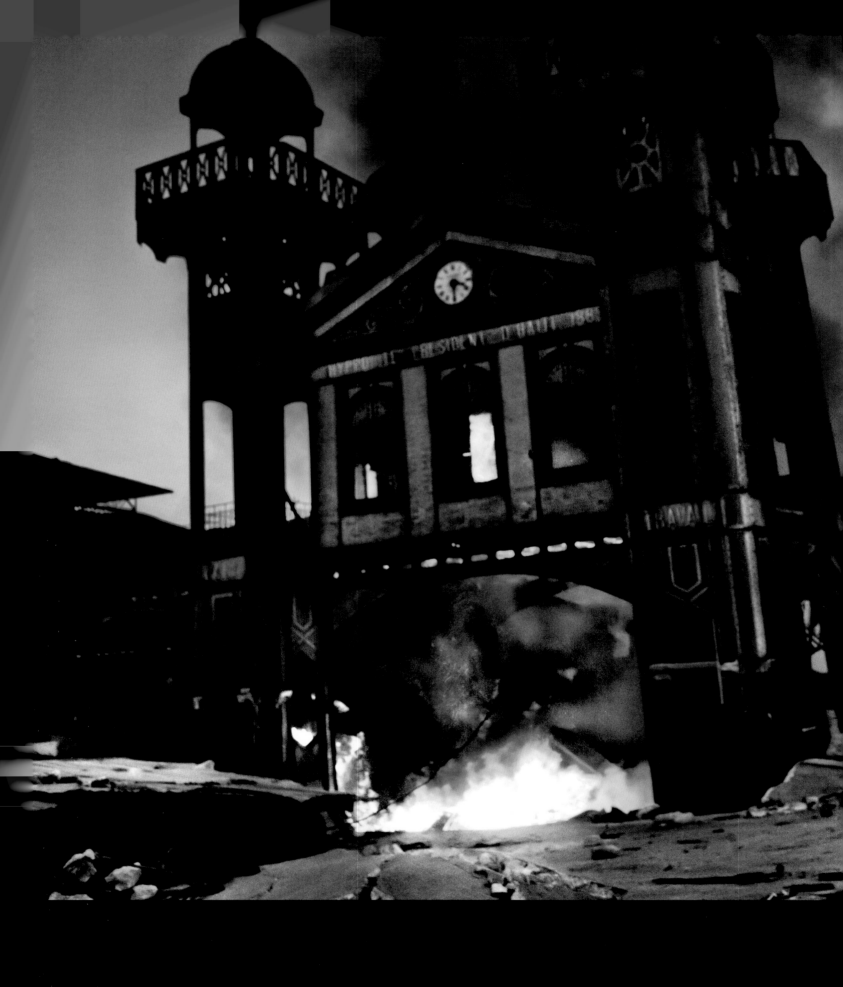

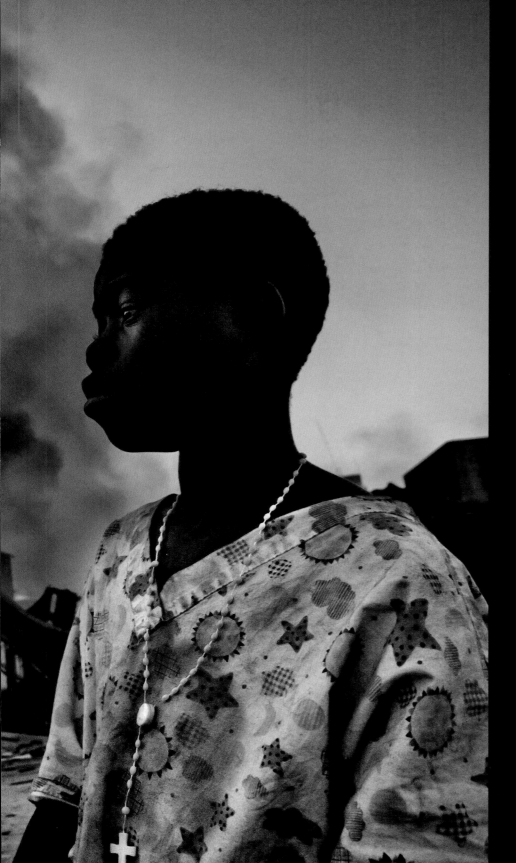

A girl looks on as the Marché Hyppolite in Port-au-Prince burns, on 18 January, six days after a 7.0 magnitude earthquake struck Haiti. The market, popularly known as the Marché en Fer (Iron Market) was a city landmark, dating back to 1891. The devastation caused by the earthquake appeared to paralyze authorities, leading to accusations of indecision and delay when it came to clean-up operations. But the enormity of the task that faced them, together with an infrastructure already weakened by decades of violent political instability and economic deprivation, were also to blame. Port-au-Prince presented further difficulties, as its hilly terrain and narrow streets, many of which became blocked by makeshift shelters, hindered access for heavy rubble-removing machinery. Aid agencies said that it could be years before reconstruction work was complete. The Marché en Fer was one of the first buildings in the capital to be restored, thanks largely to an € 8.8 million cash injection by a private donor. A year after the earthquake struck Haiti, just 5 percent of the resultant rubble had been removed from Port-au-Prince, but the Iron Market had re-opened for business, with some 900 vendors.

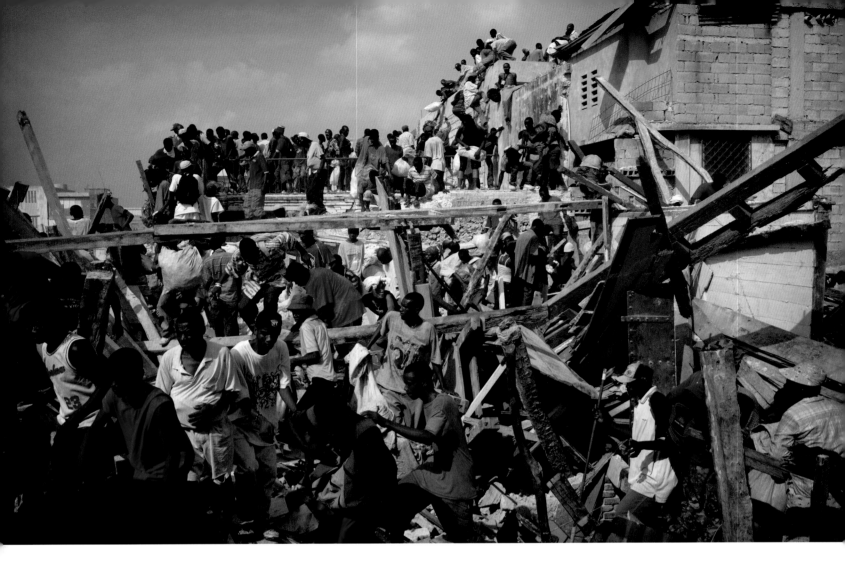

In the aftermath of the earthquake that struck Haiti in January, thousands of residents fled the capital Port-au-Prince. They said they were tired of sleeping in the streets, afraid of being robbed by gangs and looters, or fearful that aftershocks might destroy the buildings still standing. As aid was slow to reach many victims of the earthquake, particularly in the capital city, looting became a strategy for survival. Above: People remove anything they can find from a collapsed house, a week after the earthquake. Facing page, top: A man throws a corpse onto a pile of dead bodies at the morgue of a hospital in Port-au-Prince. Below: A woman walks through the streets of Port-au-Prince on 19 January, a week after the quake.

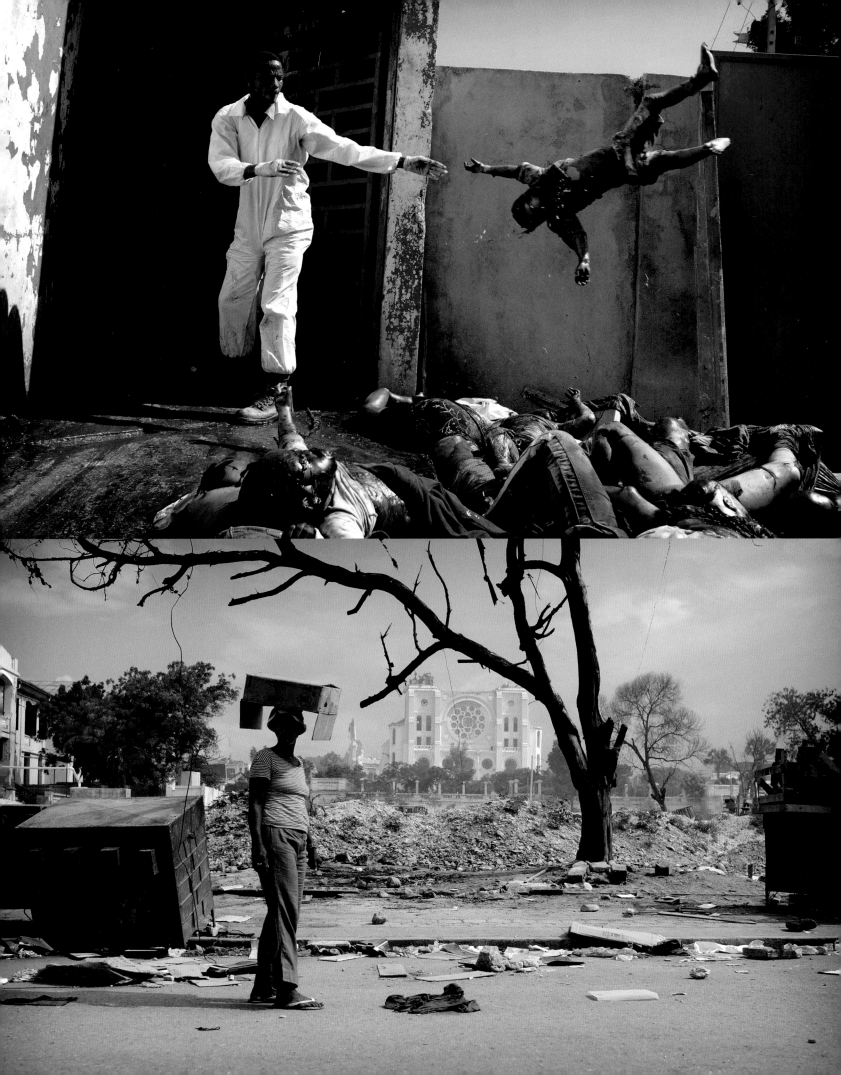

Spot News

SINGLES
1st Prize
Péter Lakatos
2nd Prize
Daniel Morel
3rd Prize
Uwe Weber
STORIES
1st Prize
Daniel Morel
2nd Prize
Corentin Fohlen
3rd Prize
Lu Guang
Honorable Mention
Alexandre Vieira

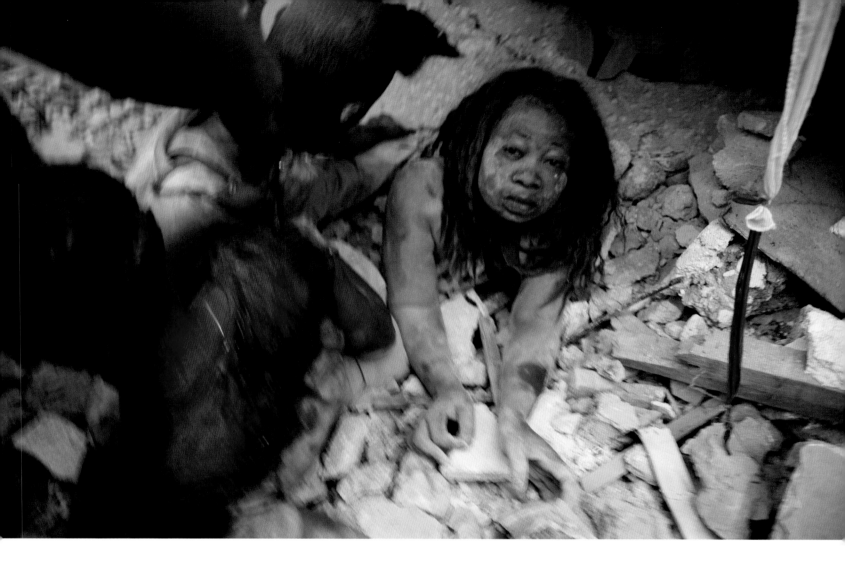

Haitians rescue a woman trapped beneath rubble in the capital Port-au-Prince, minutes after an earthquake hit on 12 January. The quake struck with an epicenter 15 kilometers southwest of the capital, near the town of Leogane. More than 50 aftershocks followed.

Some 230,000 people were killed, 300,000 injured, and more than a million left homeless. In explaining the extent of the damage, a senior Red Cross official said that it would take 200 trucks a total of 11 years to clear the rubble caused by the quake.

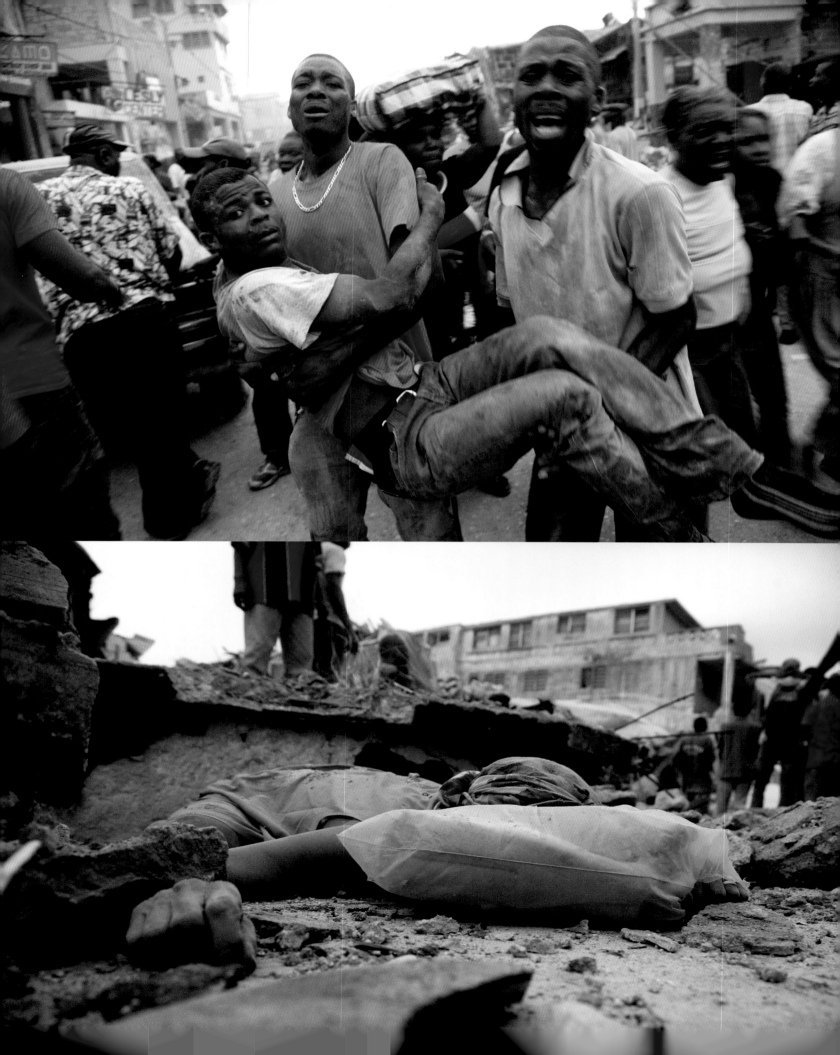

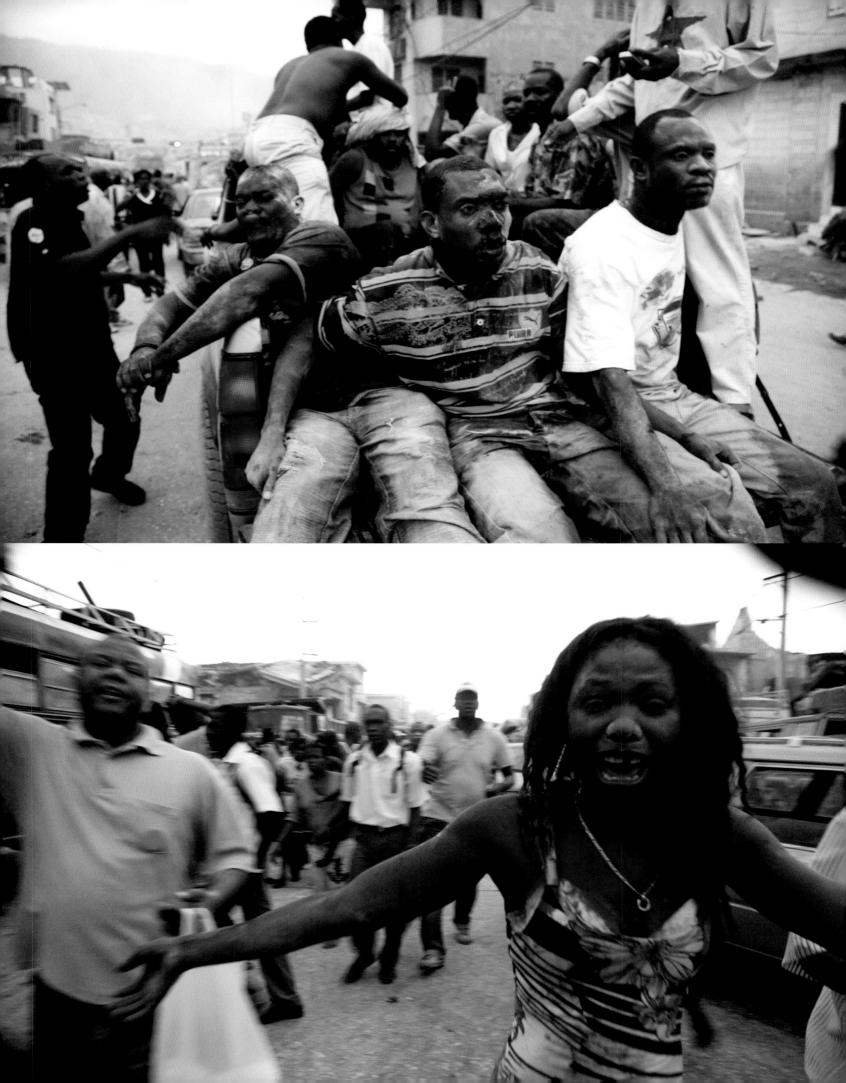

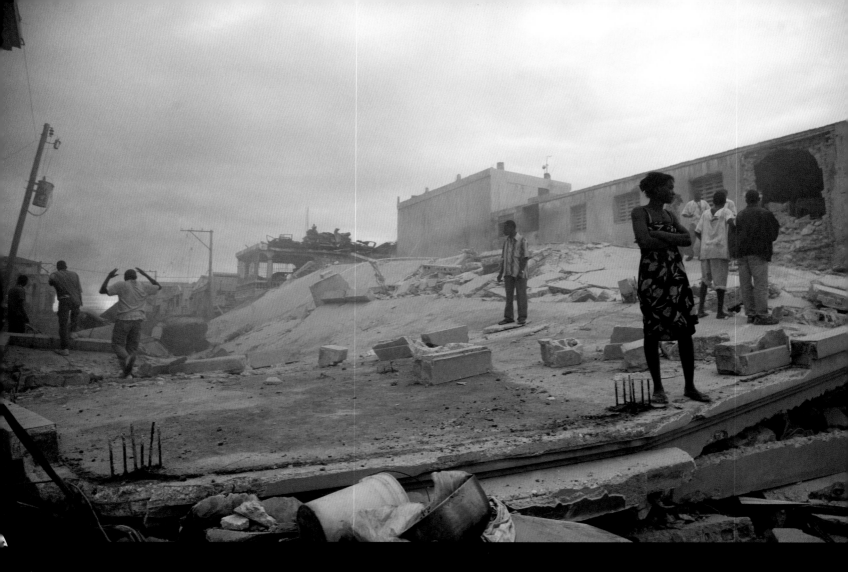

The earthquake that hit Haiti on 12 January caused the collapse of a total of 188,383 buildings, of which 105,000 were completely destroyed. The quake struck a land that, depleted by decades of instability, was already the poorest country in the Americas. Previous spread, from top left: Men carry a victim of the quake, minutes after it occurred, on Boulevard Jean-Jacques Dessalines, one of the main commercial arteries in Port-au-Prince. A pick-up truck transports people injured by the earthquake. The body of a bread vendor lies on Boulevard Jean-Jacques Dessalines. A woman flees a Port-au-Prince neighborhood after her house was destroyed. Above: People search for survivors in a collapsed building

>

People press through the crowd at the Love Parade in Duis-
burg, Germany, in a crush that left 21 dead and more than 500
injured. The Love Parade, a public party and music festival
first held in Berlin in 1989, has attained cult status around the
world. The Duisburg event, held on festival grounds at the site
of a disused railway depot, had only one entrance—a tunnel
100 meters long and 16 meters wide. Revelers packed into the
tunnel after police attempted to control access to the grounds.
Estimates after the event put attendance figures at 1.4 million,
but a later police statement reduced that to 400,000. Argu-
ment continued for months as to who was responsible for the
disaster, and an official investigation into the affair looked set
to drag on into 2012. The head organizer of the Love Parade
announced that the festival would not be held again.

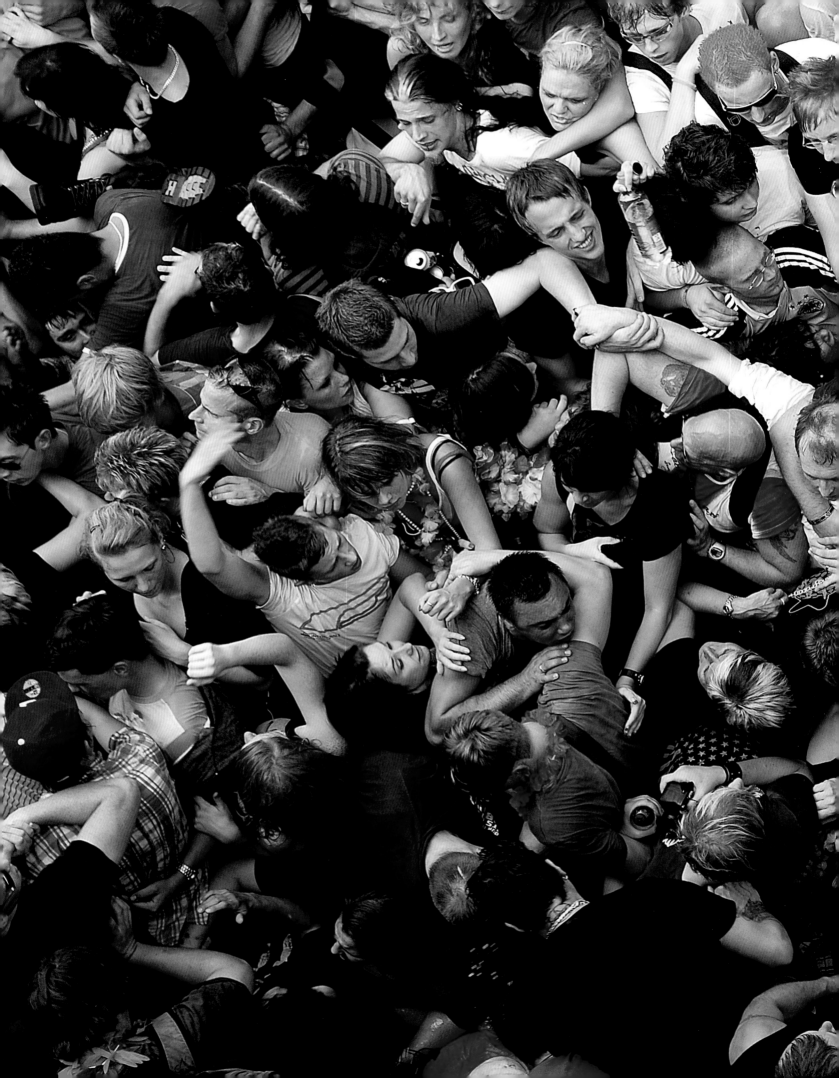

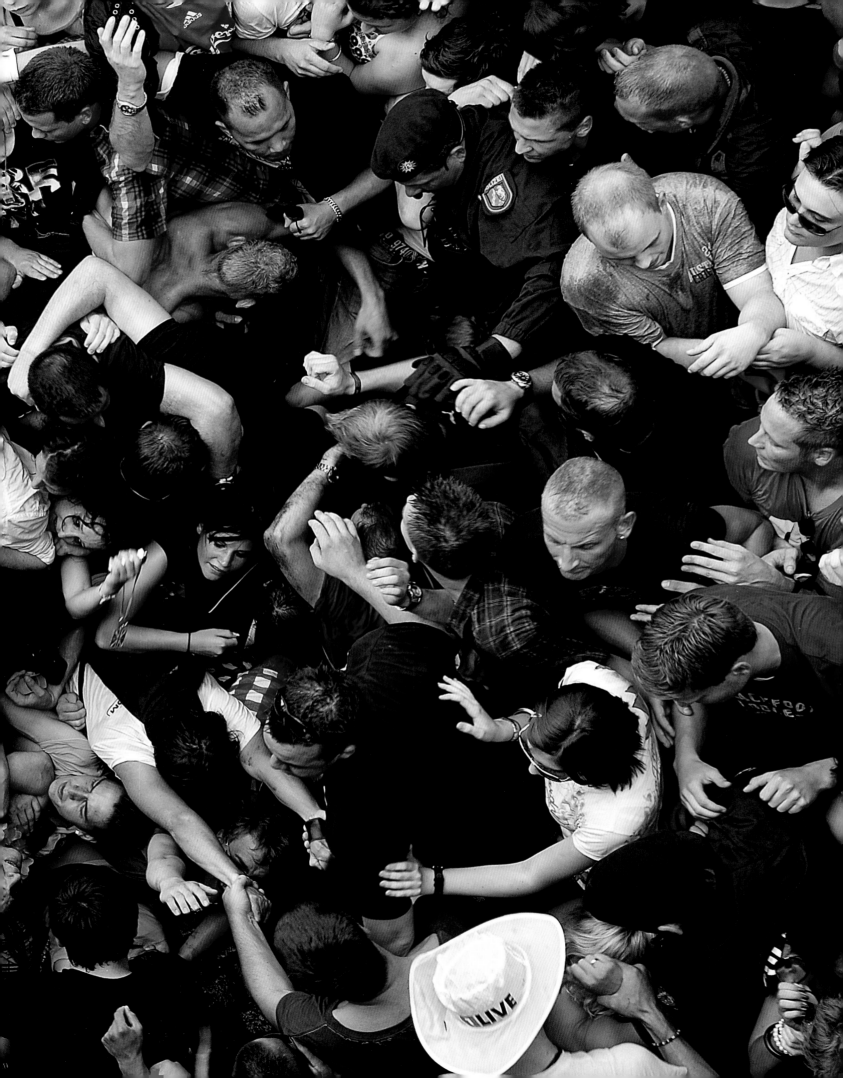

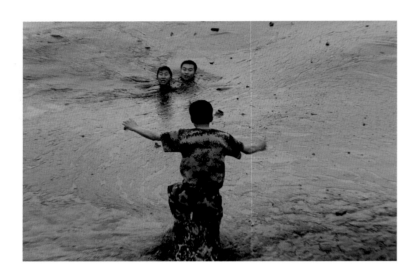 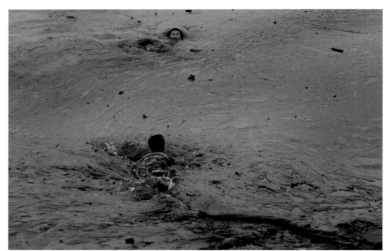

On 16 July, two pipelines exploded as crude oil was being unloaded from a tanker in the port of Dalian, in northeast China, unleashing a massive oil slick into the Yellow Sea. Firefighter Zhang Liang (25) died during clean-up operations. While diving to clear debris from the submerged pump responsible for pumping water to firefighting boats, he was caught in an undercurrent and drowned. This page, from top left: Firefighters Zhang Liang and Han Xiaoxiong wade into the polluted water to clean debris from the pump. Zhang Liang struggles to regain control as an undercurrent pulls him away from the pump. Firefighter instructor Zheng Zhanhong hears the men's cries for help and enters the water. Zhang Liang slips below the surface as Han Xiaoxiong battles to keep him afloat. Facing page, from top left: Unable to save their colleague, Han Xiaoxiong and Zheng Zhanhong struggle out of the oil to save themselves. Covered in oil, Han Xiaoxiong passes out from exhaustion. He is carried to land, and survives. A memorial service is held for Zhang Liang.

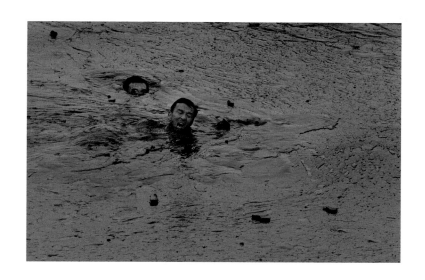

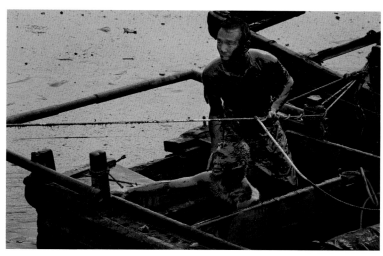

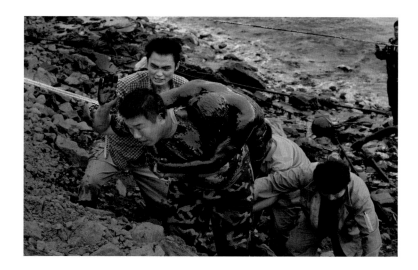

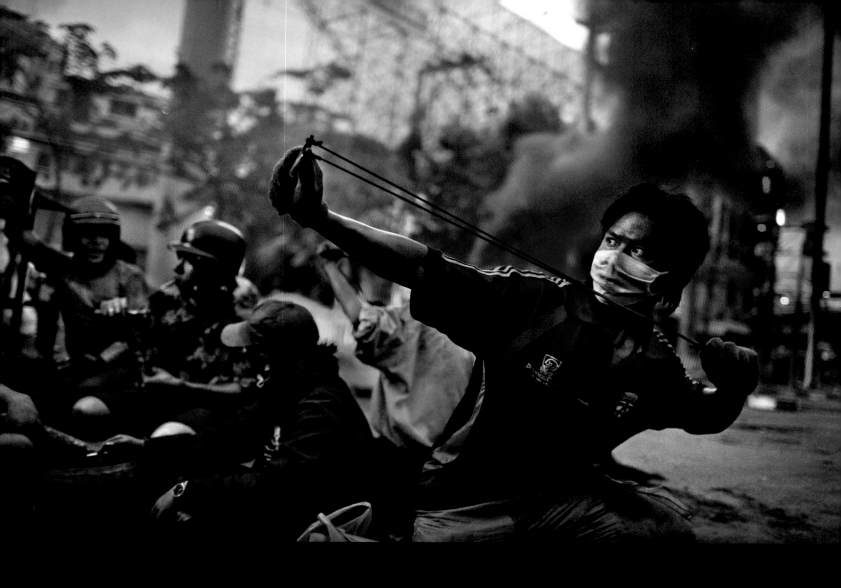

"Red Shirt" protestors clash with Thai government forces in mid-May, in the Silom commercial district of Bangkok. Violence had escalated after Khattiya Sawasdipol (better known as Seh Daeng, a prominent renegade general) was shot in the head while being interviewed by a foreign journalist. He died in a coma on 17 May. The clashes were part of a two-month stand-off between the Red Shirts and the authorities. Thailand had been gripped by political unrest since Prime Minister Thaksin Shinawatra was ousted in a military coup in September 2006. Elections in 2008 had placed Abhisit Vejjajiva, the Democratic Party leader, in power. The Red Shirts, however, coming largely from among the rural poor who had benefited from Thaksin's policies, demanded Abhisit's resignation, saying his government had come to power illegitimately and that he was a puppet of the military. (continues)

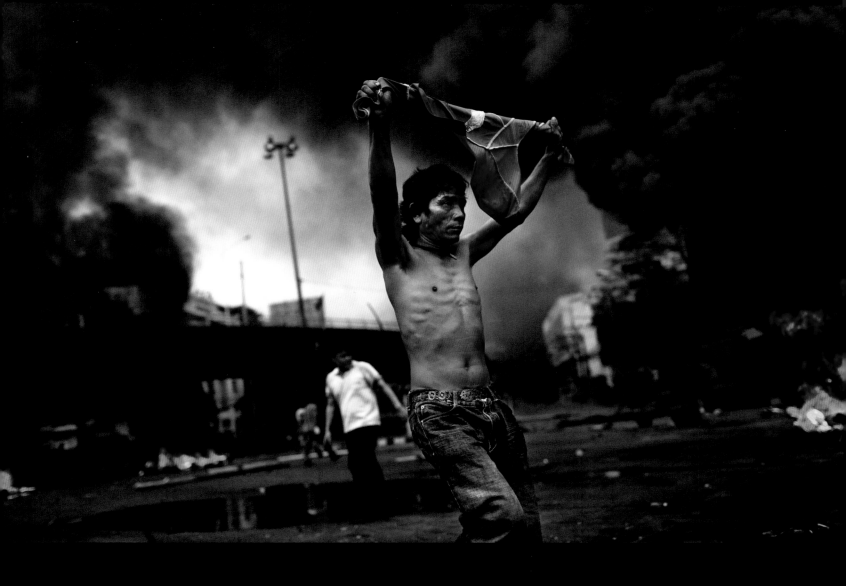

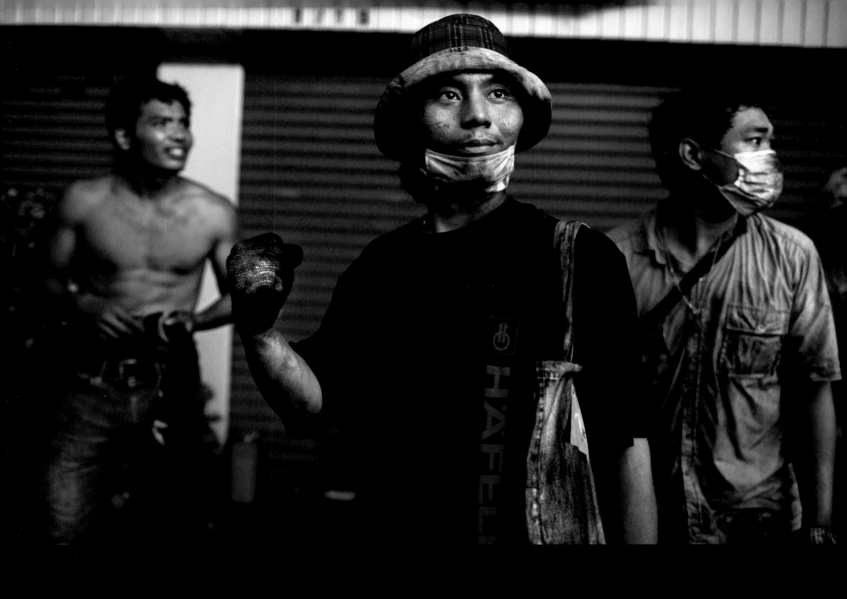

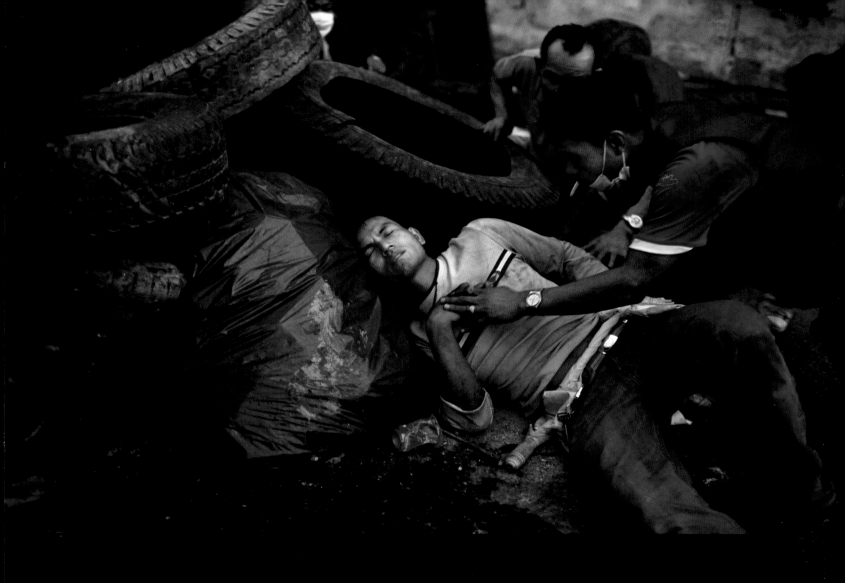

(continued) Protestors hurled rocks and fireworks at government forces and set fire to tires in the street. Troops and the police countered with rubber bullets, tear gas, and live ammunition. On 19 May, after troops in armored cars had stormed barricades around the demonstrators' encampment, Red Shirt leaders surrendered, telling their supporters to end the protest. Even after the call to surrender, some demonstrators said they would fight on. By the time unrest finally died down at the end of May, over 80 people had been killed and some 2,000 injured.

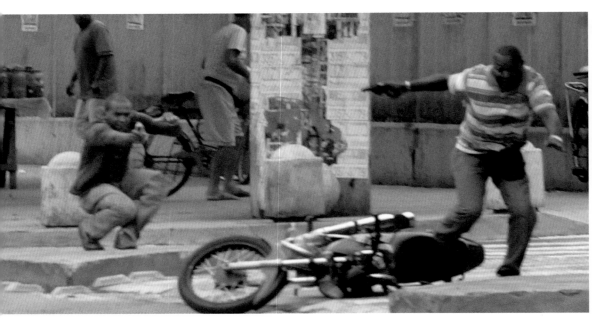

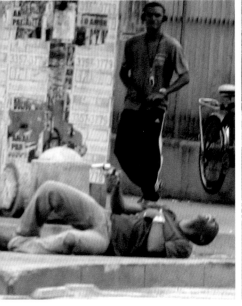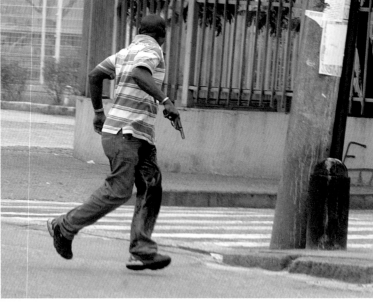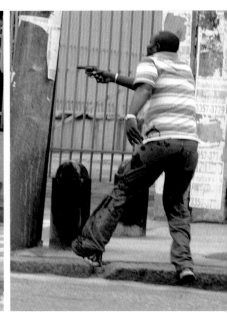

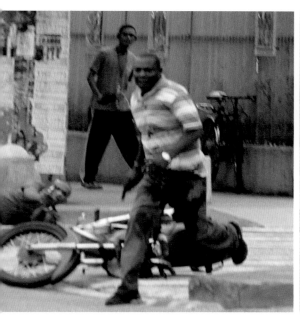
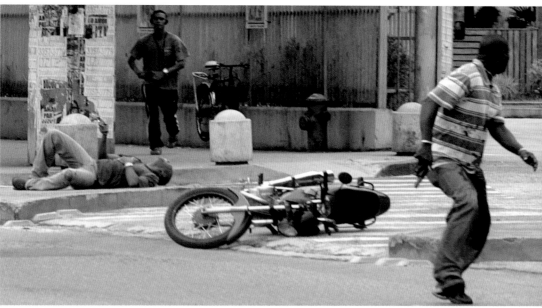
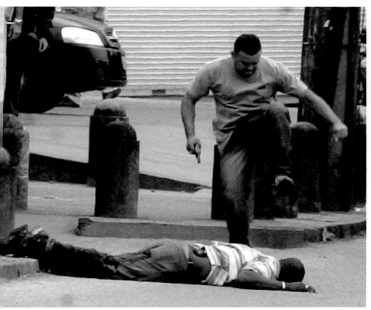
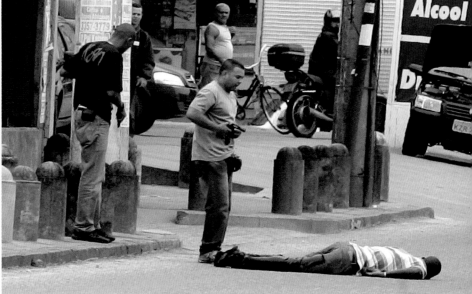

A daylight shootout on the Avenida Brasil, a busy shopping area in Rio de Janeiro. The initial exchange of fire left the man in the grey shirt injured. As the man in the striped shirt was fleeing, he was shot and trampled by apparent acquaintances of his victim, and died on the spot. The first man died in hospital the following day.

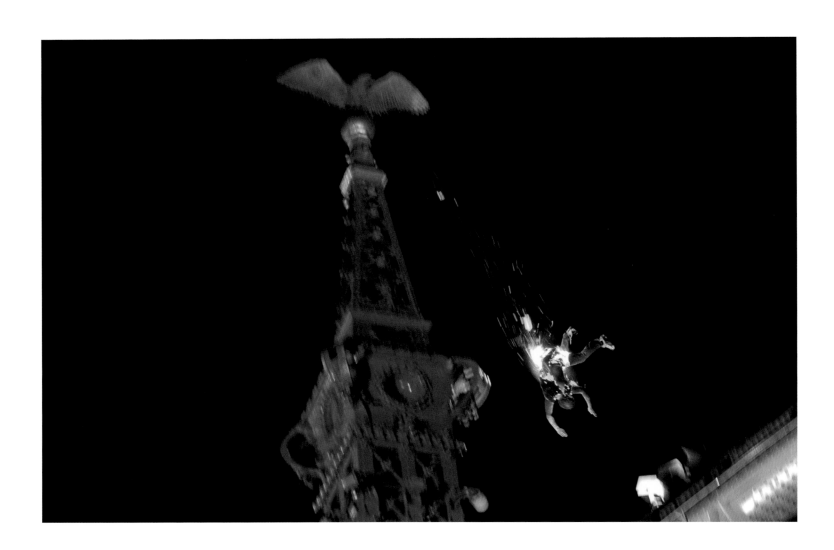

A man falls to his death from a turret of Liberty Bridge in Budapest, Hungary, after covering himself in flammable liquid and setting himself alight. Firemen had tried for half an hour to convince the man, aged around 40, to come down. His motives for suicide are not known.

Contemporary Issues

SINGLES
1st Prize
Marco Di Lauro
2nd Prize
Ed Kashi
3rd Prize
Ivo Saglietti
STORIES
1st Prize
Ed Ou
2nd Prize
Darcy Padilla
3rd Prize
Sarah Elliott
Honorable Mention
Michael Wolf

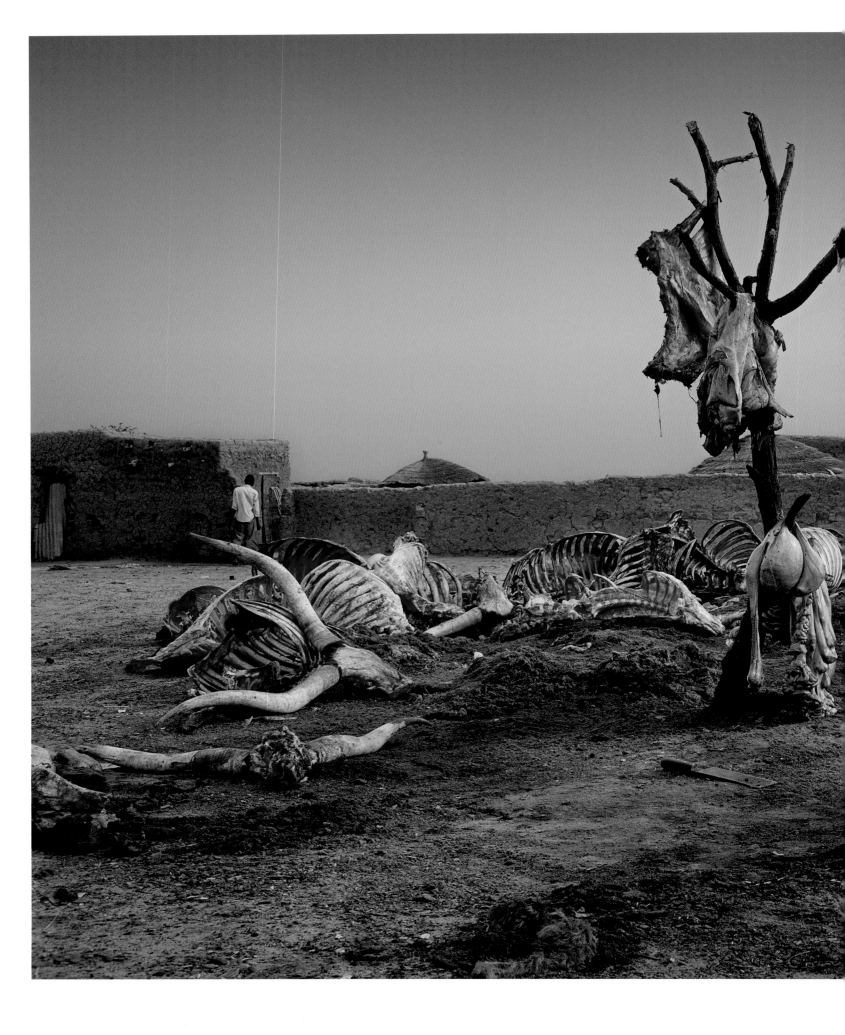

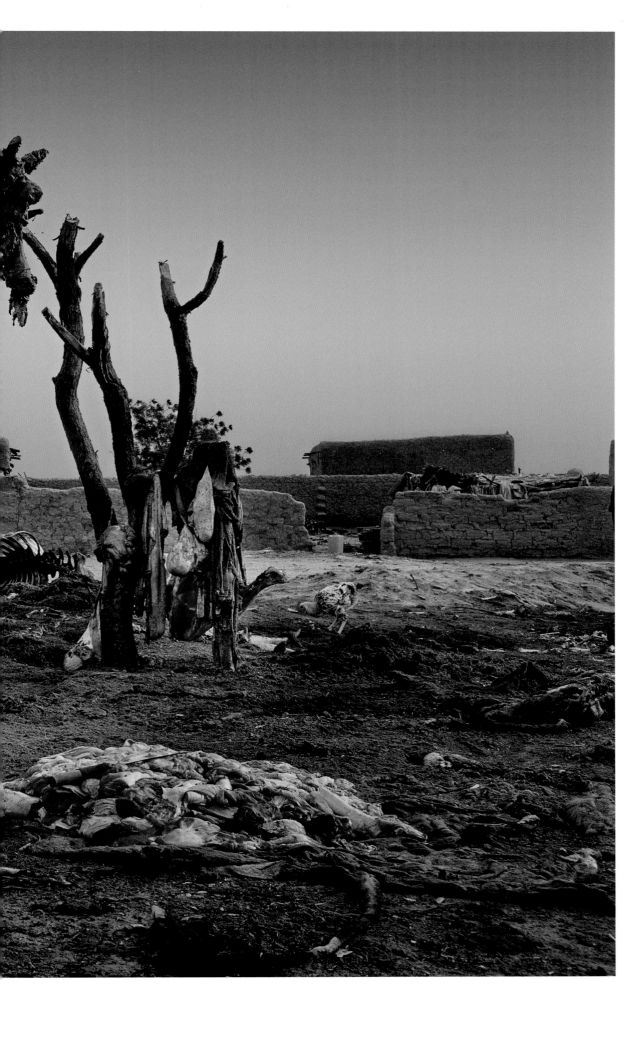

Entrails and skeletons of dead livestock lie in the Gadabedji reserve in the Maradi region of Niger in western Africa. Meat traders buy up dying livestock, slaughter the animals, cook the meat on the spot and sell it to neighboring Nigeria. The worst drought in Niger since 1984 had left farmers' herds starving and the Gadabedji reserve offered some of the last grazing land in the country. Together with a failed 2009 harvest, the drought led to a food crisis in Niger, with Maradi being one of the most severely hit regions. By mid-2010, a World Food Programme survey estimated that 2.5 million children in Niger were in need of emergency food aid. Lacking refrigeration facilities to store meat themselves, local cattle-farmers had little option but to sell their dying animals at a fraction of the usual rate, and use the money to buy what food they could.

Every year, thousands of people risk their lives crossing the Gulf of Aden to Yemen to escape conflict and poverty in the Horn of Africa. One third of those arriving are from Somalia, which has not had an effective central government for three decades and is torn apart by fighting. Some 6,600 Somalis reached Yemen in the first half of 2010. Facing page, top: Four Somalis prepare to leave Boroma, a transit point for flight to Yemen, on 4 March. Below: The men try to free their vehicle from mud, after a heavy rainfall. Overleaf, top: Exhausted men sleep in the desert after traveling all night on muddy roads and in pouring rain. Below: Fleeing Somalis rest near a safe-house, before illegally crossing the border into Djibouti. Following page, top: Having crossed into Djibouti, refugees trek across the desert to the port of Obock to find a boat to smuggle them into emen. Below: On 29 March, people swarm a boat that they hope will carry them across the Gulf of Aden. The boat broke down halfway across, forcing the occupants to return to Djibouti, where they were arrested shortly after landing.

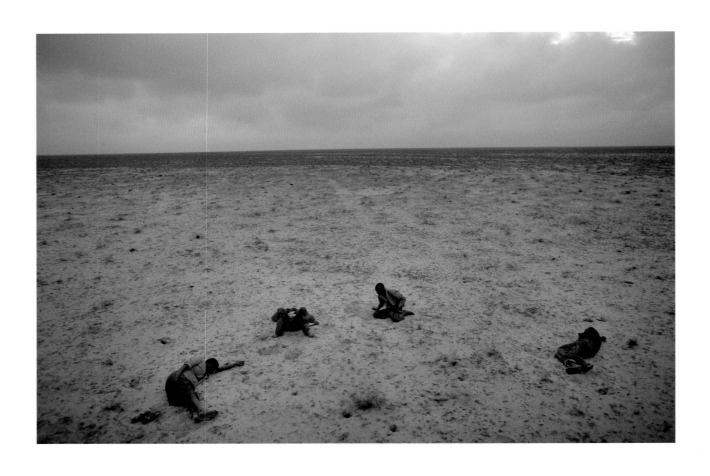

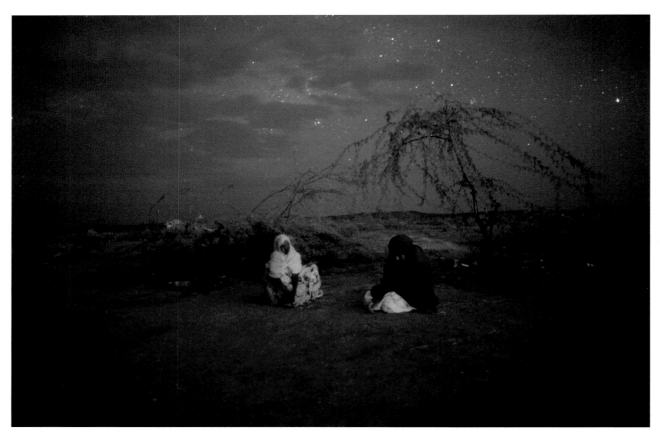

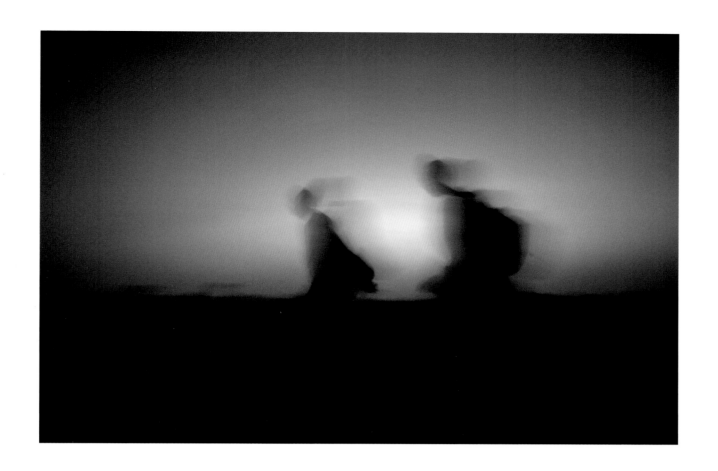

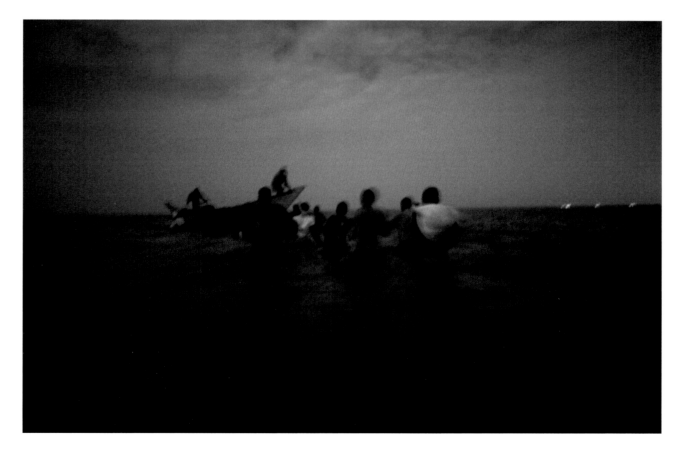

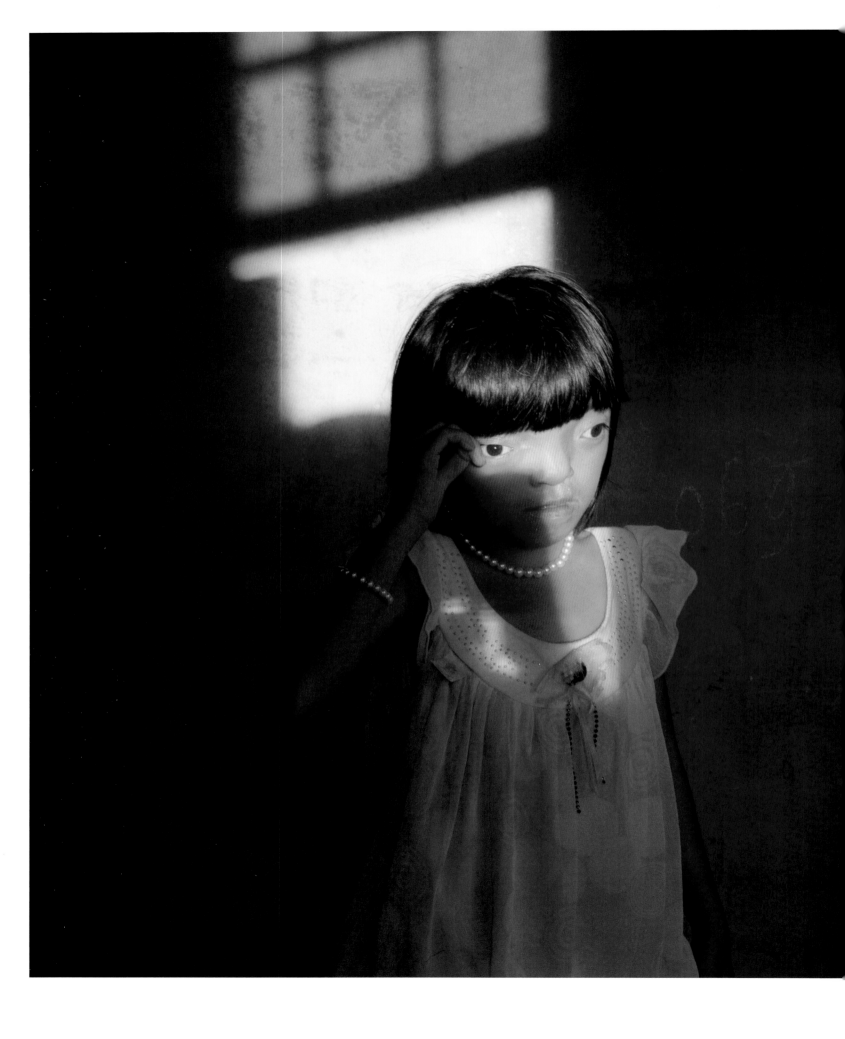

Nguyen Thi Li (9), who lives in the Ngu Hanh Son district of Da Nang in Vietnam, suffers from disabilities believed to be caused by the defoliating chemical Agent Orange. During the Vietnam War, US forces sprayed Agent Orange over forests and farmland in an attempt to deprive Viet Cong guerrillas of cover and food. The dioxin compound used in the defoliant is a long-acting toxin that can be passed down genetically, so it is still having an impact forty years on. The Vietnam Red Cross estimates that some 150,000 Vietnamese children are disabled owing to their parents' exposure to the dioxin. Symptoms range from diabetes and heart disease to physical and learning disabilities.

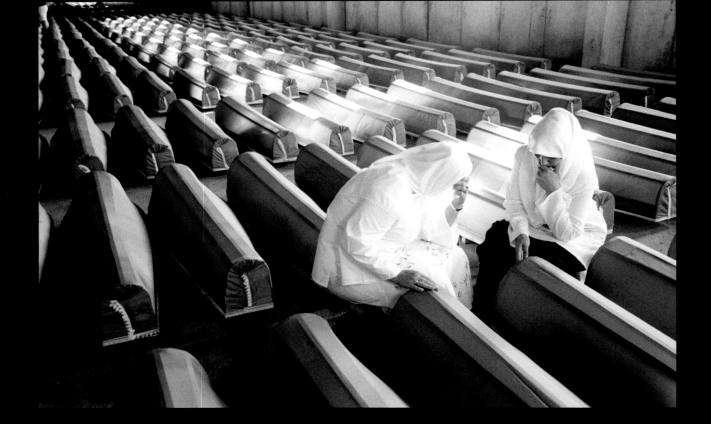

Relatives of victims mourn at the Srebrenica-Potocari Memorial and Cemetery, on the 15th anniversary of the Srebrenica massacre. During the 1992-1995 Bosnian War, the town of Srebrenica was declared a UN safe zone, to which thousands of Bosnian Muslims fled. The advancing Bosnian Serb Army overran the Dutch peacekeepers there in July 1995, killing more than 8,000 men and boys from in and around the town. The massacre is considered the worst atrocity in Europe since the Second World War, and is the only episode from the Bosnian War to be declared an act of genocide by the UN war crimes tribunal. During the anniversary ceremony, 775 bodies newly identified from mass graves using DNA testing were buried at the cemetery, joining the 3,749 already interred there.

Abortion is a crime in Kenya, unless the life of the mother is in danger. Penalties run up to seven years in prison for a woman trying to procure a termination, and twice as long for anyone conducting one. Women from richer classes can afford the € 60-80 it costs to have an abortion secretly performed by a compliant professional in a proper clinic. Poorer women have to rely on backstreet establishments, where untrained practitioners terminate pregnancies using knitting needles, bleach, malaria pills and other non-medical methods. Each year, at least 2,600 Kenyan women die after illegal abortions, and 21,000 are hospitalized with complications from unsafe procedures. Overleaf, top: Latex gloves hang up to dry after being used and then washed. The gloves are re-used to save money. Below: A woman prays in church with nine of the relatives she has looked after since other family members died. Her 17-year-old niece also lives with her, and is pregnant. Following page, top: A 24-year-old unmarried mother of three lies on the examination table of a pharmacy, having received an injection of ergometrine, which is terminating her pregnancy. Below: A 44-year-old woman displays the knitting needle and rubber tube she uses to perform abortions. She learned the technique from a midwife, and has been using it since 1986.

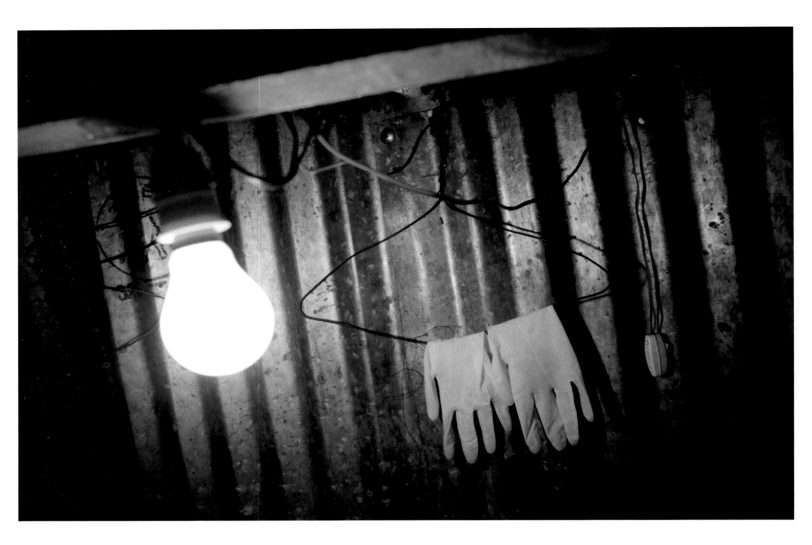
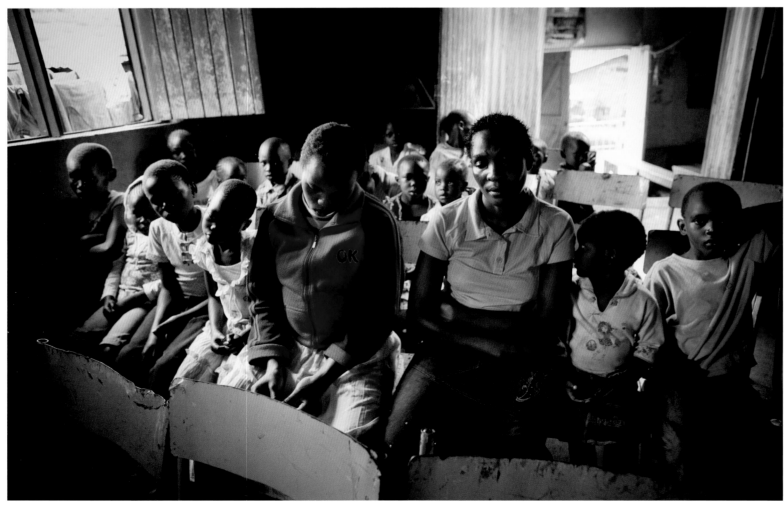

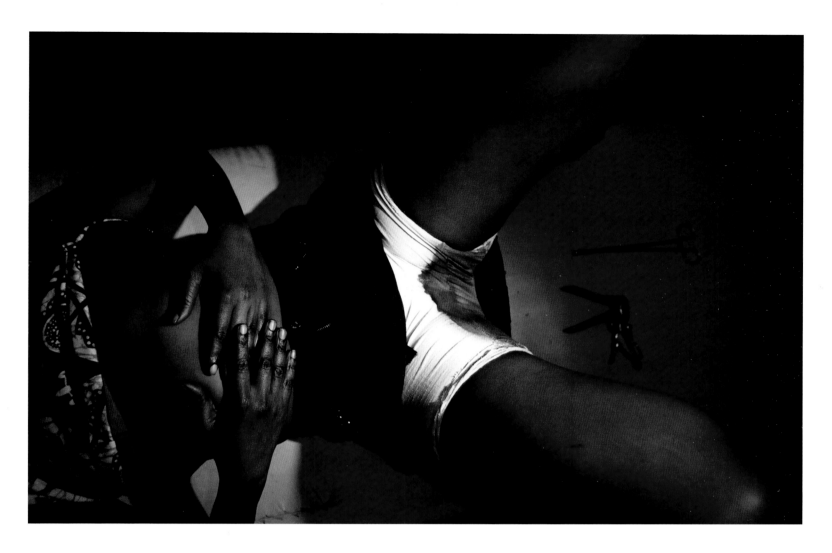
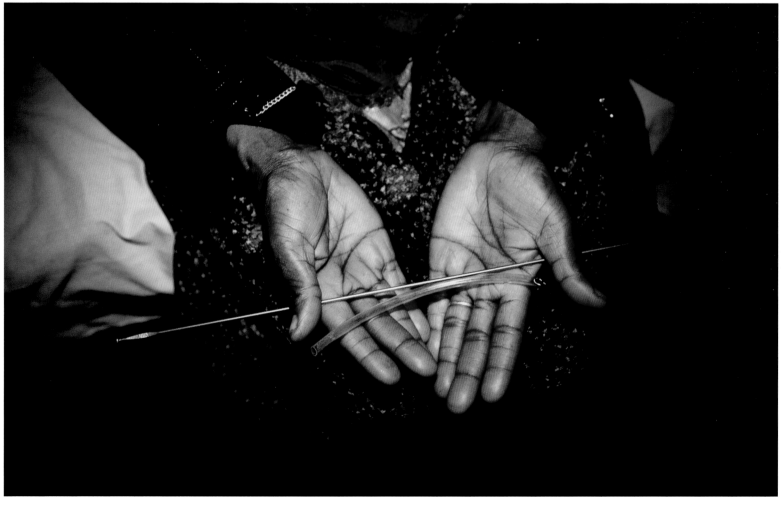

For 18 years the photographer documented the life of Julie Baird, whom she met by chance in San Francisco. Julie was then 18 and HIV positive, with a newborn child and a history of drug abuse. The photographer aimed to provide an in-depth look at poverty, Aids and other social issues by focusing on one woman's struggle. After Julie lost custody, and had to give up her children for adoption, the photographer wanted the project to also be a record for Julie's children of their mother's story. Facing page, from top left: Julie in 1993 with Rachel, (aged 3 months), in the lobby of the Ambassador Hotel in San Francisco, where she lived with her partner, Jack, who was also HIV positive. Julie and Rachel in the lobby of the West Hotel in 1995, after breaking up with Jack. In 2005, Julie moved to Valdez, Alaska, to be reunited with her father, after responding to an Internet posting by her uncle, but she was hospitalized only a week after making the trip. A doctor holds Julie's newborn baby Elyssa, in 2008. Julie looks on, as Jason scolds Elyssa. Elyssa, (aged 2), crawls into bed beside her mother. Julie reaches out from bed for someone who is not there. Jason holds Julie for the last time. She died on 27 September 2010. She was 36.

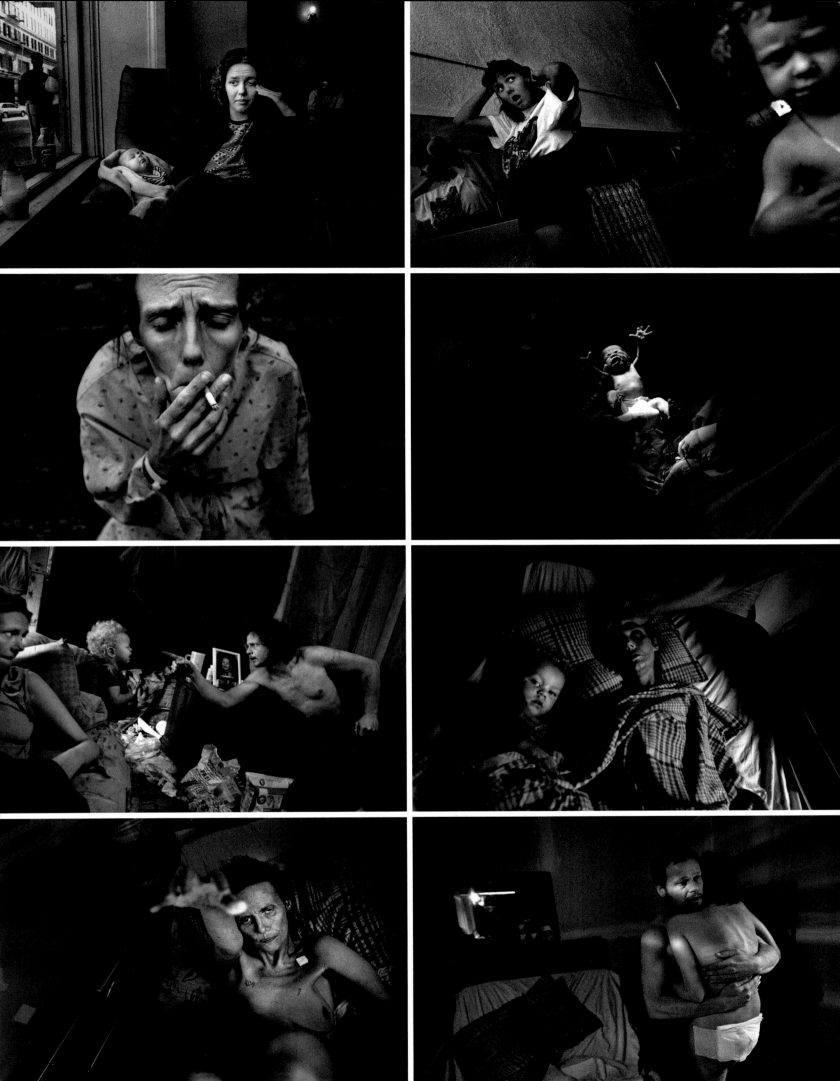

Incidents around the world, all photographed from Google Street View, taken by placing a camera on a tripod in front of a computer screen in Paris. Google Street View is a technology that displays images taken by a fleet of specially adapted cars, providing online panoramic views of different places around the globe. Since its launch in May 2007, it has expanded from just a few cities in the US to cover a range of locations worldwide. The technology has raised privacy issues, although Google maintains that photos are taken from public property, that features can be blurred on-screen, and that users can flag inappropriate or sensitive imagery for Google to remove. The service was nevertheless suspended in a number of countries, including Austria, Australia, and the Czech Republic, as a result of objections on privacy grounds. Italy asked Google to give its citizens notice before starting mapping operations, and, in November, Germany became the first country to negotiate an opt-out before the service went live, with almost 250,000 Germans requesting their properties be pixelated.

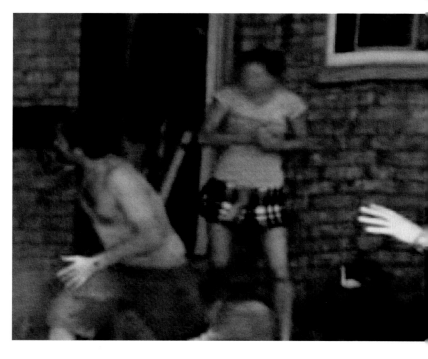

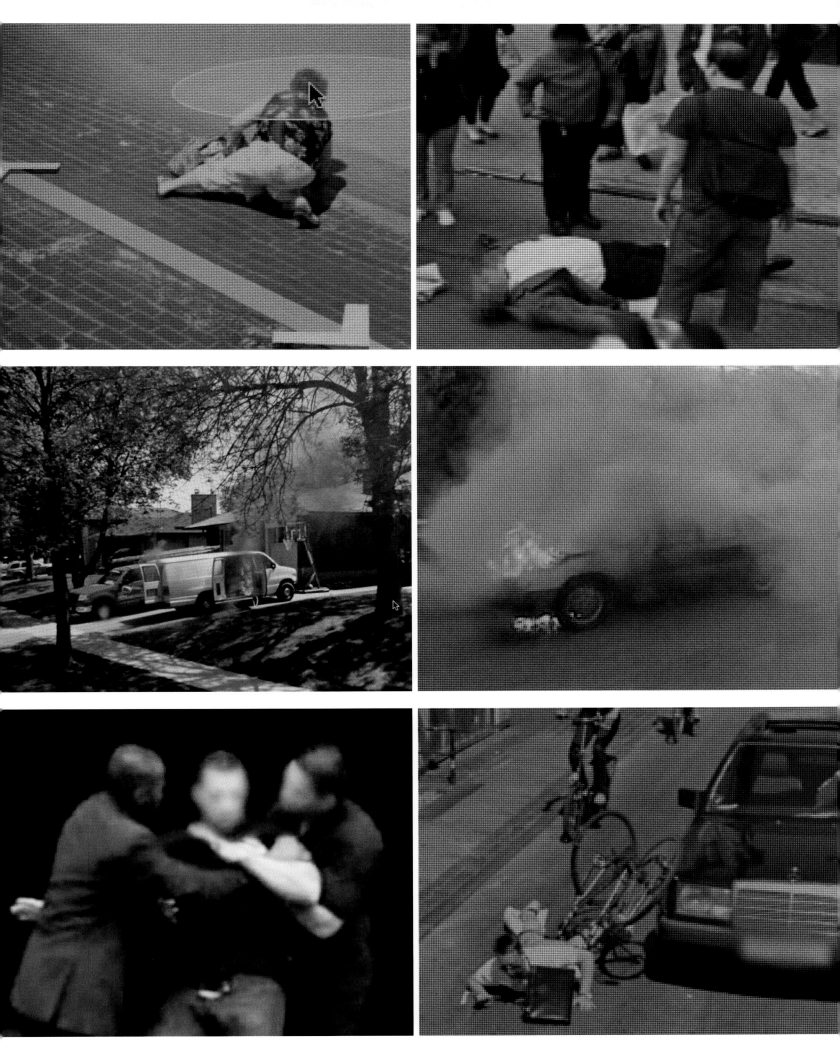

Daily Life

SINGLES
1st Prize
Feisal Omar
2nd Prize
Malte Jäger
3rd Prize
Andrew Biraj
STORIES
1st Prize
Martin Roemers
2nd Prize
Fernando Moleres
3rd Prize
Mads Nissen

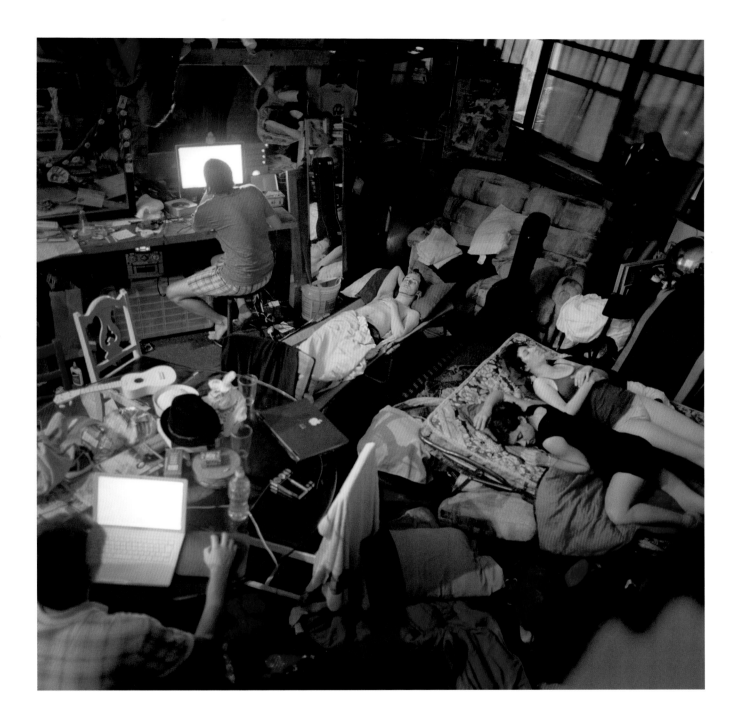

Couchsurfers hang out at the apartment of their host, "Naked Paul", in Brooklyn, New York. Websites put travelers, or couchsurfers, in touch with potential hosts from around the world. No money is exchanged for overnight stays. The aim of such hospitality websites is to promote cultural exchange, and to offer an alternative travel experience to staying in hotels.

Half of humanity now lives in a city, and the United Nations has predicted that 70 percent of the world's population will reside in urban areas by 2050. This page: Kolkata, India. Next spread: Mumbai, India.

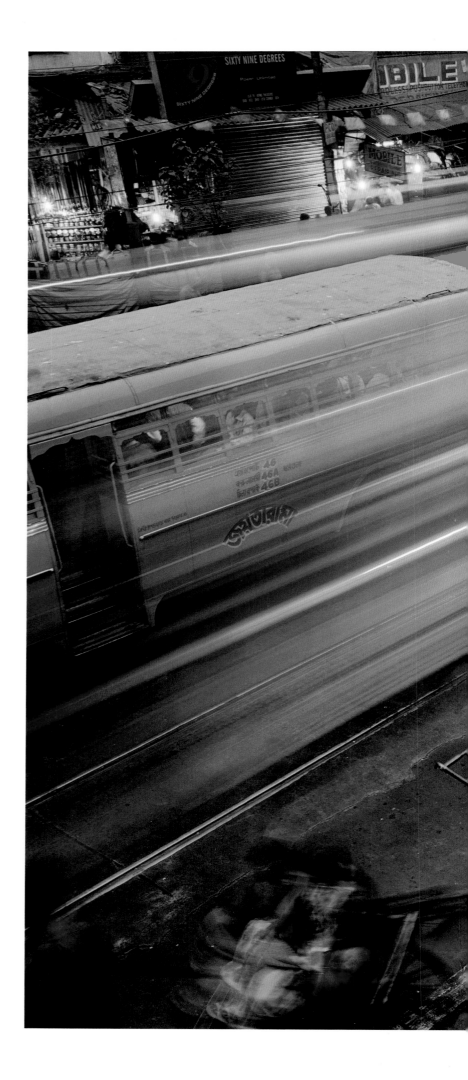

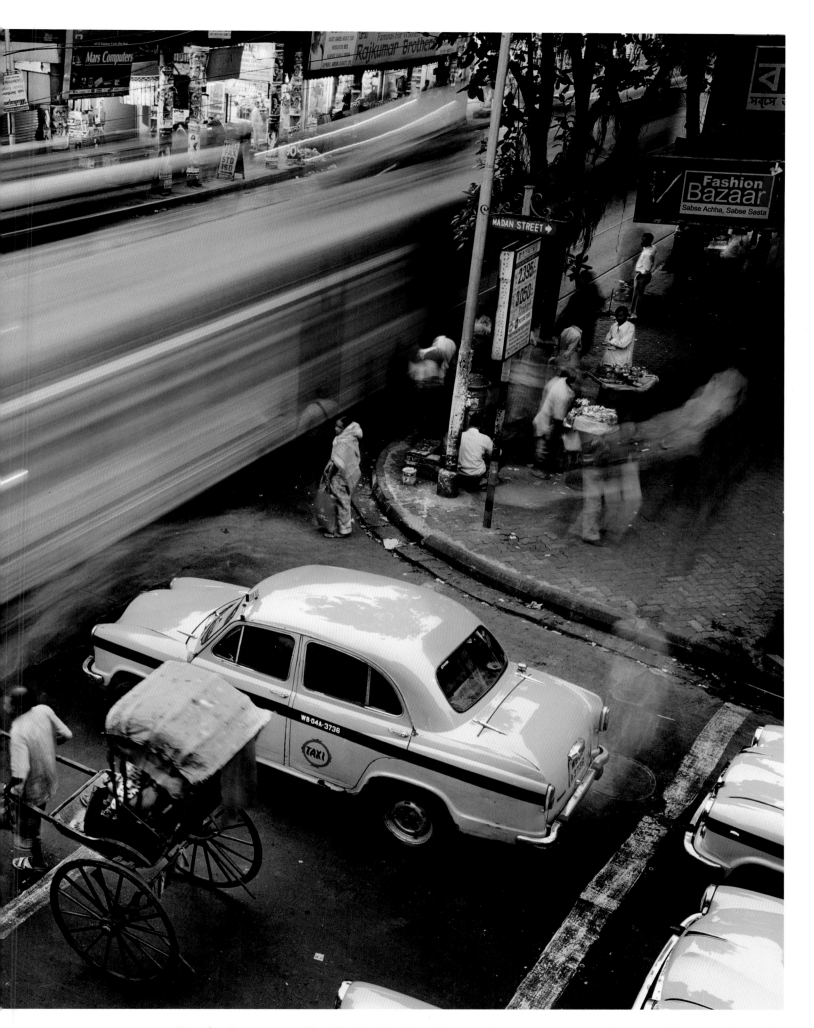

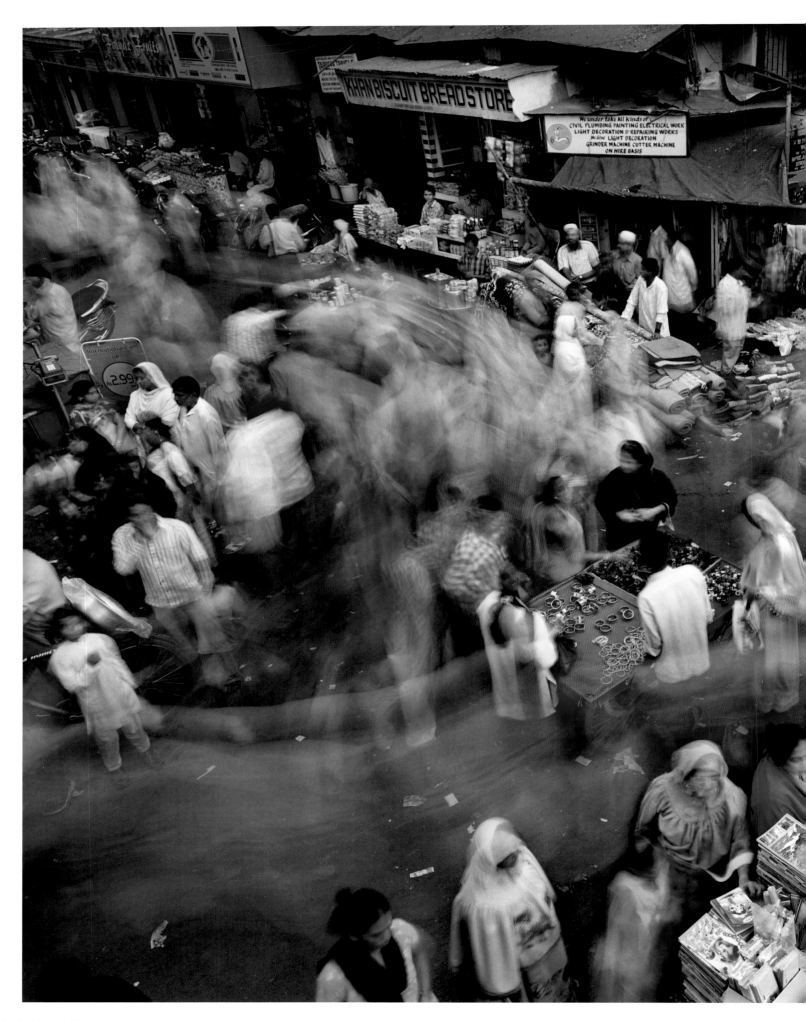

Pademba Road Prison, in Freetown, Sierra Leone, holds a number of juveniles, although according to the law, children under 17 should not be imprisoned with adults. But poor documentation means that it is not always easy to prove age. Above: Ibrahim Sesay is interrogated by fellow prisoners after a theft from cell. He says he was 14 when arrested on suspicion of stealing a mobile phone. Police set his age at 19. Below: A prison officer in the registration room. (continues)

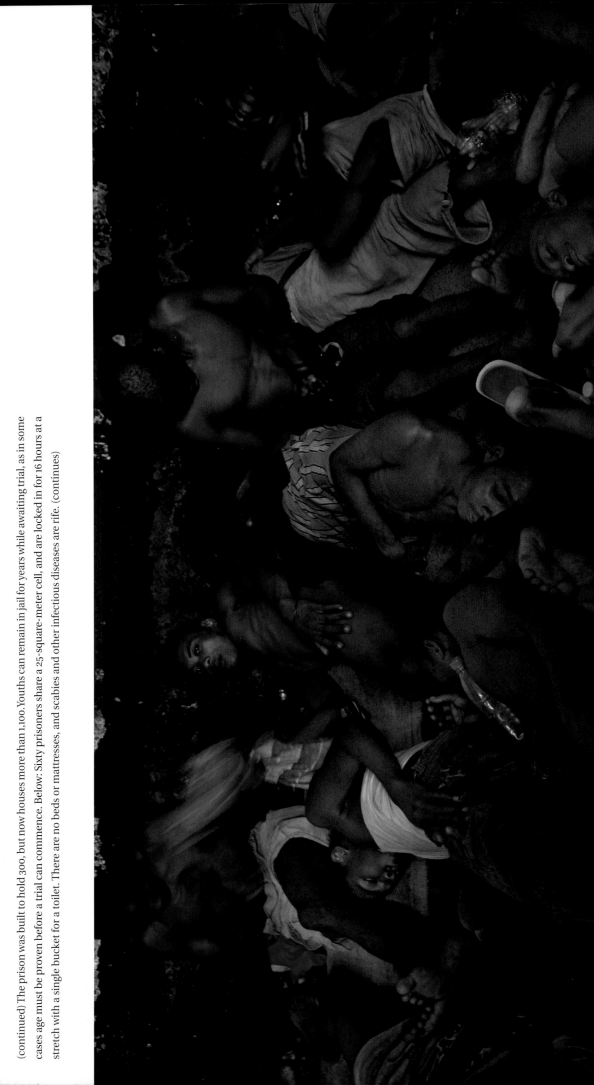

(continued) The prison was built to hold 300, but now houses more than 1,100. Youths can remain in jail for years while awaiting trial, as in some cases age must be proven before a trial can commence. Below: Sixty prisoners share a 25-square-meter cell, and are locked in for 16 hours at a stretch with a single bucket for a toilet. There are no beds or mattresses, and scabies and other infectious diseases are rife. (continues)

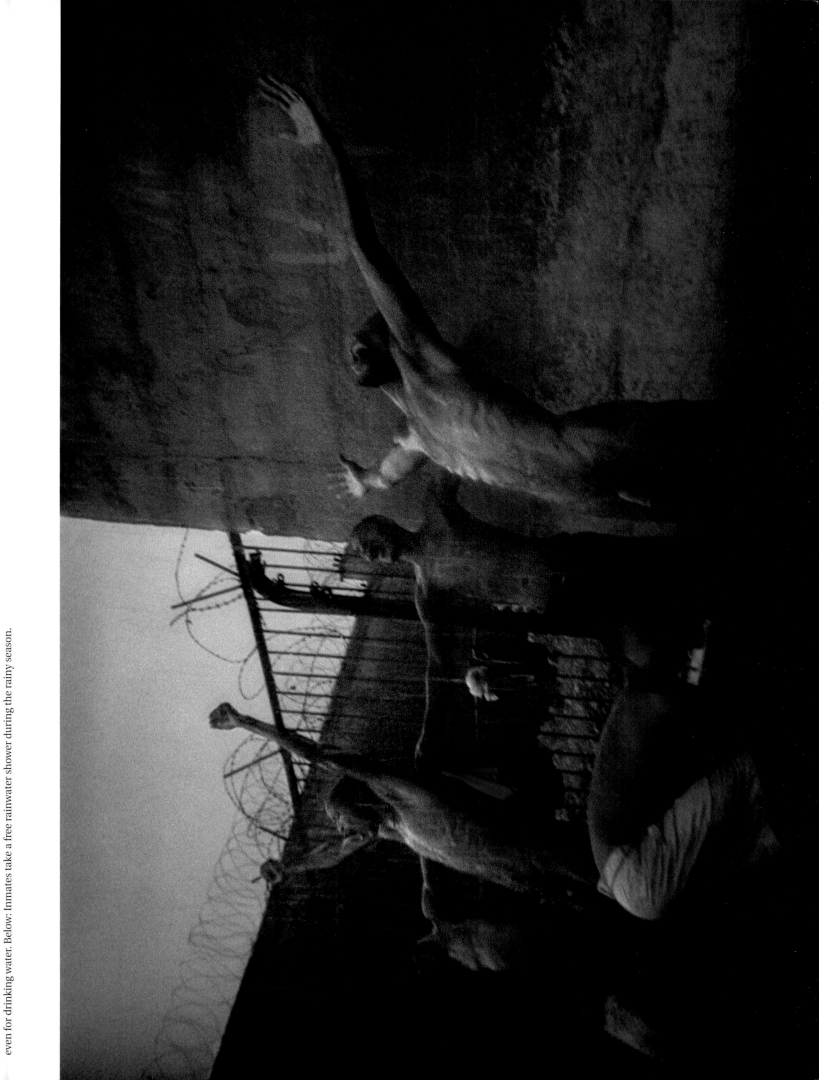

(continued) Water shortages are common in the prison. There is no running water, and prisoners have to pay for a bucket-bath, and sometimes even for drinking water. Below: Inmates take a free rainwater shower during the rainy season.

In September, a Danish daily newspaper ran a picture of an 18-month-old orphan from Nepal with hydrocephalus (the condition also known as "water on the brain"). She had been abandoned at birth and had no name —although hospital staff called her Ghane ("Bighead"). The condition can be treated in the West, however doctors at the clinic could not help her. Danish business executive Cecilie M. Hansen was deeply affected by the photo, and decided to try to help the little girl. Cecilie visited Nepal, gave the girl a name—Victoria, for victory—and made arrangements with Nepal's leading neurology clinic to operate, covering the cost herself. Because nothing had been done to relieve Victoria's condition since birth, surgery was risky. In the time Cecilie was in Nepal, she bonded closely with Victoria, but eventually had to return to Denmark. A few days after arriving home she heard that despite doctors' efforts, Victoria had died from heart failure. Facing page, top: The photo that first appeared in *Berlingske* in September. Below: Cecilie holds a mirror up to Victoria. In addition to her physical disability, Victoria had never had much human contact. Over-leaf, top: Cecilie spent nights at the neurology clinic, sleeping next to Victoria. Below: An X-ray reveals that the water under Victoria's skull has put the cranium under so much pressure that it has opened at the top. Following page, top: Victoria is taken to the operating room. Below: Cecilie leaves for Kathmandu Airport, on her way back to Denmark.

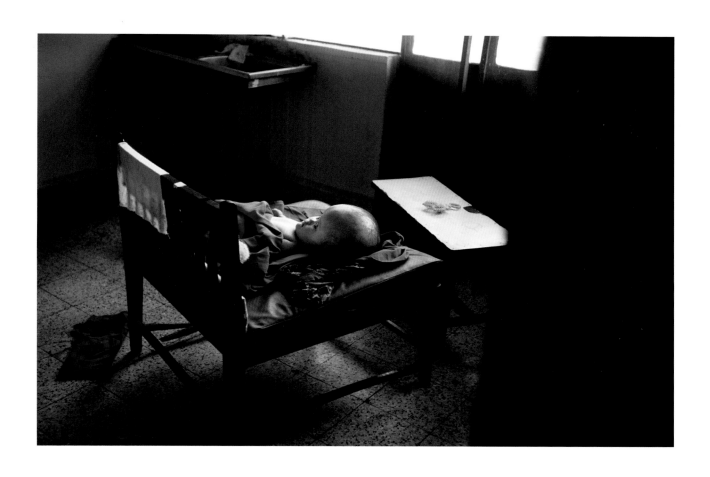

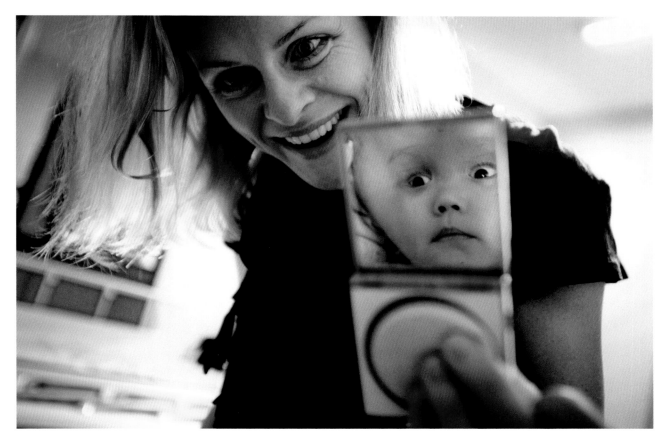

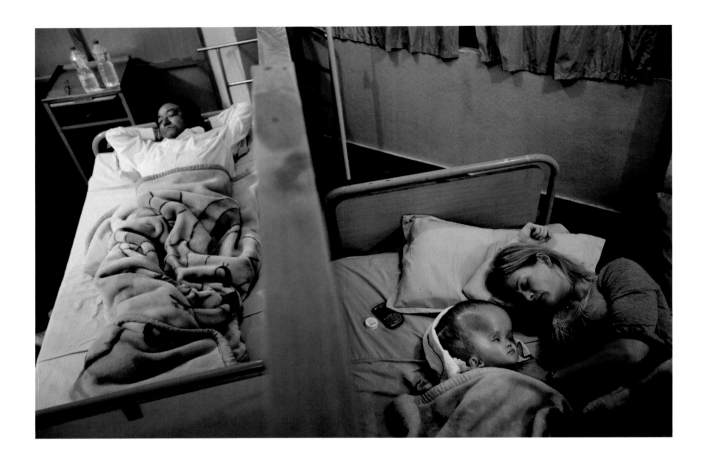

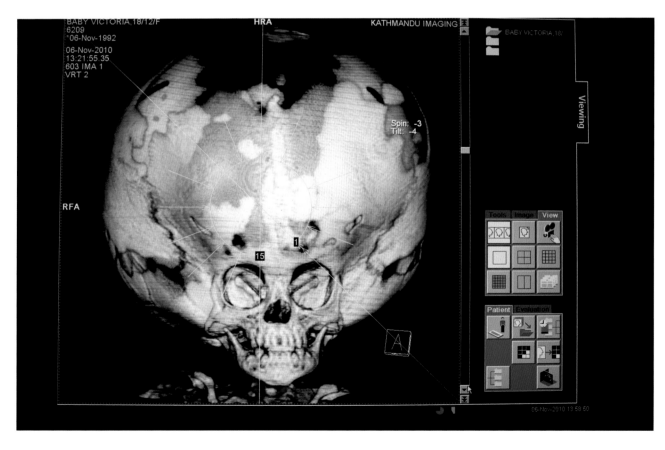

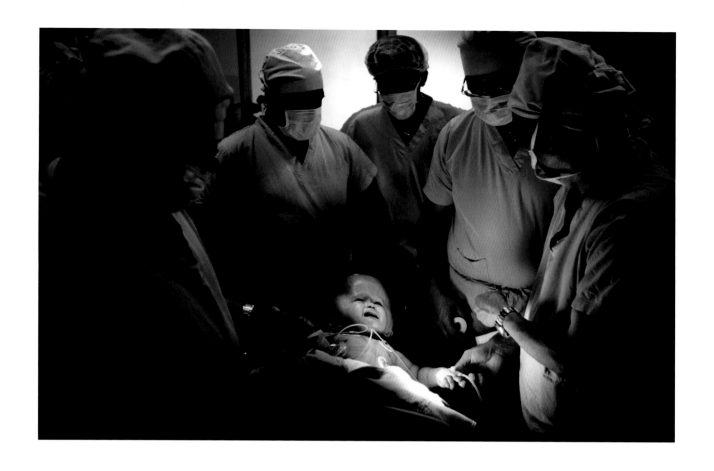

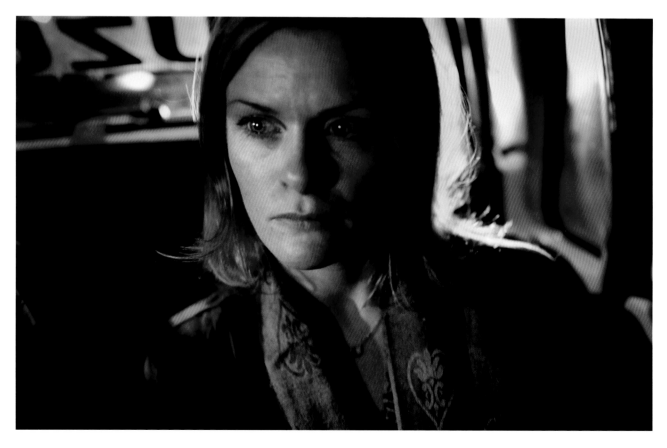

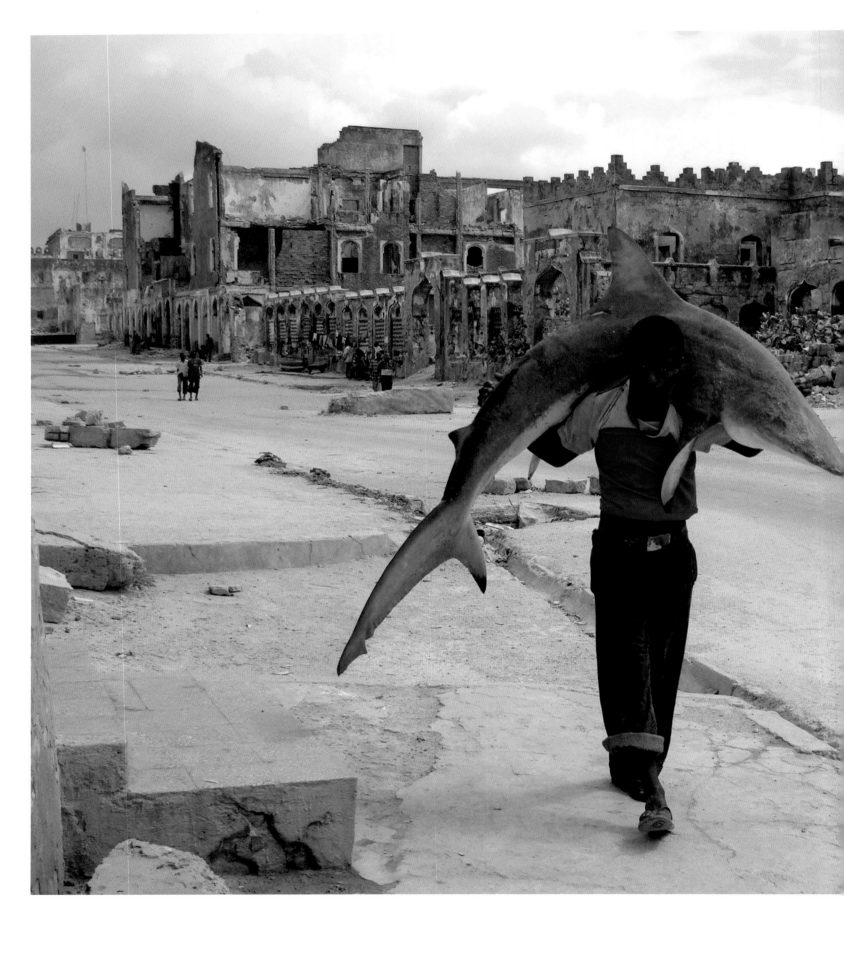

A man carries a shark through the streets of Mogadishu, Somalia, in September. The capital had seen some heavy shelling that month, part of the conflict between Islamist militants and pro-government troops. Sharks form a large portion of total Somali fish landings. The fish is not commonly eaten in Somalia, but shark meat is dried and salted for export.

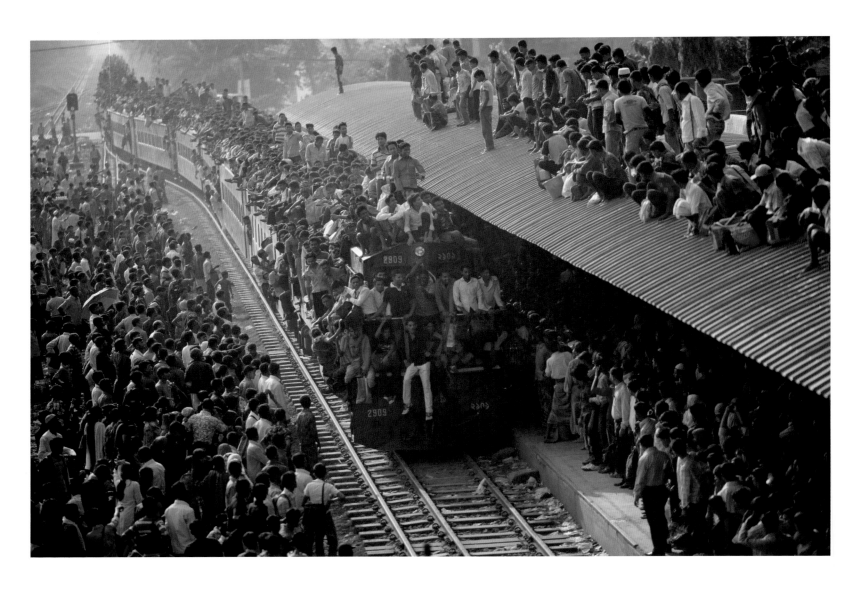

An overcrowded train approaches a railway station in Dhaka, Bangladesh, as more passengers wait to board. Millions of residents of Dhaka were traveling to their home villages to celebrate the Eid al-Adha holiday. Dhaka is fast becoming one of the largest cities in the world. Its present population of 13 million is expected to rise to between 22 and 25 million by 2020. The rapid population growth has put severe pressure on transport infrastructure.

Nature

Atlantic sailfish drive sardines into a bait ball, off the Yucatán coast, Mexico. Sailfish get their name from the large dorsal fin that stretches almost the entire length of their body and is higher than their bodies are thick. They can swim at speeds of up to 110 kilometers per hour. Their size, speed, and spirited fight make sailfish a favorite among big-game fishers.

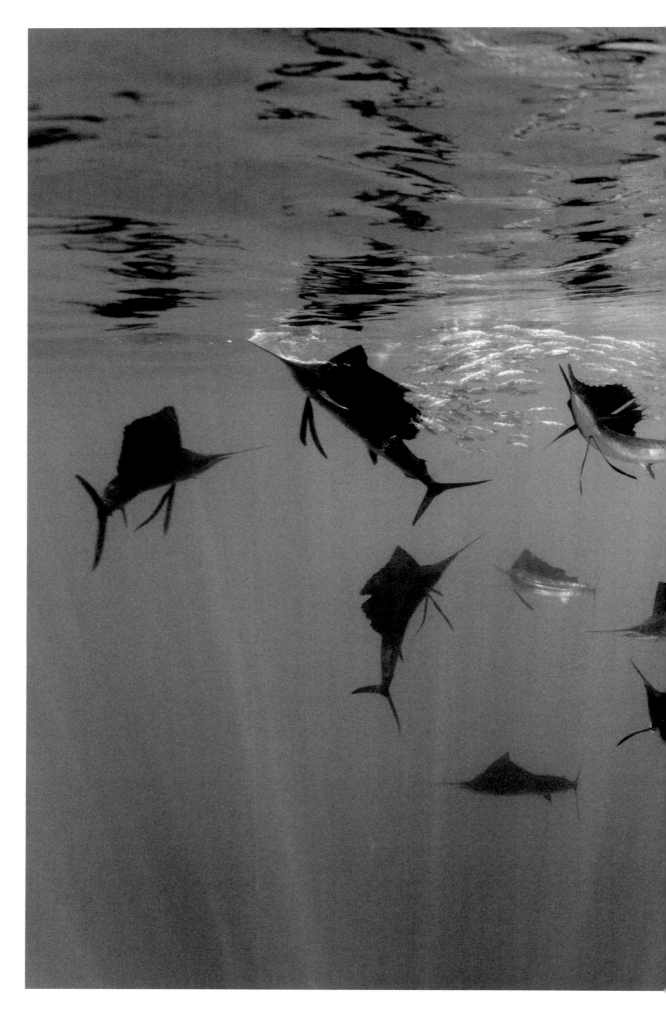

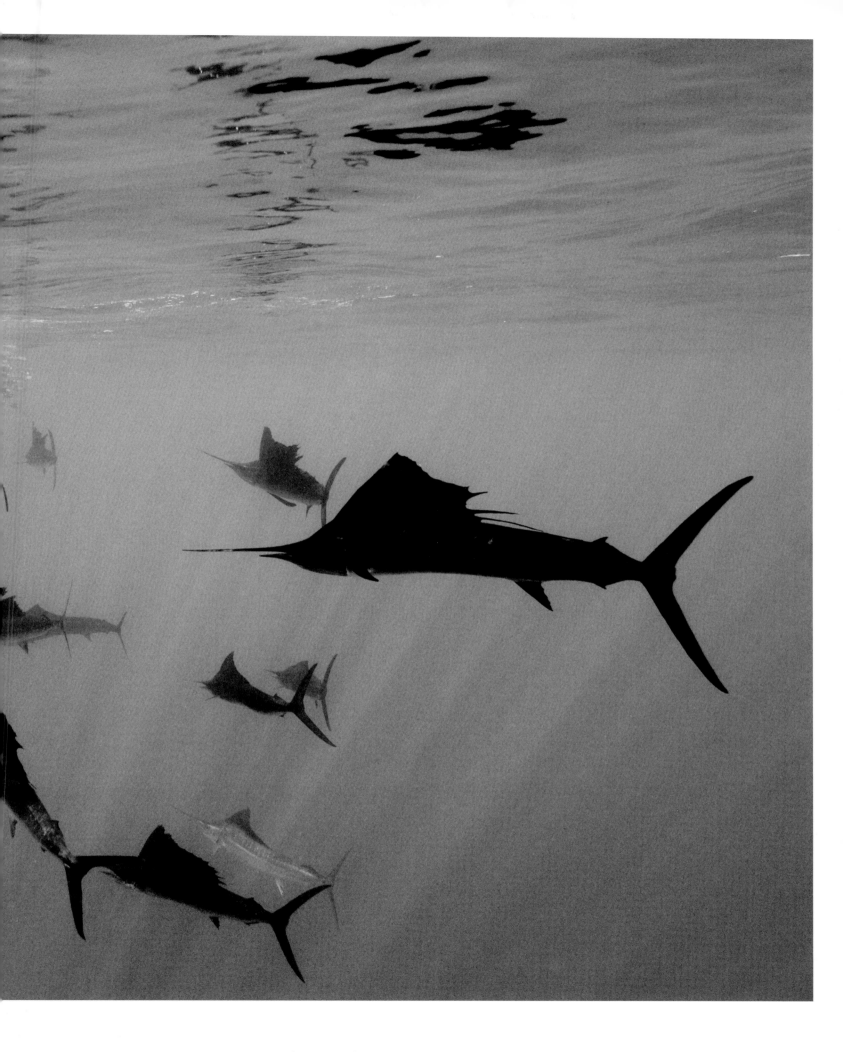

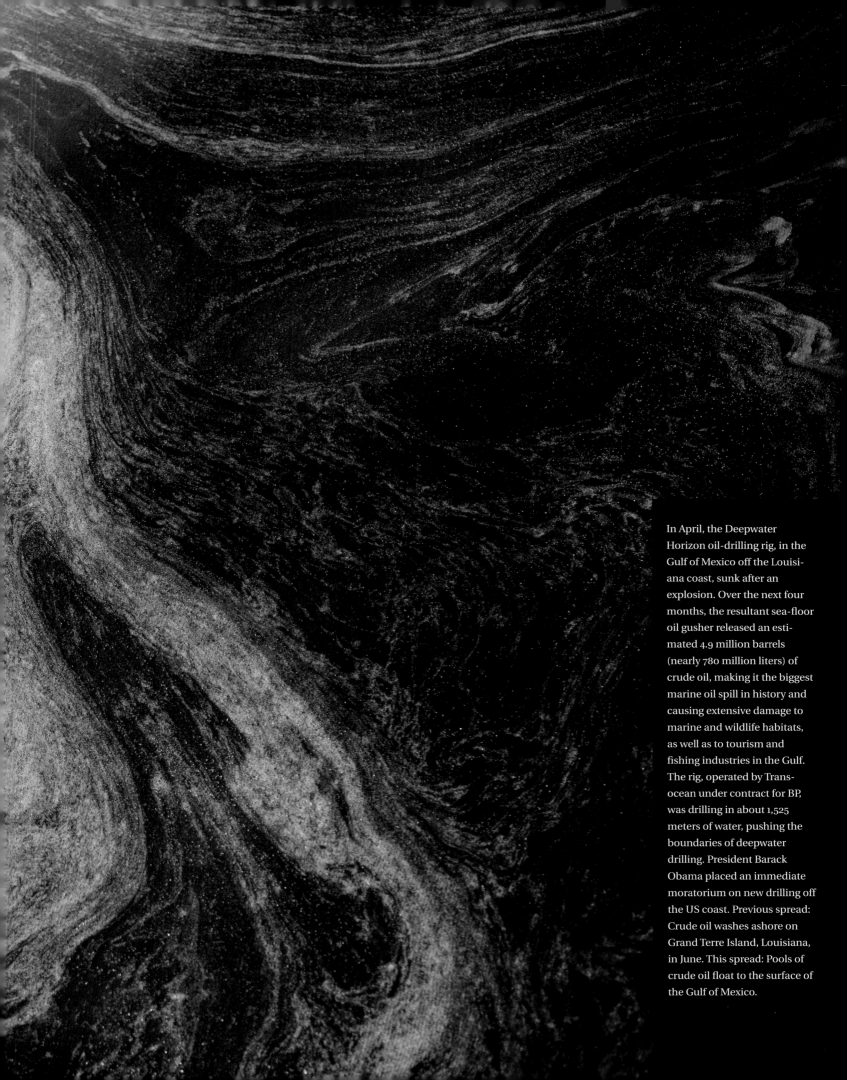

In April, the Deepwater Horizon oil-drilling rig, in the Gulf of Mexico off the Louisiana coast, sunk after an explosion. Over the next four months, the resultant sea-floor oil gusher released an estimated 4.9 million barrels (nearly 780 million liters) of crude oil, making it the biggest marine oil spill in history and causing extensive damage to marine and wildlife habitats, as well as to tourism and fishing industries in the Gulf. The rig, operated by Transocean under contract for BP, was drilling in about 1,525 meters of water, pushing the boundaries of deepwater drilling. President Barack Obama placed an immediate moratorium on new drilling off the US coast. Previous spread: Crude oil washes ashore on Grand Terre Island, Louisiana, in June. This spread: Pools of crude oil float to the surface of the Gulf of Mexico.

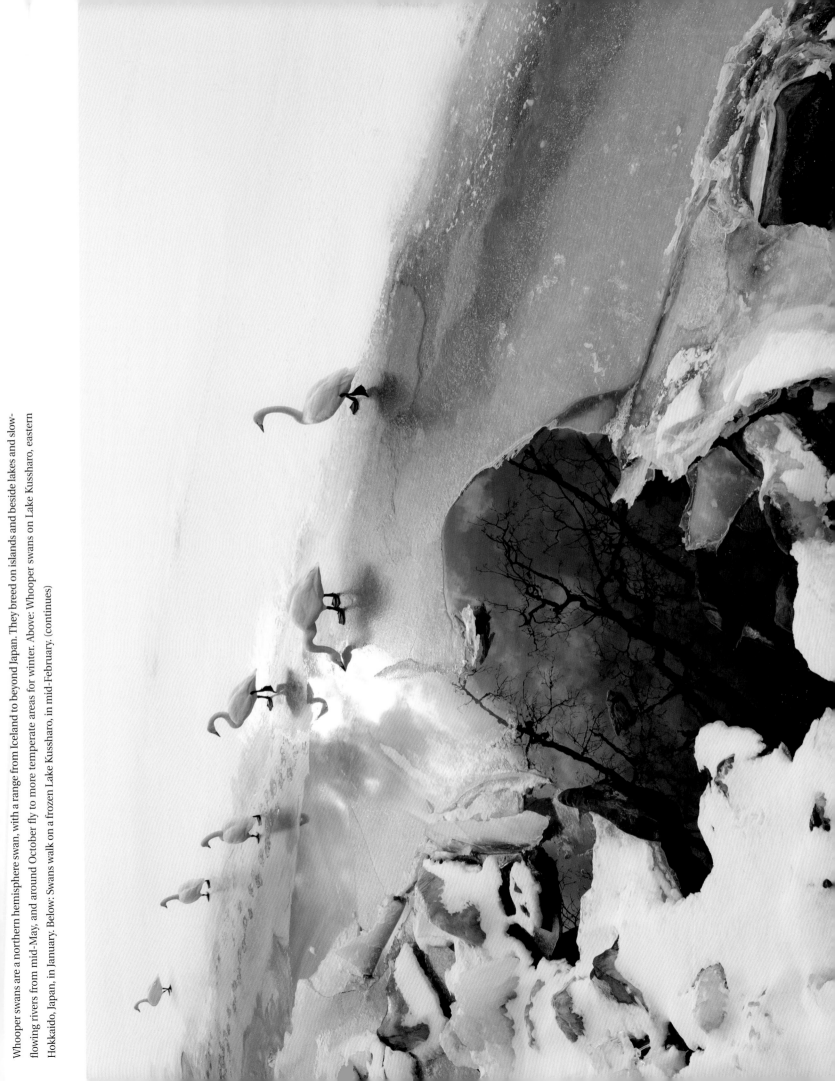

Whooper swans are a northern hemisphere swan, with a range from Iceland to beyond Japan. They breed on islands and beside lakes and slow-flowing rivers from mid-May, and around October fly to more temperate areas for winter. Above: Whooper swans on Lake Kussharo, eastern Hokkaido, Japan, in January. Below: Swans walk on a frozen Lake Kussharo, in mid-February. (continues)

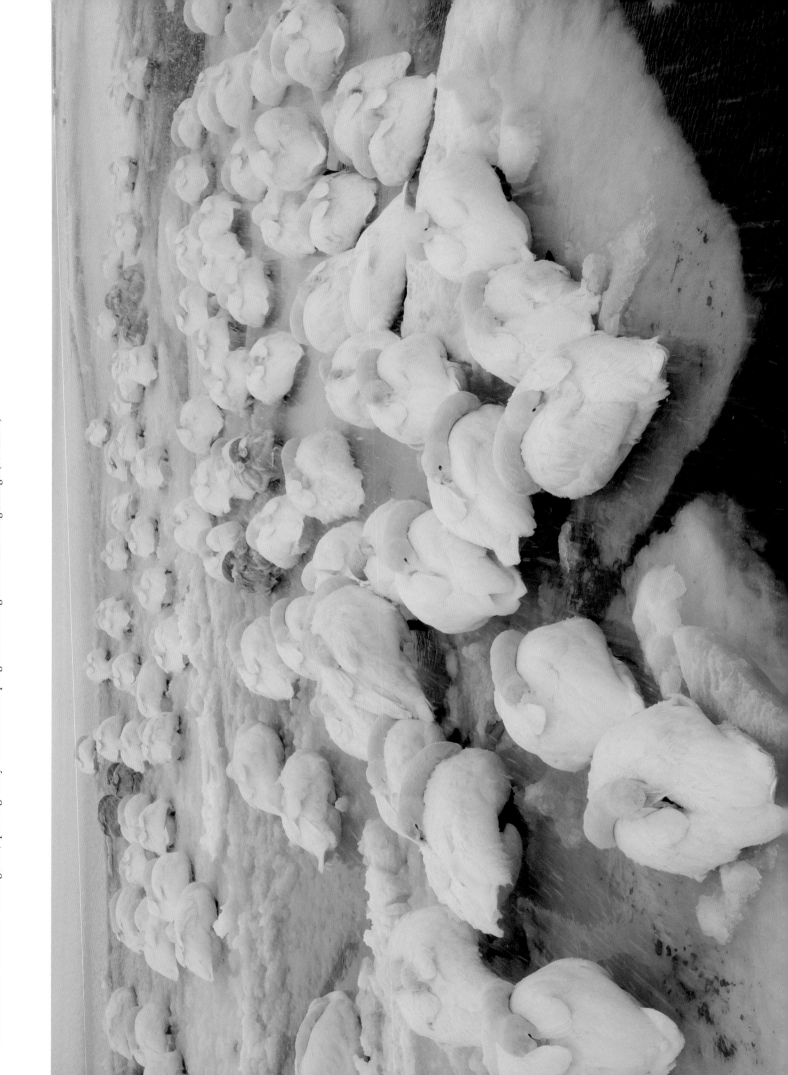

(continued) A 1,280-kilometer-long migration route, from Iceland to Ireland, is possibly the longest sea crossing by any swan species. Below: The birds shelter from the weather in strong wind, spending all day on the ice. Attempting to take off might have risked wing damage. (continues)

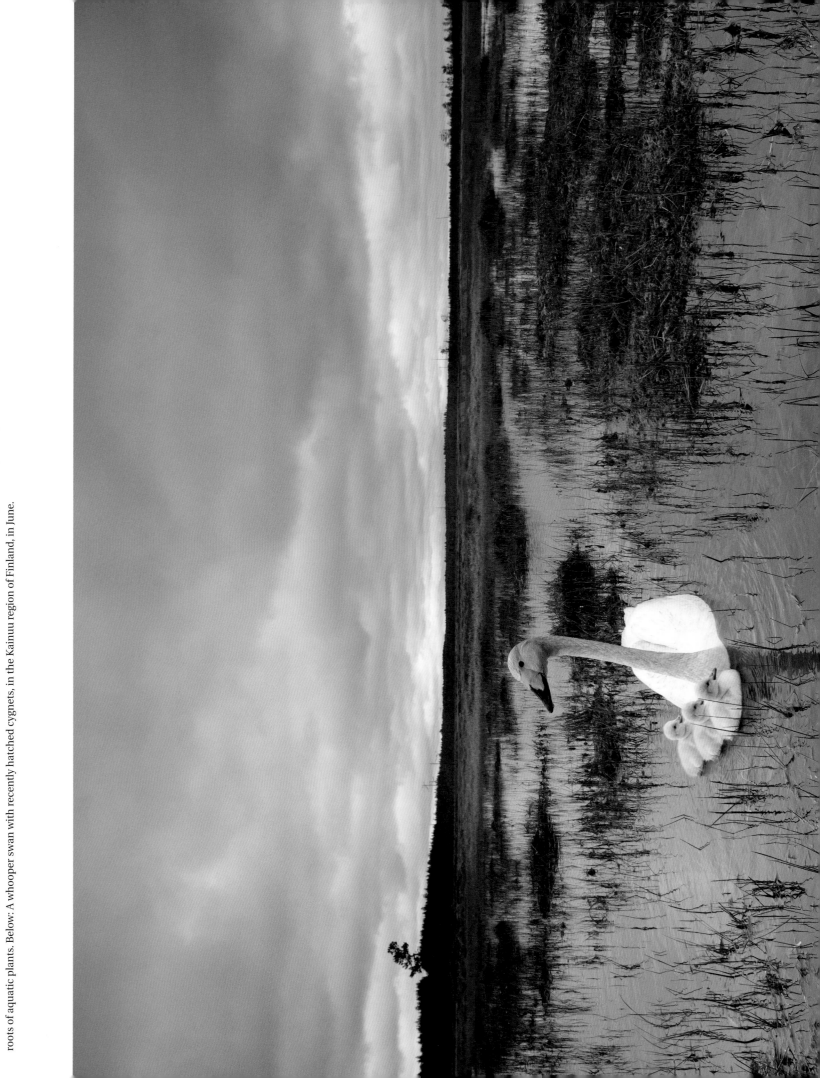

(continued) The swans also frequently inhabit estuaries, marshes, and floodplains. Their diet consists predominantly of leaves, stems, and roots of aquatic plants. Below: A whooper swan with recently hatched cygnets, in the Kainuu region of Finland, in June.

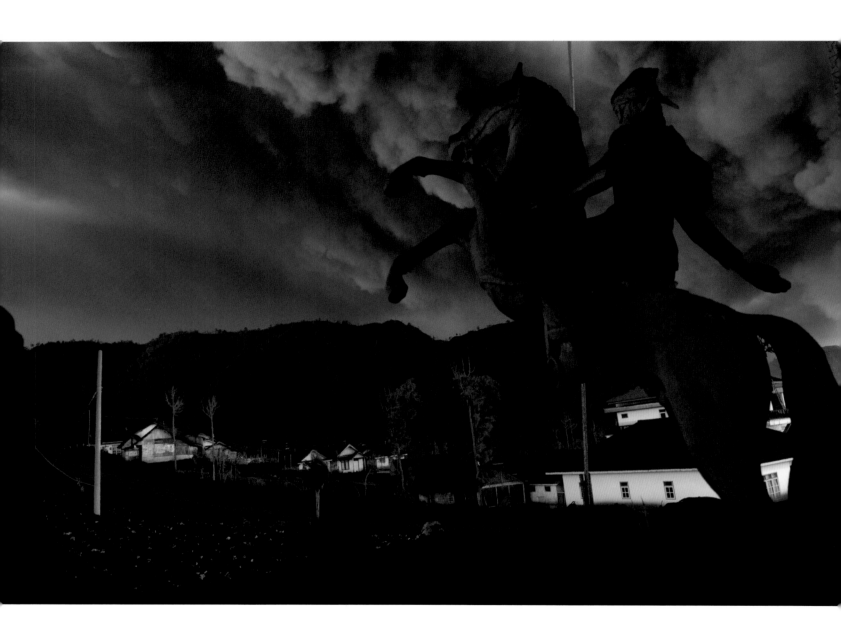

Mount Bromo volcano, a popular tourist attraction in East Java, Indonesia, began to show signs of activity in November, with a major eruption on 19 December spewing stones and ash 2,000 meters into the air. Above: A statue covered in ash stands at the entrance to the village of Cemoro Lawang, the major tourist access point for Mount Bromo. Facing page: In Cemoro Lawang, a man wears a mask to avoid inhaling ash on 24 December. Officials had warned people to wear masks, and not to go within two kilometers of the volcano.

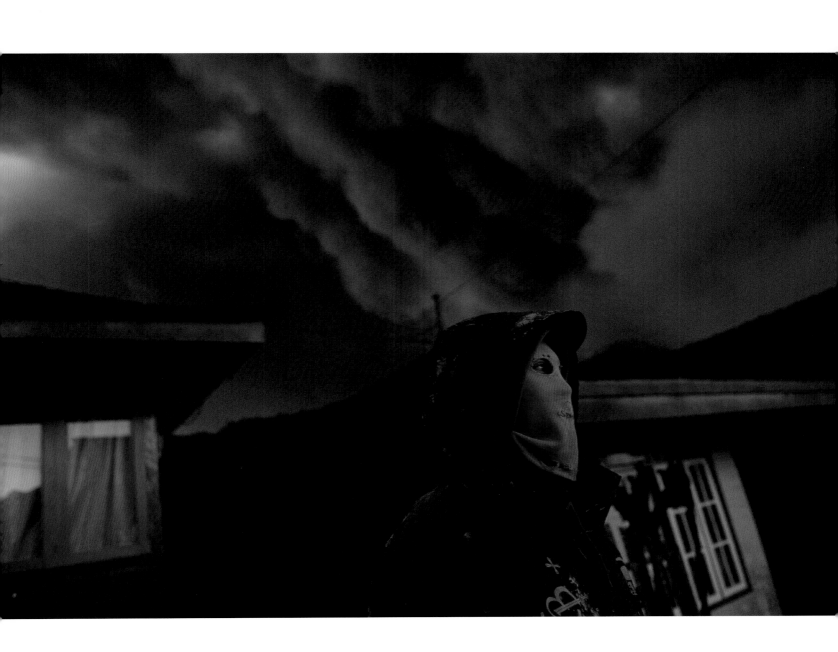

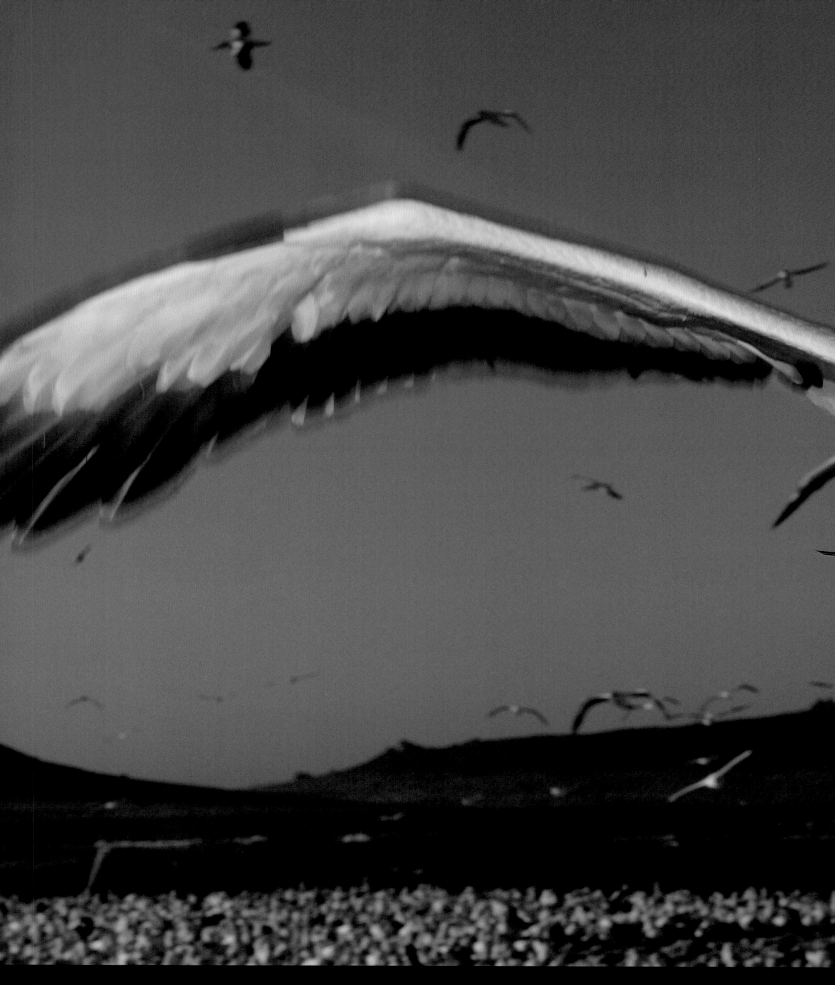

A Cape gannet comes in to land at Malgas Island during the summer nesting season. The island, off the west coast of South Africa, is an important seabird breeding ground.

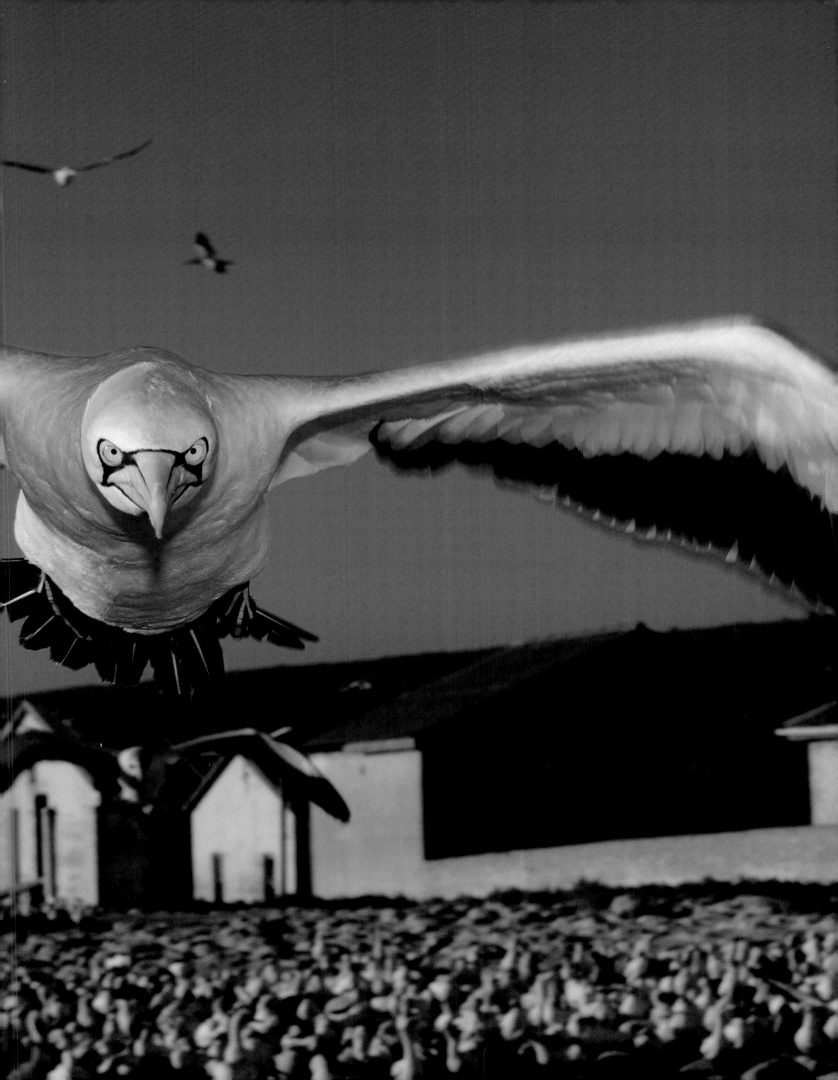

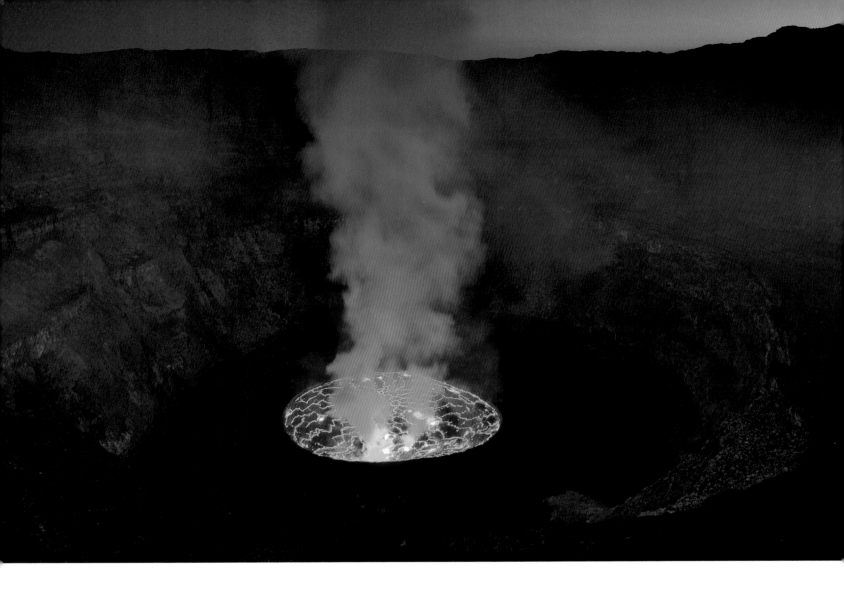

The lava lake of Mount Nyiragongo in the Virunga National Park, Democratic Republic of Congo, bubbles at the bottom of the volcano's immense crater. Persistent lava lakes in volcanic craters are rare, with only five currently known in the world. The one on Mount Nyiragongo varies in size, but has at times been one of the most voluminous lava lakes in the planet's recent history.

Arts and Entertainment

SINGLES

1st Prize
Andrew McConnell

2nd Prize
Davide Monteleone

3rd Prize
Fabio Cuttica

STORIES

1st Prize
Amit Madheshiya

2nd Prize
Daniele Tamagni

3rd Prize
Amit Sha'al

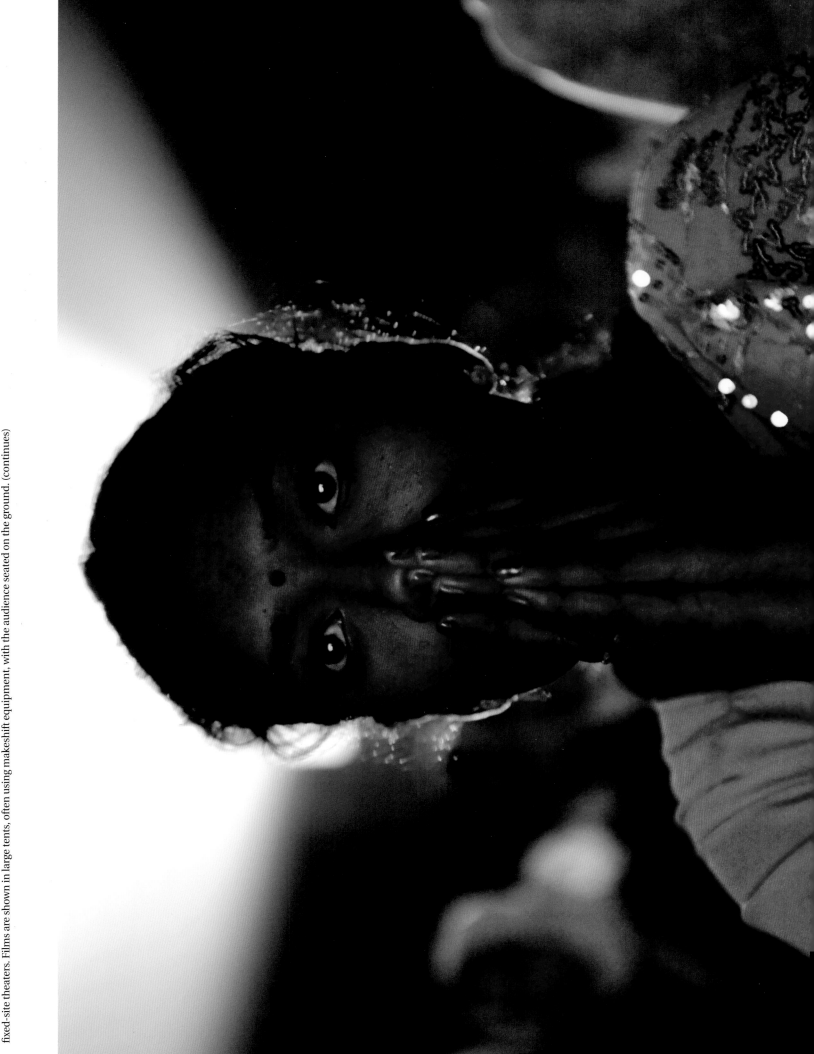

Patrons of traveling cinemas watch films at night screenings in Maharashtra, western India. Nomadic cinemas travel to remote villages far from fixed-site theaters. Films are shown in large tents, often using makeshift equipment, with the audience seated on the ground. (continues)

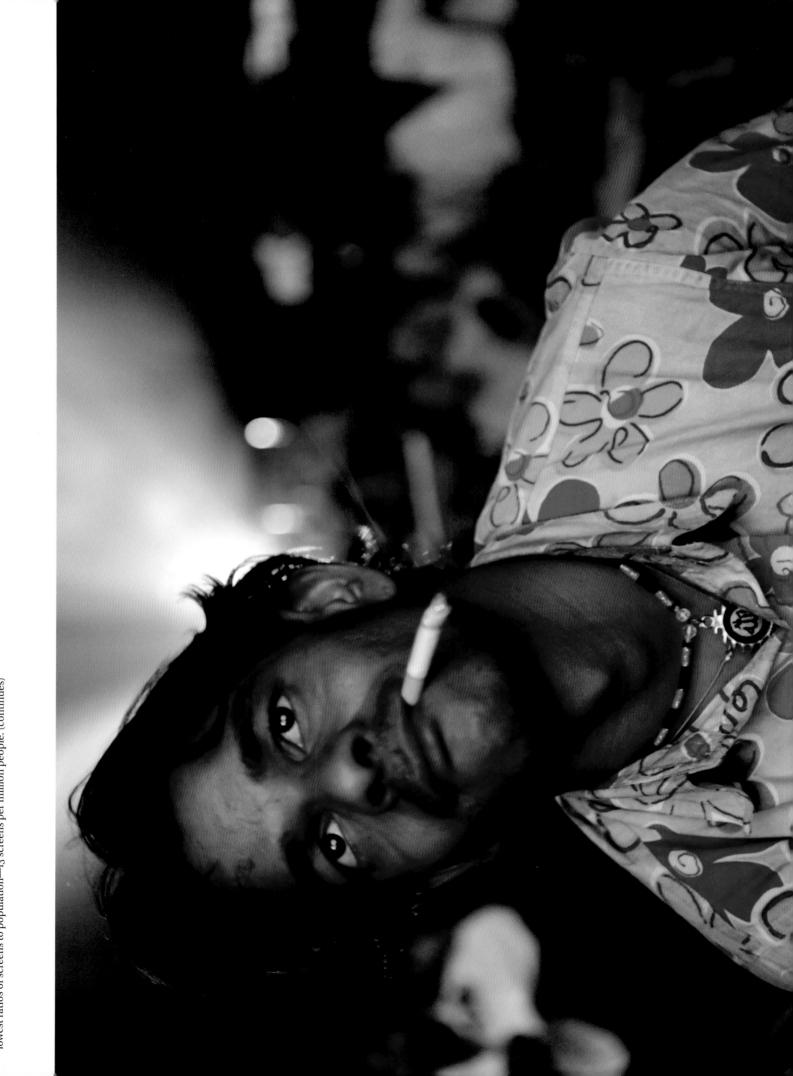

(continued) Although India is home to the most prolific movie industry in the world (producing around 800 films a year), it has one of the lowest ratios of screens to population—13 screens per million people. (continues)

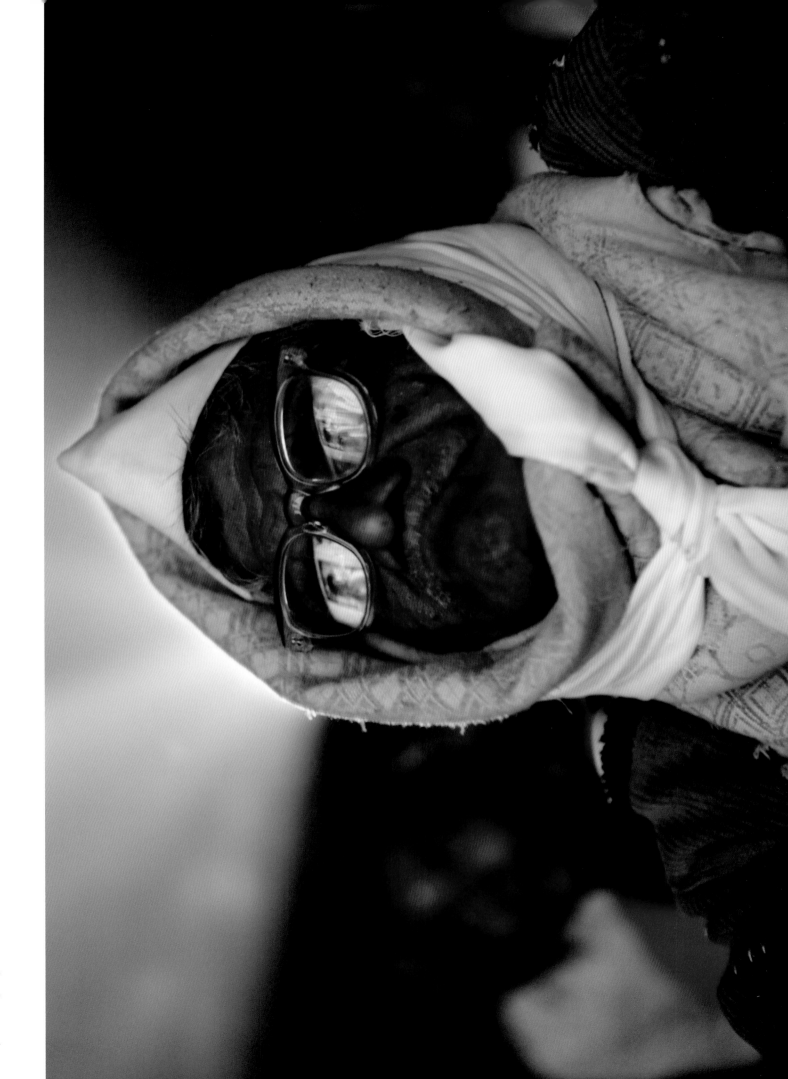

(continued) The traveling cinemas show mixed fare, including regional language films, Bollywood blockbusters, and Hollywood movies, but they are facing a fight for survival as DVDs become more easily accessible, and cable networks penetrate further into the country.

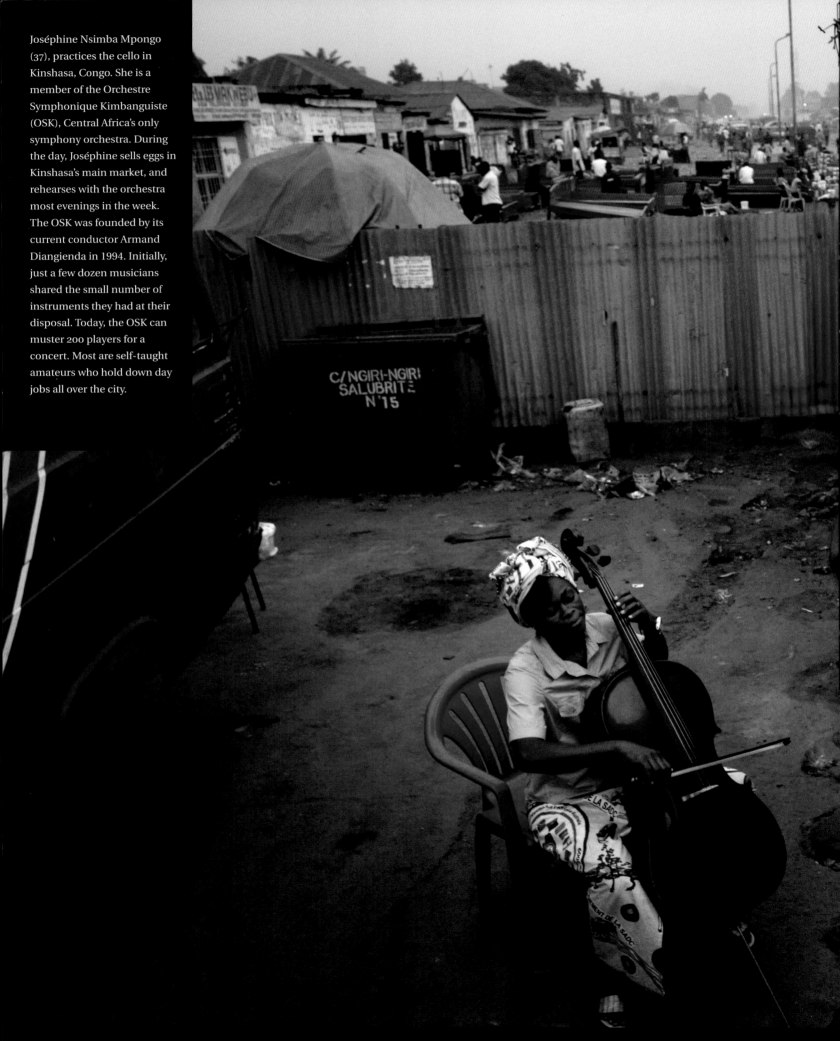

Joséphine Nsimba Mpongo (37), practices the cello in Kinshasa, Congo. She is a member of the Orchestre Symphonique Kimbanguiste (OSK), Central Africa's only symphony orchestra. During the day, Joséphine sells eggs in Kinshasa's main market, and rehearses with the orchestra most evenings in the week. The OSK was founded by its current conductor Armand Diangienda in 1994. Initially, just a few dozen musicians shared the small number of instruments they had at their disposal. Today, the OSK can muster 200 players for a concert. Most are self-taught amateurs who hold down day jobs all over the city.

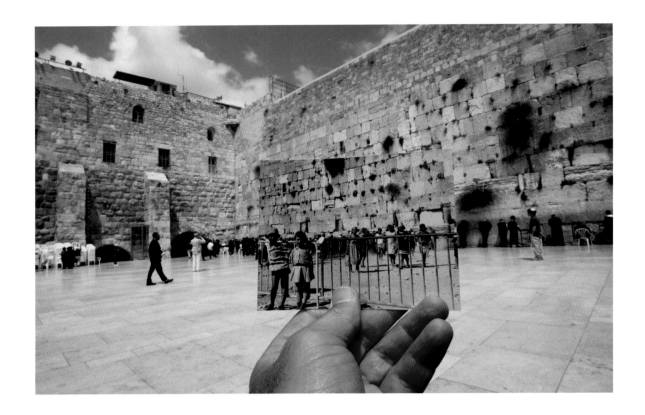

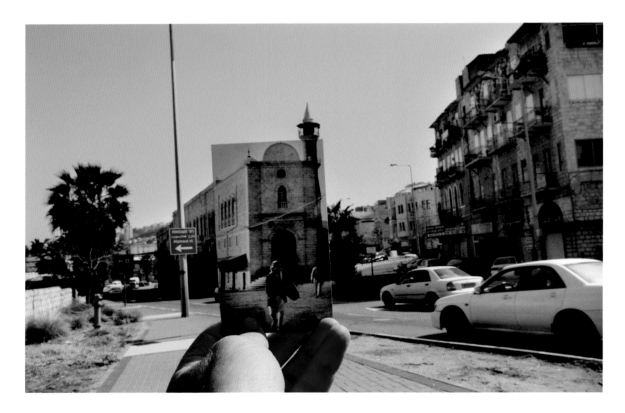

Archive photos set against their present-day backdrops in Israel. The photographer rested his arm on a tripod so that his hand did not move while juxtaposing the images. Top: The Wailing Wall, Jerusalem, the most sacred site in Judaism, seen in 1967 and 2010. Below: The Istiklal Mosque, Haifa, in 1941 and 2010.

Top: The Aaronsohn family home, in Zikhron Ya'aqov, near Haifa, in 1949 and 2010. The Aaronsohns were at the heart of Nili, an underground network that assisted Britain in its fight against the Ottoman Empire in Palestine, during the First World War. Below: The corner of Rothschild and Herzl Streets, Rishon Le Ziyyon, south of Tel Aviv, in 1979 and 2010.

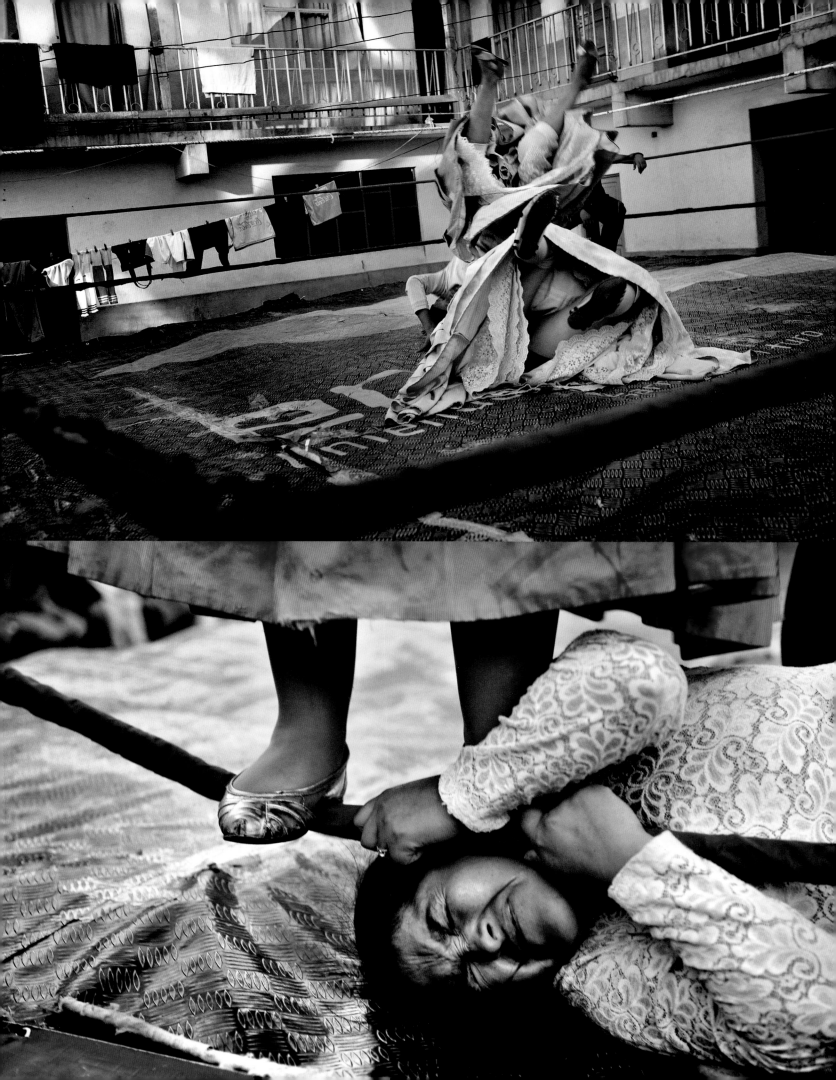

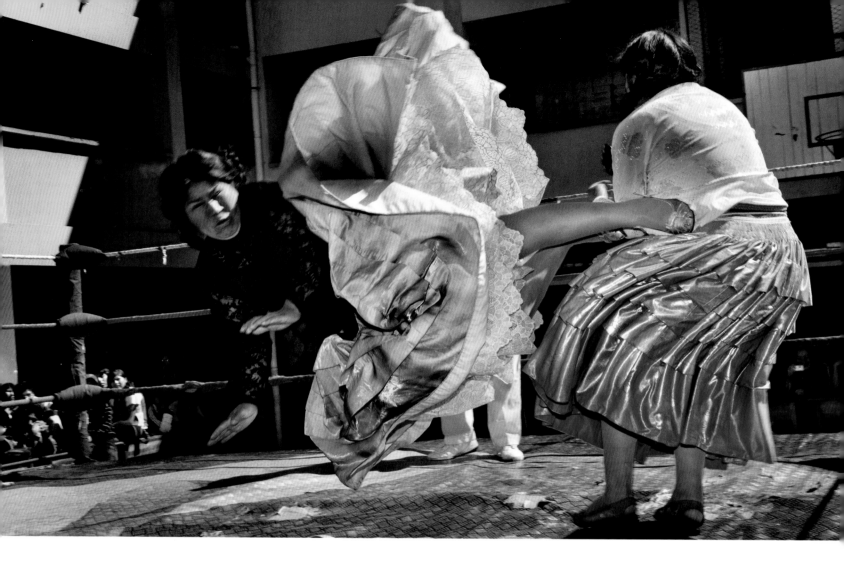

Freestyle wrestling, or *lucha libre*, one of the most popular entertainments in Bolivia, was once the domain of men only. Now *cholitas*, women wearing the traditional skirts and bowler hats of the indigenous Aymara and Quechua people, are making a mark. The choreographed tussles, part-comic, part-epic struggles between good and evil figures, attract enthusiastic audiences. Some of the women even take on their male counterparts. Facing page, top: Two *cholitas* wrestle in the city of La Paz. Below: Carmen Rosa ("La Ruda"), and Julia la Paceña ("La Tecnica") at a tense moment. This page: Carmen Rosa and Julia la Paceña perform at a charity show in a school courtyard.

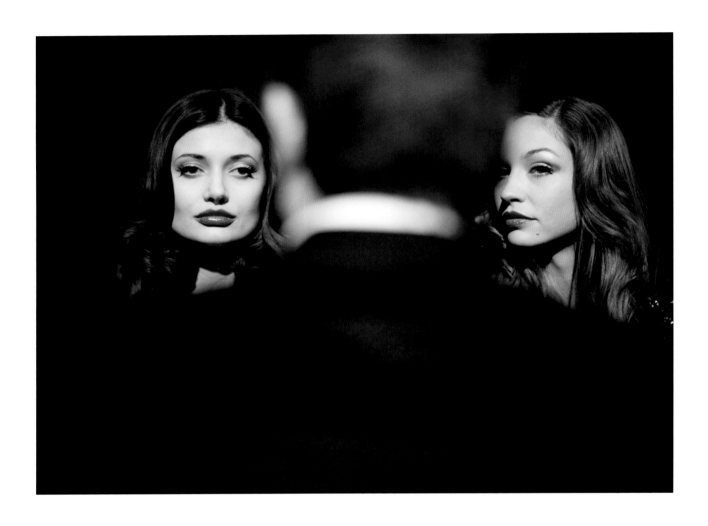

The show of TV star-turned-fashion designer Valeria Marini, at Milan Fashion Week in February.

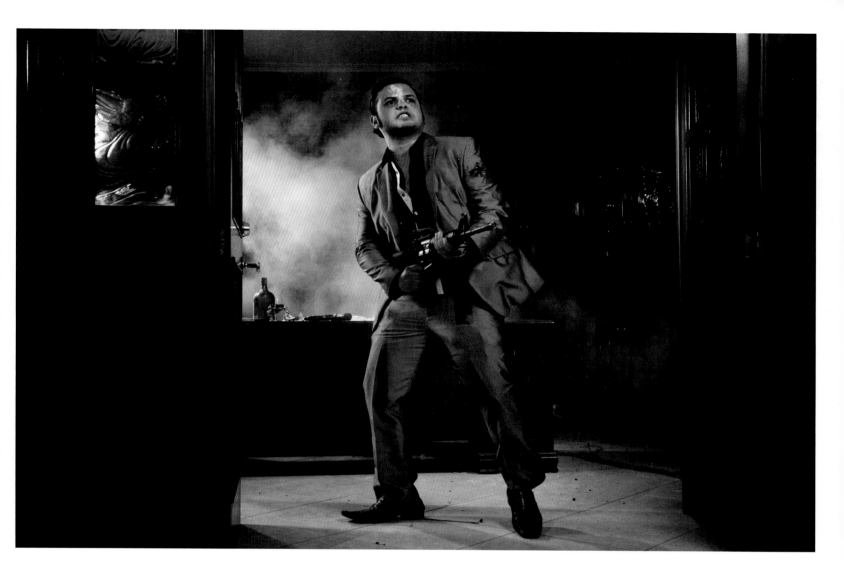

Actor Fabian Lopez on set in Tijuana, Mexico, playing the lead in the film *El Baleado 2*. A cloud of cocaine rises behind him in his office. Tijuana is a focal point of real-life drug wars raging in Mexico. The wars have inspired "narco cinema", a B-movie genre dating back to the 1980s, that has become increasingly violent in recent years.

Formulaic and action-packed, the films have been accused of glamorizing the drug lords' way of life, but reflect a world much of the audience recognizes. Narco cinema is enormously popular both in Mexico and with Mexicans living in the US. Over 30 such narco movies are shot each year in Tijuana alone, and many actors achieve star status.

Sports

SINGLES
1st Prize
Mike Hutchings
2nd Prize
Gustavo Cuevas
3rd Prize
Steve Christo
STORIES
1st Prize
Adam Pretty
2nd Prize
Tomasz Gudzowaty
3rd Prize
Chris Keulen

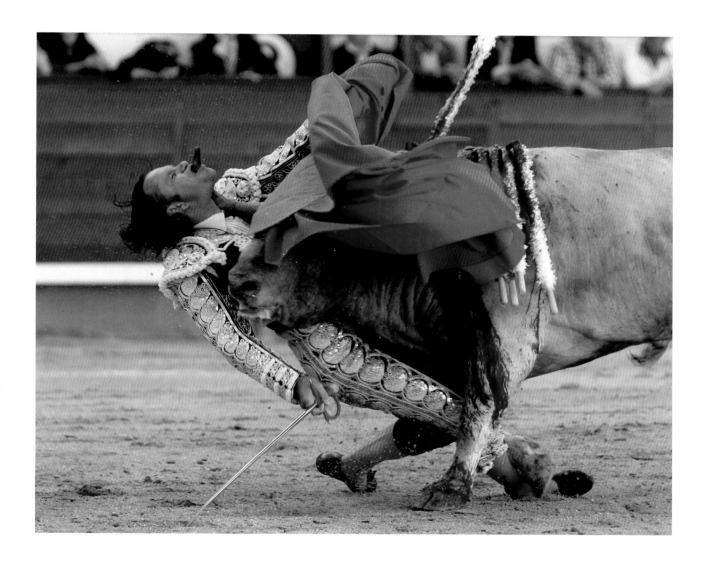

Matador Julio Aparicio is gored by a bull after losing his footing during a bullfight in Madrid in May. One of the animal's horns pierced his throat and punched through the bottom of his mouth, puncturing his tongue and fracturing his jaw. After an emergency one-hour operation in the medical center at the bullring, Aparicio was transferred to hospital for further surgery. He recovered, and returned to the ring in August.

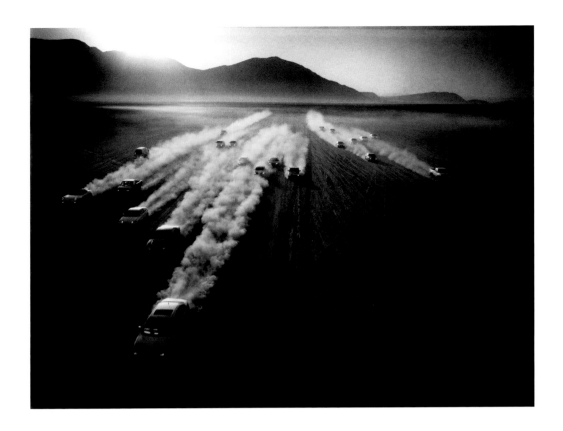

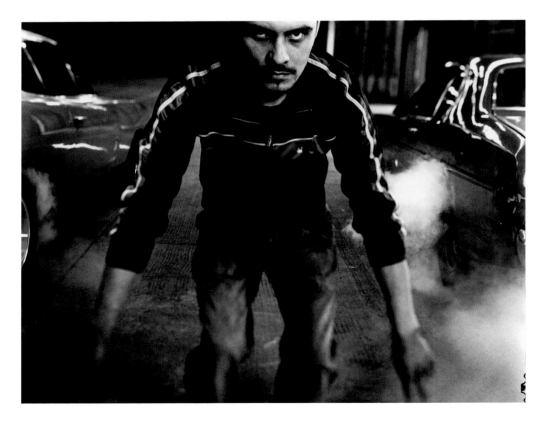

A small community of motor enthusiasts in Mexico devote much of their spare time to restoring, fine-tuning, and customizing their cars, before meeting for informal races. This page, top: The even, hard surface of Laguna de Sayula, a dried-up salt lake in western Mexico, is ideal for high-speed races. Below: Fernando Mendoza Cardenas starts a race in Mexico City between Hugo Loyo Vero (in a 1968 Dodge Charger) and José Andreas de la Barrera Rivera (in a 1970 Dodge Mexican Super Bee).

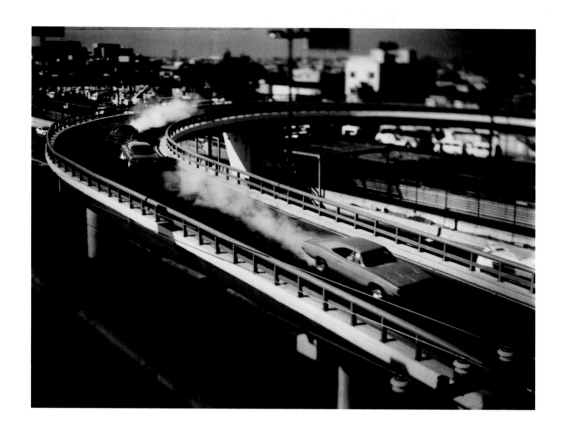

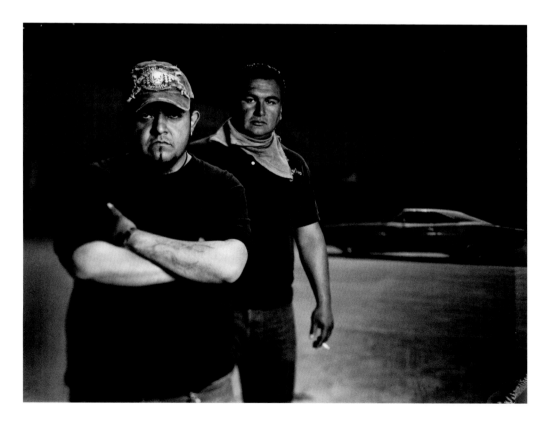

City streets, highways, parking lots, and even indoor spaces become locations for spontaneous races. This page, top: Hugo Loyo Vero (in his Dodge Charger), Aaron Cervantez Flores (in a 1969 Ford Mustang), and Fernando Mendoza Cardenas (in a 1969 Dodge Super Bee) race in Mexico City. Below: Armando Cerda Hernandez and Miguel Romero Valenzuela, with a 1968 Dodge Charger in the background.

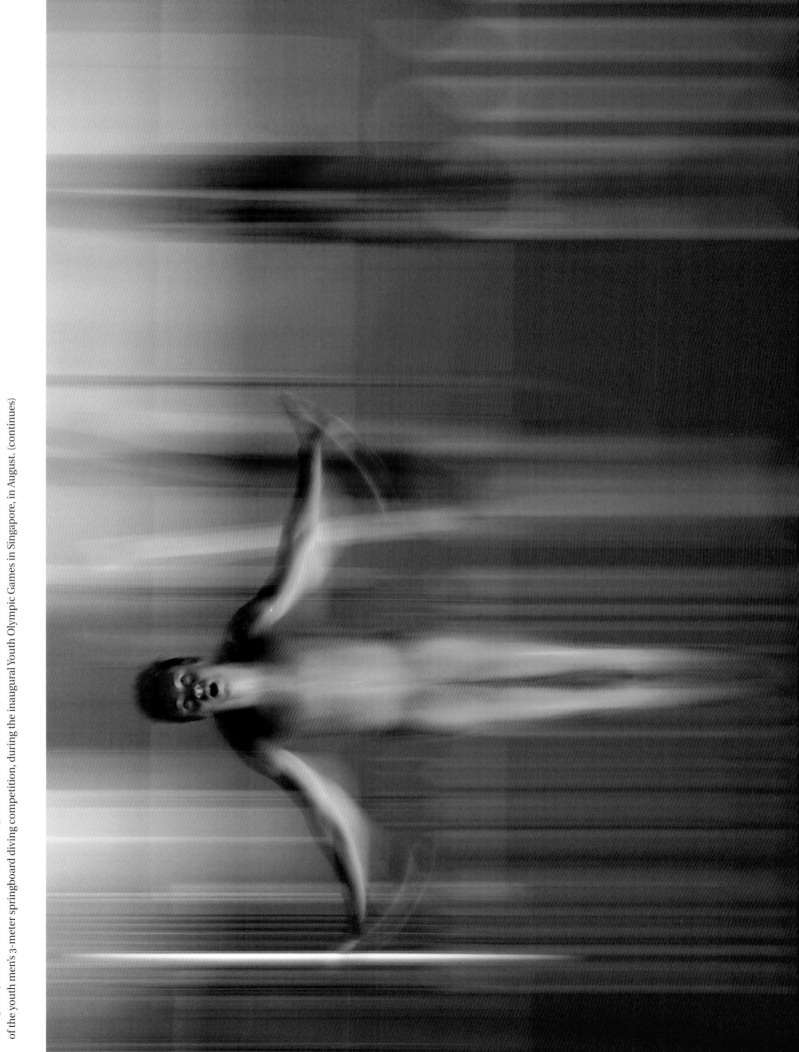

A portfolio of sports images. Above: Gold medalist Cao Yuan of China resurfaces after diving, during training for the men's 10-meter platform diving competition, at the Asian Games in Guangzhou, China, in November. Below: Thomas Daley of Great Britain competes in the preliminaries of the youth men's 3-meter springboard diving competition, during the inaugural Youth Olympic Games in Singapore, in August. (continues)

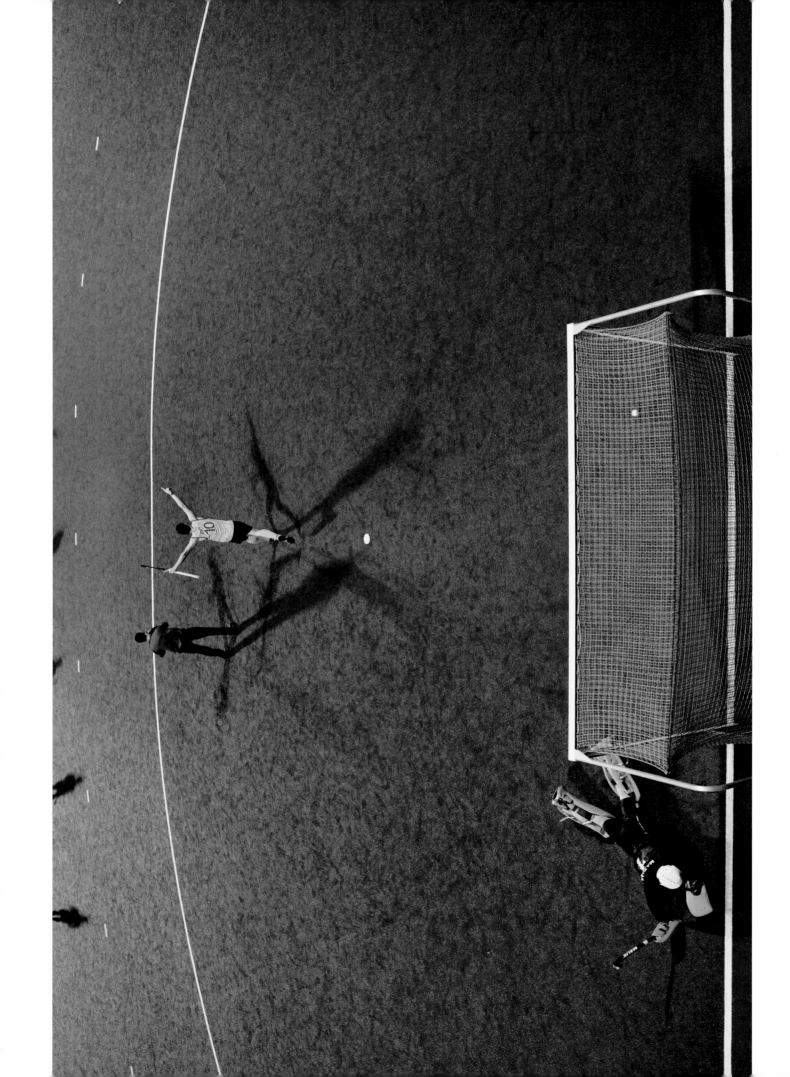

(continued) Luke Noblett of Australia celebrates after scoring a penalty and the winning goal of the boys gold medal hockey match, between Australia and Pakistan, at the Sengkang Hockey Stadium, during the Youth Olympics. (continues)

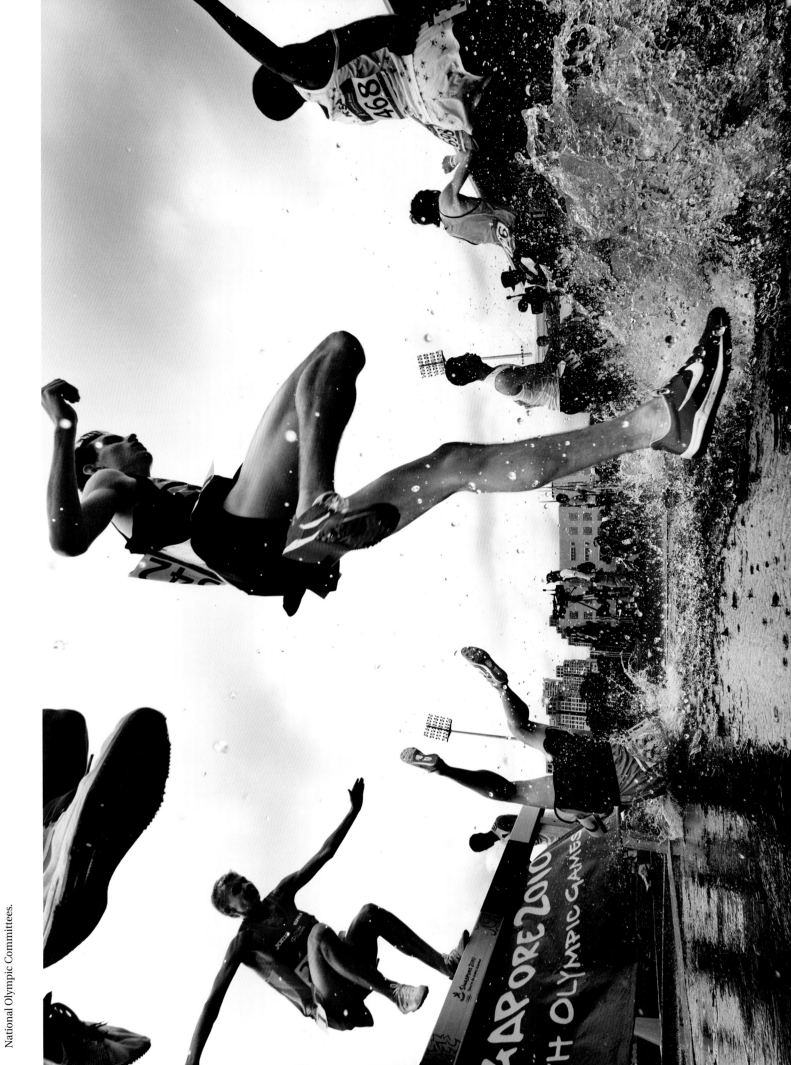

(continued) Ioran Etchechury of Brazil trips and falls headfirst, during the boys 2000 meters steeplechase, at Bishan Stadium, during the Youth Olympics, in August. The first ever Youth Olympic Games attracted 3,351 athletes between the ages of 14 and 18, nominated by 204 National Olympic Committees.

The Netherlands' Demy de Zeeuw is accidentally kicked in the face by Uruguay's Martin Caceres during a World Cup semi-final soccer match in Cape Town, South Africa, on 6 July. The Dutch won the match 3-2. De Zeeuw was taken to hospital with a suspected broken jaw. He was later able to rejoin his teammates but was not selected to play in the final, when the Dutch lost 0-1 to Spain.

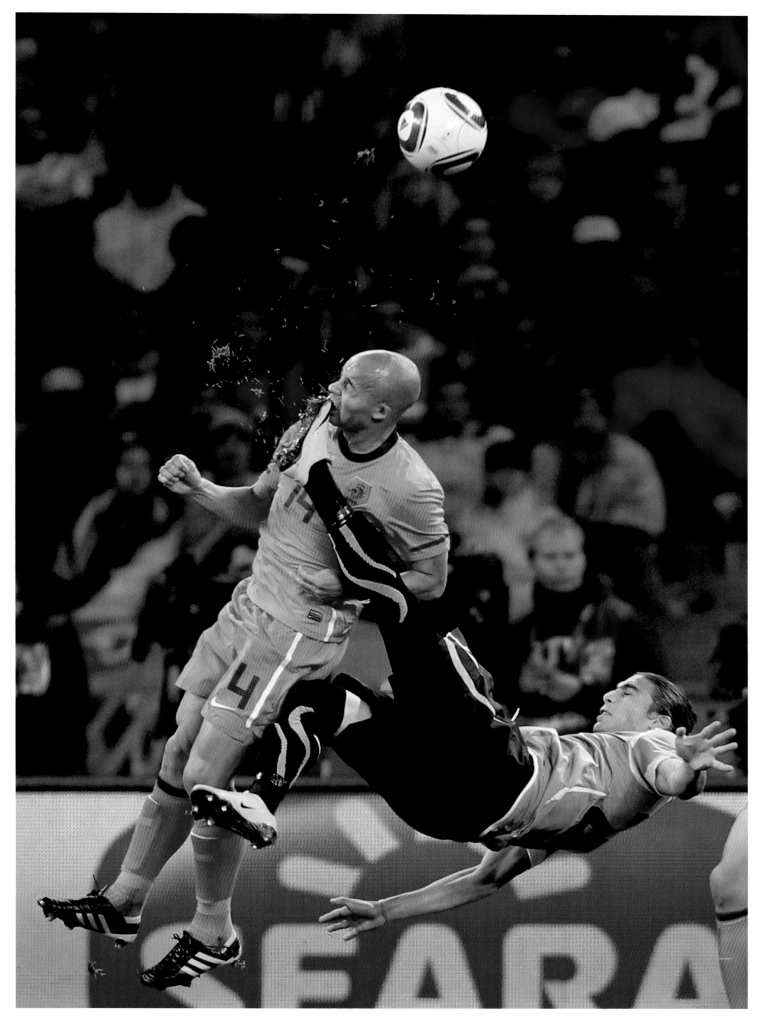

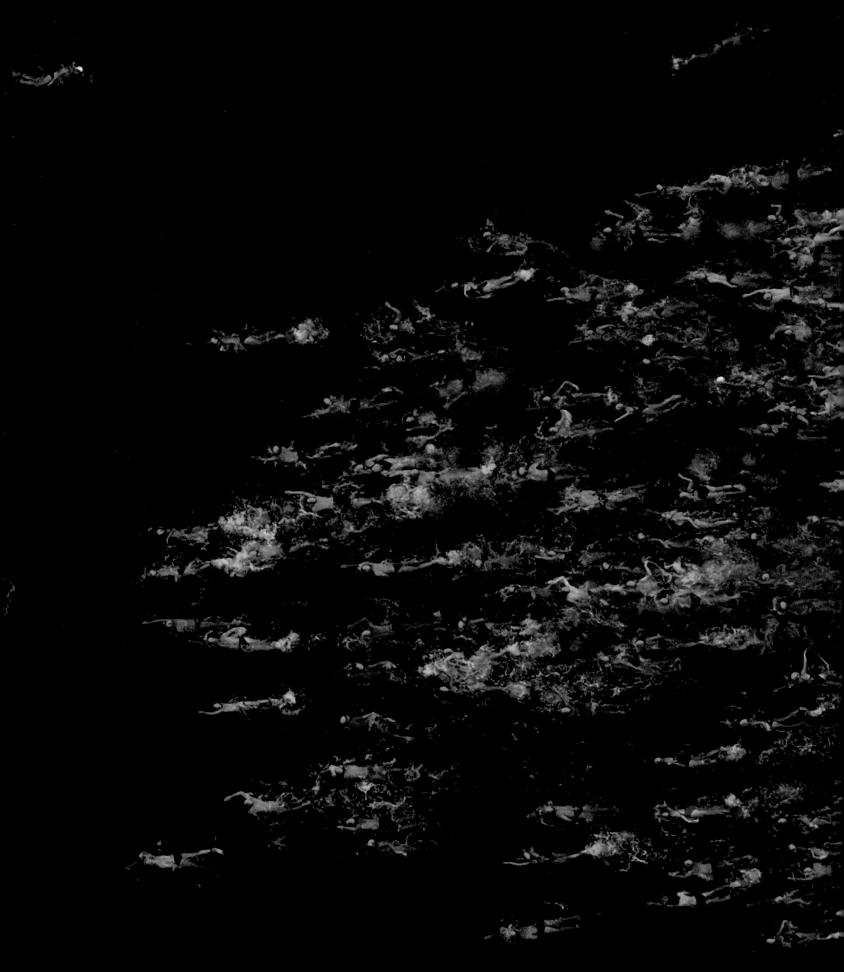

Swimmers participate in the Cole Classic ocean race, near Manly Beach, Australia, on 7 February. Together, the 1-kilometer and 2-kilometer events in the race attracted 4,500 entrants.

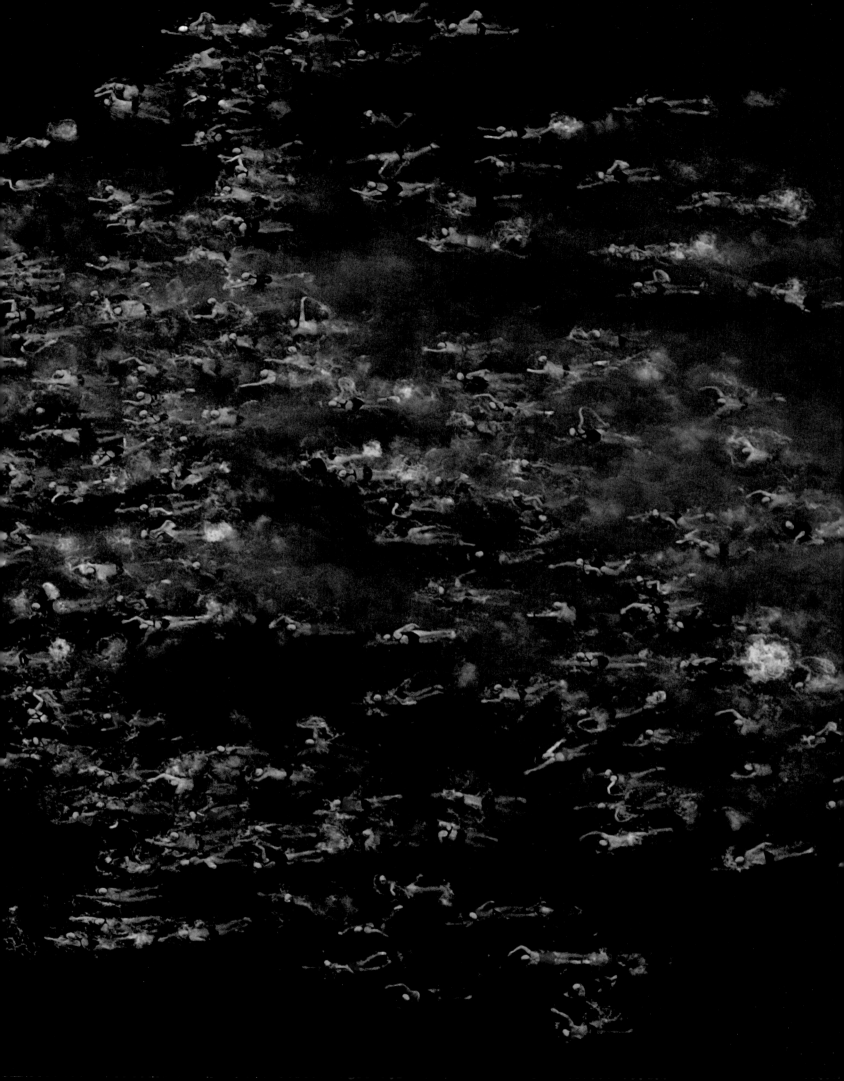

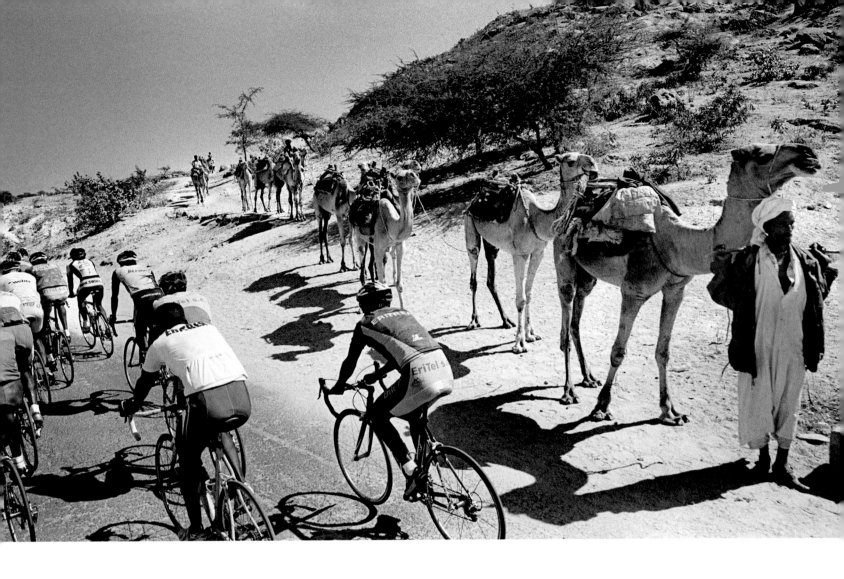

The Tour of Eritrea has its origins in a cycle race first held in 1946, though the form of the present-day event dates from 2001. It takes place in ten stages, over 710 kilometers, with some 100 professional and many more amateur participants. Cycling is enormously popular in Eritrea, and the contest attracts thousands of spectators. Above: Cyclists pass a Bedouin camel caravan, on the road between Barentu and Keren in central Eritrea. Facing page, top: People line the streets of Mendefera, at the finish of the first stage of the race. Below: Cyclist Meron Russom sits exhausted after the fourth stage, a 62-kilometer-long climb from Massawa on the coast to Asmara, 2,350 meters above sea level.

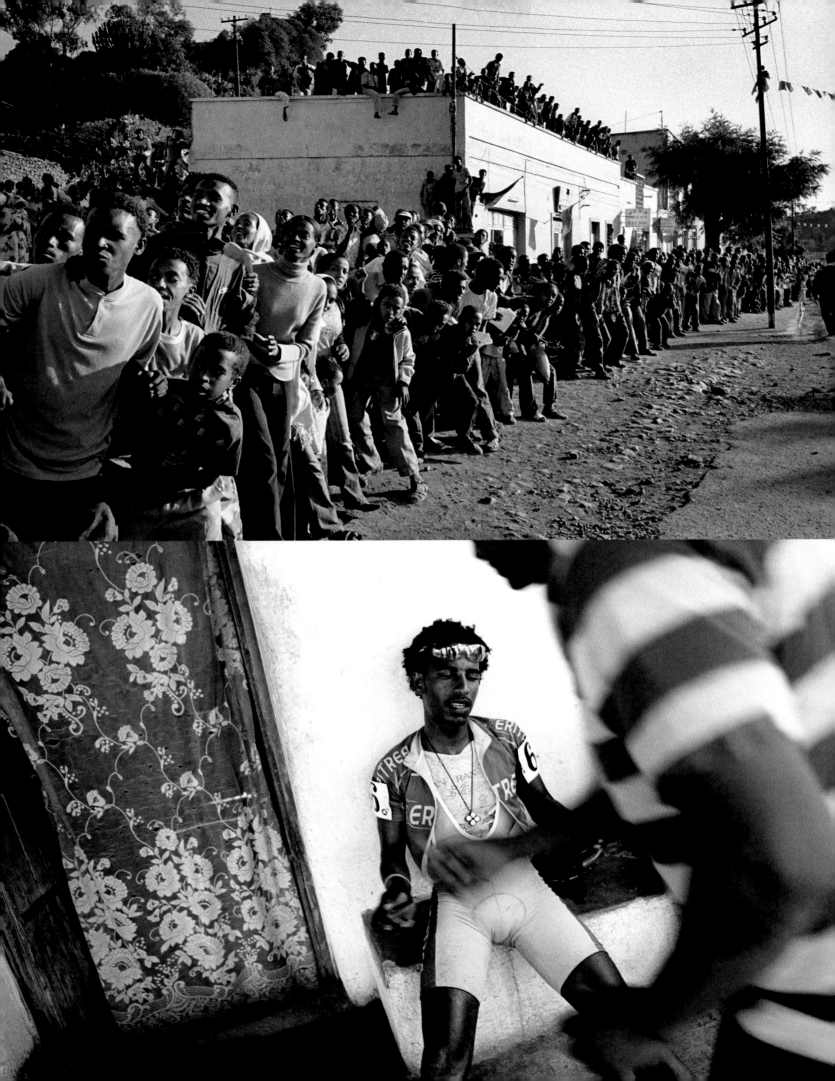

Special Mention

Following the judging of the World Press Photo contest, the jury decided to give Special Mention to a 12-picture series of photographs made by miners caught in the San José mine in Chile after a cave-in. The men were trapped 700 meters underground for 69 days, before they were rescued on 13 October.

The pictures show the difficult conditions inside the mine, and feature one of the men, Edison Peña, a keen runner who kept up his exercises underground. Writer Dan McDougall and photographer Adam Patterson spent weeks with Peña's family before he was rescued, and the pair began corresponding with him by letter. McDougall and Patterson were able to send Peña a pair of running shoes and a small digital camera through the narrow tube that was set up to connect the trapped miners to the surface.

Jury member Abir Abdullah said: "The Special Mention opens up the possibility of recognizing citizen journalism. Technological developments now allow people to record events in places where professional photographers have not had the opportunity to be. This brings us into a new era that challenges professionals, and these photos are good examples of images taken in a place where a photojournalist could not possibly have been."

Jury member Vince Aletti said: "We are able to see the conditions … the images respond to our curiosity in a vivid way."

The jury considers a visual document for a Special Mention when it has played an essential role in the news reporting of the year worldwide and could not have been made by a professional photographer.

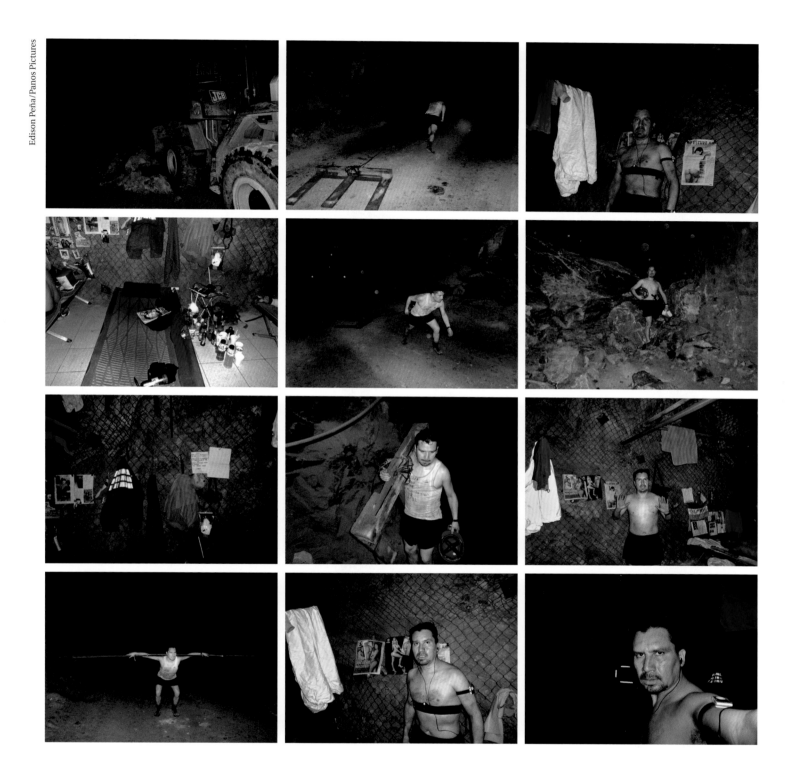

Photos: Michael Kooren / Hollandse Hoogte

Chair:
David Burnett, USA,
photojournalist and founding member
Contact Press Images

Marizilda Cruppe, Brazil,
photographer *O Globo* / Eve
Photographers

Wim Melis, the Netherlands,
curator Noorderlicht

Abir Abdullah, Bangladesh,
photographer EPA and vice principal
Pathshala South Asian Media Academy

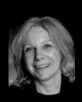

Ruth Eichhorn, Germany,
director of photography *Geo*

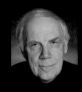

Terence Pepper, UK,
curator of photographs National
Portrait Gallery

Vince Aletti, USA,
freelance critic

Renata Ferri, Italy,
photo editor *Io Donna – Corriere
della Sera*

Sophie Stafford, UK,
editor *BBC Wildlife Magazine*

Koji Aoki, Japan,
chief photographer Aflo Sport / Aflo
Dite and president Aflo Co., Ltd.

Heinz Kluetmeier, USA,
photographer *Sports Illustrated*

Sujong Song, South Korea,
independent curator and photo
editor

Harry Borden, UK,
photographer

Mattias Klum, Sweden,
photographer and filmmaker

Aidan Sullivan, UK,
vice president photo assignments
Getty Images

Peter Bialobrzeski, Germany,
artist

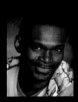

Héric Libong, Cameroon,
head of photo department Panapress

Secretary:
Daphné Anglès, France/USA,
European picture coordinator
The New York Times

Giovanna Calvenzi, Italy,
picture editor *Sportweek* / *La Gazzetta
dello Sport*

Enric Martí, Spain,
regional editor AP for Latin America
and Caribbean

Secretary:
Stephen Mayes, UK,
managing director VII Photo Agency

Participants 2011 Contest

In 2011, 5,691 photographers from 125 countries submitted 108,059 entries. The participants are listed here according to nationality as stated on the contest entry form. In unclear cases the photographers are listed under the country of postal address.

Afghanistan
Barat Ali Batoor
Hossein Fatemi
Shahmarai
Ahmad Masood
J MH
Musadeq Sadeq
Rahmatullah Naikzad
Basir Seerat
Fardin Waezi

Albania
Arben Bici
Edvin Celo
Nuri Cumani
Bevis Fusha
Petrit Kotepano
Arben I Llapashtica

Argentina
Rodrigo Abd
Luis Carlos Abregú
Martin Acosta
Rodrigo Alfaro
Angel Daniel Amaya
Manuel Arce Molino
Martin Arias Feijoo
Facundo Arrizabalaga
Walter Astrada
Leo Aversa
Diego Azubel
Carlos Barria
Alejandra Bartoliche
Marcos Brindici
Victoria Cabral
Marcelo Caceres
Victor R. Caivano
Ariel Alejandro Carreras
Marcos Carrizo
Ana Laura Castro
Fabian Ceballos
Daniel Dapari
Leonardo Di Gregorio
Charly Diaz Azcue
Mariana Eliano
Maxi Failla
Eva Fisher
Tomy Fragueiro
NKO Galuya
Dafne Gentinetta
Martin Eduardo Gerardi
Ileana A. Gómez Gavinoser
Jeremias Gonzalez
Renzo Gostoli
Patrick Haar
Santiago Hafford
Juan Hein
Claudio Herdener
Axel Indik
Bea Isabello
Gustavo Jononovich
Andres Kudacki
Emiliano Lasalvia
Kcho Livera
Gabriel Antonio Luque
Sebastian Marjanov
Alfredo Martinez
Fabián Mattiazzi
Juan Medina
Lucia Merle
Emiliana Miguelez
Juan Obregon
Atilio Orellana
Julio Pantoja
Javier Orlando Pelichotti Peretti
Andres Perez Moreno
Natacha Pisarenko
Nicolas Pousthomis
Mario Quiroga
Héctor Rio
Lola Ripoll
Andrés Riveras
Sebastián Salguero
Juan Sandoval
Matias Sarlo
Carlos Sarraf
Sebastian Scheiner
Fernando Serani
Eduardo Soteras

Nicolás Stulberg
Mario Travaini
Tony Valdez
Maximiliano C. Vernazza
Gisela Volá
Henry von Wartenberg
Irina Werning
Hernan Zenteno

Armenia
Nazik Armenakyan
Eric Grigorian
Anahit Hayrapetyan
mirzOyan
Inna Mkhitaryan
Hasmik Smbatyan

Australia
Nicolas Axelrod
Daniel Berehulak
Rowan Bestmann
Penny Bradfield
Philip Brown
Patrick Brown
Andrew Brownbill
Vince Caligiuri
Glenn Campbell
Aletheia Casey
Brian Cassey
Steve Christo
Robert Cianflone
Warren Clarke
Lisa Clarke
Tim Clayton
Brett Costello
Graham Crouch
Mark Dadswell
Howard Davies
Dale de la Rey
Jane Dempster
Andy Drewitt
Stephen Dupont
Jason Edwards
Alex Ellinghausen
Nic Ellis
Mark Evans
Jenny Evans
Adam Ferguson
Andrea Francolini
Alex Frayne
Tim Georgeson
Kate Geraghty
Ashley Gilbertson
Kirk Gilmour
Craig Golding
David Gray
Toni Greaves
Natalie Grono
Mark Gunter
Andrew Gyopar
Phil Hillyard
Ian Hitchcock
Arsineh Houspian
Glenn Hunt
Paul Jeffers
Peter Joli
David L. Kelly
Jeremy Kelly
Ken Ming Ng
Adam Knott
Cam Laird
Dean Lewins
Glenn Lockitch
Jesse Marlow
Brendan McCarthy
Brent McGilvary
Chris McGrath
Justin McManus
Georgia Metaxas
Paul Miller
Palani Mohan
Nick Moir
Graham Monro
Fiona Morris
John Morris
Dean Mouhtaropoulos
Tracey Nearmy
Jason O'Brien
Martine Perret
Jack Picone
Ryan Pierse
Gregg Porteous
Adam Pretty
David Prichard
Andrew Quilty
Gary Ramage
Jon Reid
Quinn Rooney
Dean Saffron
Emma Sailah
Anthony Sernack
Dean Sewell

Russell Shakespeare
Troy Snook
Cameron J Spencer
Matt Sullivan
Dave Tacon
Andrew Tauber
Adam Taylor
Mick Tsikas
Gemma-Rose Turnbull
Lisa Maree Williams
Iain D Williams
Annette Willis
Craig Wilson
Tim Wimborne
Krystle Wright

Austria
Heimo Aga
Michael Appelt
Heinz-Peter Bader
Christian Bruna
Matthias Cremer
Guenter Filzwieser
D. Gebhart de Koekkoek
Helmut Graf
Georg Hochmuth
Philipp Horak
Kurt Hoerbst
Petr David Josek
Alex Kals
Christa Knott
Miro Kuzmanovic
Lois Lammerhuber
Helmut Mitter
Lisi Niesner
Werner Puntigam
Erwin Scheriau
Eva Schimmer
Stefanie J. Steindl
Petra Steiner
Heinz Stephan Tesarek
Aram Voves
Michael Winkelmann

Azerbaijan
Majid Aliyev
Vugar Amrullaev
Agdes Baghirzade
Rena Effendi
Rafiq Gambarov
Irada Humbatova
Ilgar Jafarov
Osman Karimov
Emil Khalilov
Etibar
Vuqar Ibadov

Bangladesh
Maruf Hasan
A.M.Ahad
G.M.B. Akash
Md. Akhlas Uddin
Taslima Akhter
Shahidul Alam
Monirul Alam
K.M. Jahangir Alam
Md Didarul Alam Chy
Syed Ashraful Alom
Amin
K. M. Asad
Abdul Malek Babul
Soumitra
Andrew Biraj
Rabi Sankar
M.N.I. Chowdhury
Rasel Chowdhury
Emdadul Islam Bitu
Al Emrun Garjon
Khaled Hasan
Hasan Mohammad Rakibul
Rashed Hasan
Mahfuzul Hasan Rana
Abu Ala
Kabir Hossain
Anwar Hussain
Ibrahim
M. Shafiqul Islam
Nazrul Islam
Shafiq Kajol
Zahidul Karim Salim
Enayet
Naymuzzaman Prince
Abu Taher Khokon
Lailunnahar
Yasin
Saikat Mojumder
Md. Moniruzzaman
Indranil Kishor
Fateheen
Md. Rashed Kibria Palash
Shahadat Parvez
Kakoli Prodhan
Zahidur Rahman Biplob

Mahbub
Probal Rashid
Chandan Robert Rebeiro
Jashim Salam
Jewel Samad
Naman Protick Sarker
Oviek Sarwar
Shaikh Mohir Uddin
Avik
M. Yousuf Tushar
Sumon Yusuf
Munir uz Zaman

Belarus
Yuliya Ruzhechka
Kseniya Avimova
Aliaksandr Halkevich
Hudzilin Siarhei
Memsahib
Evheniya Kondak
Dmitrij Leltschuk
Andrei Liankevich
Eugene Reshetov
Dmitry Rusak
Alexander Sayenko
Leonid Shchahlou
Olga Ulko
Alexander Vasukovich
Tanja Zenkovich

Belgium
Layla Aerts
Anthony Asael
Malek Azoug
Yann Bertrand
Pauline Beugnies
Michael Chia
Gert Cools
Anne Sophie Costenoble
Hans de Greve
Koen de Langhe
Jasmine Debels
Delfosse
Tim Dirven
Sarah van den Elsken
Cedric Gerbehaye
Jean-Christophe Guillaume
Max D. Gyselinck
Nick Hannes
Gregory Heirman
Hendrik Heuver
Olivier Hoslet
Nicol' Andrea
Roger Job
Christophe Ketels
Jan Locus
S. M. Maes
Sébastien Van Malleghem
Ludo Mariën
Wendy Marijnissen
Virginia Mayo
Mashid Mohadjerin
Samer Mohdad
Bob Moors
Tom Palmaers
Kris Pannecoucke
Fred Pauwels
Joost De Raeymaeker
Patrick De Roo
Anabelle Schattens
Alice Smeets
Bruno Stevens
Pablo Da Silva
Wouter van Vaerenbergh
Katrijn Van Giel
Tomas van Houtryve
Thomas Vanden Driessche
Davy Vanham
Alex Vanhee
Philip Vanoutrive
Ingrid Vekemans
Eva Vermandel
Peter de Voecht

Bolivia
Patricio Crooker
Marcelo Perez del Carpio
Luis Salazar

Bosnia-Herzegovina
Haris Calkic
Ziyah Gafic
Ahmed Hadrovic
Aljivo Husein
Aljabak
Amer Kuhinja
Dijana
Almir Panjeta
Prijak Branimir
Dado Ruvic
Damir Sagolj

Brazil
J. Adeilson (Ade Zeus)
AF Rodrigues
Lalo de Almeida
Raphael Alves
Paulo Amorim
Rafael Andrade
Keiny Andrade
Andre Arruda
Eduardo Anizelli
Alberto César Araújo
Kenji Arimura
Juan Barbosa
Joao Ripper
Nário Barbosa
Monara Barreto
Paulo Barreto
Zé Barretta
Jorge Bechara
Ailton Cruz
Fernando Borges
Mario Bourges
Leonardo Costa Braga
Bruno Falcão
J.L. Bulcão
Tony Bullard
Calil Neto
Reinaldo Canato
Luciano Candisani
Claudio Capucho
Marcelo Carnaval
Daniel Caron
Ernesto Carrico
Weimer Carvalho
A. Cassiano de Sousa
Francisco Cesar
André Coelho
Julio Cordeiro
Antonio Costa
Claudia Ferreira
Rahel Patrasso
Felipe Dana
Daniel Mobilia
Fernando Dantas
Eduardo Lima
Ratão Diniz
José Francisco Diorio
Edvaldo Santos
Bruno Domingos
Fernando Donasci
Bruno Mancinelle
Eugênio Vieira
AC Junior
Kita Pedroza
Felipe Feca
Edmar Melo
Joédson Alves
Epitácio P. Ferreira
Pio Figueiroa
André François
Ricardo Teles
Valdir Gomes Friolin
Christina Rufatto
Dado Galdieri
Fábio Caffé
Maria dos Retratos
Apu Gomes
Jonne Roriz
Leo Pinheiro
Choque
Cesar Greco
Caio Guatelli
Leonardo Lepsch
Francisco Guedes de Lima
Felipe Hanower
Iano Andrade
Rafael Jacinto
Jonny Ueda
João Kehl
Daniel Kfouri
Antonio Lacerda
Elisângela Leite
Léo Lima
Ulisses Job Lima
Mauricio Lima
Ricardo Funari
Celso Luiz
Benito Maddalena
Cezar Magalhaes
Gustavo Magnusson
Paulo Magri
Ricardo Nogueira
Daniel Marenco
Ivo Gonzalez
Jadson Marques
Berge Arabian
Fernando Martinho
Maycom Brum
Adriana Medeiros
André Teixeira
Alexandre Meneghini
Sergio Moraes
Letícia Moreira

Marcelo Ferrelli
Fernando Naiberg
Marta Nascimento
Luisa Nolasco
Malabi
Michael Patrick O'Neill
Dolores Ochoa
Adrovando C. de Oliveira
Diego Padgurschi
Anderson Paes
Euler Paixao
Paulo Pampolin
Paulo Barros
Hamilton Pavam
Gustavo Pellizzon
Andre Penner
Izan Petterle
Marcos Piffer
Paulo Pinto
Claudinei Plaza
André Porto
Bruna Prado
Marcelo Prates
Eduardo Queiroga
Fernando Quevado
Sergio Ranalli
Genesio
Mastrangelo Reino
Rogerio Resende
Renan Rosa
Anderson Schneider
Tárlis Schneider
Jean Schwarz
Severino Silva
Albari Rosa
Ferdinando Ramos
Anderson Barbosa
Tiago Silva
Orlando Filho
Sergio Jr.
Ueslei Marcelino
André Americo
Jean Lopes
Rogério Stella
Daniel Teixeira
Toninho Cury
Ricardo Trida
Francisco Valdean
Luiz Vasconcelos
Danilo Verpa
Ricardo Medeiros
Wilson Vicente Jr.
Cláudio Vieira
Alexandre Vieira
Tadeu Vilani
Weber Sian
Widio Joffre
Michele Zambon
Alejandro Zambrana
Guilherme Zauith
Adriana Zehbrauskas
Anderson Zomer

Bulgaria
Iosif Astrukov
Mehmed Aziz
Vassil Donev
Yanne Golev
Boryana Katsarova
Dimitar Kyosemarliev
Eugenia Maximova
Aydan Metev
Nikola Mihov
Stoyan Nenov
Denislav Stoychev
George Vachev
Ivaylo Velev
Boris Voynarovitch

Cambodia
Tang Chhin Sothy

Cameroon
Okumo Angwa
Happi Raphaël Mbiele

Canada
Logan Abassi
Tyler Anderson
Benoit Aquin
Berge Arabian
Terry Asma
Olivier Asselin
Brian G. Atkinson
Charles Mathieu Audet
Martin Beaulieu
Jan Becker
Mathieu Belanger

Shaun Best
Mark Blinch
Normand Blouin
Laëtitia Boudaud
Bernard Brault
Peter Bregg
Douglas Brown
Simon Cauvier Goupil
Philip Cheung
Andy Clark
Roger Cullman
Nick Czernkovich
Nathalie Daoust
Barbara Davidson
Etienne de Malglaive
Ivanoh Demers
John Densky
Don Denton
Daniel Desmarais
Mike Drew
Darryl Dyck
Natasha Fillion
Colleen Flanagan
Kevin Frayer
Benoit Gariépy
Jennifer Gauthier
Ryan Gauvin
Brian J Gavriloff
Christopher Grabowski
Brett Gundlock
Roger Hallett
Jenna Hauck
Caroline Hayeur
James Helmer
Leah Hennel
Roberta Holden
Michel Huneault
Chul-Ahn Jimmy Jeong
Emiliano Joanes
Saeyun Koh
Todd Korol
Allan Kosmajac
Nick Kozak
Jeannot Levesque
Roger Lemoyne
Nicolas Lévesque
Brent Lewin
Laura Leyshon
Lung S Liu
Karen Longwell
Larry Louie
John Lucas
Fred Lum
Douglas MacLellan
Rick Madonik
Jude Mak
Jo-Anne McArthur
Jeff McIntosh
Diane Misaljevic
Stephen Morrison
Farah Nosh
Gary Nylander
Finbarr O'Reilly
Lucas Oleniuk
Jen Osborne
Ed Ou
Kieran Oudshoorn
Charles-F. Ouellet
Kevin van Paassen
Louie Palu
François Pesant
Wendell Phillips
André Pichette
Vincenzo Pietropaolo
Saul Porto
Peter Power
Duane Prentice
Anna Prior
Jim Rankin
Ryan Remiorz
Alain Roberge
Lara Rosenoff
Jim Ross
Andrew Rowat
Liz Rubincam
Steve Russell
Derek Ruttan
Derek Shapton
Peter Sibbald
Dave Sidaway
Steve Simon
Jack Simpson
Sami Siva
Rob Skeoch
Lana Slezic
David W. Smith
Timothy Smith
Elaisha Stokes
Leon Switzer
Michael Talbot
Stephen Uhraney
Aaron Vincent Elkaim
George Webber

Donald Weber
Bernard Weil
Ian Willms
Larry Wong
Adrian Wyld
Jim Young
Hugo Yuen
Iva Zimova

Chad
Dunzhu Wang

Chile
Espinosa
Eduardo Banderas G.
Orlando Barría
Roberto Candia
Geraldo Caso Bizama
Rodrigo Chodil
Mario Davila
Marco Fredes
Fernando Gallardo Sanz
Edgard Garrido
R. E. Garrido Fernándezz
Manuel A. Garrido Garrido
Carlos F. Gutiérrez
Jaime M. Hernández
Luis Hidalgo
Hugo Infante
Ji Chen
Chino Leiva
Rodrigo López Porcile
Fernando Morales
Tomás Munita
Ale Olivares
Cristobal Olivares
Ronald Patrick
Christian Peña
Hector Retamal Correa
Álvaro Riveros
Pedro Rodriguez
Amparo Rogel
Victor Rojas
Ian Salas
Sebastian Sepulveda
Marcelo Silva
Pedro Ugarte
Marcelo Vildósola Garrigó
Carlos Villalon
Nicolas Wormull
Ernesto Zelada

China
A Yin
Aman
BaiYing
Bai Gang
Zhoufeng Bai
Jinhe Bai
Bai Jie
Chen Wen Bi
Bian Qiwu
Machunbin
Liu Bin
Zhou Bing
Chen Binrong
Bu Ensa
Cai Tongyu
Cai Mingjang
Delong Cai
Cai Wenyuan
Kingson
Cao Zhi Zheng
Liu Chan
Changhe
Chang Liang
NiuChao
Cheliang
Chen Qiang
Li Chen
Chen Qinggang
Yan Chen
Chennan
Chen Zhuo
Chen Hui
Chen Zhigang
Chen Fan
Chenliang
Shaohua Chen
Yongping Chen
Chen Xiaodong
Qituo Chen
Chengeng Sheng
Yigang Chen
Xiaomei Chen
Chen Xiaoxia
Alice Chen
Chen Kunrong
Chen Daoqing
Xiaochuan Chen
Fresh air
Chen Zhongqiu
JianZeng Chen

149

Chen Shihong
Chen Ai Juan
Chen Yuan Zhong
Cheng Heping
Cheng Xuliang
Wenjun Cheng
Wang Cheng
Cheng Long
Cheng Dongbo
Chenglong Yang
Yongzhi Chu
Lu Tingchuan
Zheng Chuan
Zhang Chunhai
Hucong
Cui Heping
Yue Yong Cui
Sun De Li
Deng Bo
Deng Xiaowei
Denghuosheng
Deng Jianbin
Wu Di
Diyongsheng
Jinjun Di
Ding QingLin
Zhang Dong
Yangdonghua
Du Yang
Du Jiang
Shang Erming
Fan RenLi
Li Fan
Fan Fangbin
Fan Liyong
Fang Qianhua
Tian Fei
Fei Maohua
Feng HuaPing
Feng Jie
Yan Jia Feng
Hongwei Feng
Feng Xiaozhu
Victor Fraile
Fu Yongjun
Xiao Fu
Fu Xinghua
Chang Gang
Li Xiaogang
LiGang
Gao Yong
Gao Hetao
Lu Gao
Gao Xiao
Gao Zhongyiin
Guhaibo
Haitao Gu
Guan Haitong
Guang Niu
Luo Guanghua
Guo Tao
Tieliu Guo
Lei Guo
Guo Jijiang
Guo Yong
Jianzheng Guo
Wang Guozhen
Guo Hai
Xu Haibin
Han Meng
Han shiqi
Handan
Hanxin Lu
Shan Min Hao
Jian He
Dingsanlang
He Ben
Wang He
Yi He
He Haiyang
Hei Feng
Jun Hou
Hou Yu
Xiaojun Hou
Hu Guoqing
Hu Lingyun
Hu Chengwei
Hufusheng
Tingmei Hu
Di Hu
Huang Yue-Hou
Huang Jingda
Chengfeng Huang
Like Huang
Jixiang
Jia Guorong
Jia Baerqie
Chen Jian
Zhu Jianxing
Tong Jiang
Jiang Hao
Jiang Yue
Jiang Yan
Jiangsheng
Yang Jianmin
Chen Jianyu
Jin Liwang

Alfred Cheng Jin
Jin Xing
Li Jinhe
Fan Jinyu
Mark Joe
Cui Jun
Xu Ka
Ma EnKai
Kaida Liu
KangZhen
Xu kangping
Liu Ke
Yang Kejia
Kong Linjian
Liang Kong
Huimin Kuang
Hongguang Lan
Lan Jun
Lang Shuchen
Jason Lee
Lee Lin
Jan lee
Leijia
Li Cheng
Jiangang Li
Zhen Yu Li
Li Yong
Li Qizheng
Feng Li
Liweiguang
Li Wei
Sunday Lee
Qiang Li
Li Fan
Li Ming
LiBin
Li Ga
Li Gang
Hui Li
Li Ming Yang
Song Li
Li Shupeng
Li Wei
Lijianshu
Linlin Li
Li Lin
Ma Li
Li Geng
Liang Li Xin
Lian Xiang Ru
Liang Daming
Liang Meng
Zhen Liang
Liuliang
Xuehong Liang
Liang Zhentang
Jin liangkuai
Liao Pan
LinGuoRui
Susan_su
Liu Dajia
Liu Jiangfeng
Liu Tao
Liu Hang
Liu Tao
ZhengLiu
Tomas
LiuSong
Liutong
LiuLei
Liu Lihang
Zhiyu Liu
Liu Ji
Liu Yang
Liu Jie
Liu Jun
Liupeng
Kaide Lui
Liu Debin
ZhiFeng Liu
Zhongjun
Feiyue Liu
Zhou Lixin
Chengguanlong
Long Yudan
Lu Guang
Guozhong Lu
Huiming Lu
PengLu
Lu Bei Feng
Lu Weiwei
Luan Zheng Xi
Luo Kaifeng
Lv Wenzheng
lvjia
Ma Hongjie
Majun
Ma Junhao
Mengge
Mengjunliang
Miao Jian
Xie MingGang
Mingjia Zhou
Jiwu Mu
Ni Li Xiang
Ning Feng
Ning Zhouhao

Zhang Ning
Ning Biao
Niushiyun
Yang Ou
Xingkai Ouyang
Pan Jinglin
Pan Shiguo
Pei Jingde
Zhang Peiren
Peng Hui
Nian Peng
Zhang Bao Ping
Feng Pu
Qi Heng
Qi Xiaolong
Qi JieShuang
Qi Hao
HuZhenqi
Han Qian
Qiao Jianguo
Song Qiao
Qin Bin
Qin Shixiang
Zhou.Q
Qiu Yan
Qiu Weirong
Qiu Jianhua
Xiaoyi Qu
Cheng Quan
Lu Ran
Ren Shi Chen
Ren Zhenglai
Yuming Ren
Zhang Bang Ren
Shang Huage
Shao Quanhai
Shen Zhicheng
Shen Xiaomin
Xianghui
Lan Pu Sheng
Sheng Jia Peng
Lanzhou Chenbao
Yi Shi
Shi Tao
Shiwei
Guangzhi Shi
Huanrong Shi
Shi Lifei
Feng Shuting
Jin Siliu
Rongcheng Song
Songlu
Song Yue feng
Jinyu Song
Aly Song
Pan Songgang
Songqing
Shiri Su
Ning Dong Sun
Tao Sun
Sun Chen
Debo Sun
Sunxin
Little Hugo
Guoshu Sun
Changrong Sun
Sun,Yi
Sun Hongjun
Jinglei Sun
Tan Qingju
Tan Weishan
Tang Xiaoyi
Fan Tao
Zhang Zhitao
ZhangTao
Deng Tao
Baoxi Tian
Tian Zhenlong
Tian feng
Tian LI
Tianming
Jianguo Tong
Joseph Tu
Yanming
Wang Da Bin
Wang Wen Yang
Xinke Wang
Wang Ye
Wang Mianli
Wang Jingchun
Wang Jing
Wang Xiwei
Wang Zhao-hang
Wang Pan
Hui Wang
Xiaoming Wang
Wang Yan
WangHongda
Wang Zhen
Wang Haixin
Shen Wang
Wang Jianing
Wang Qingqin
Wang Lei
Guibin Wang
Wang Yuanling
Wang Yuheng

Shijun Wang
Lili Wang
Wang Xiaoming
H.M.Lenstalk
Wang Dengkui
Dongwei
Wang Wei
Yuchen Wang
Shouze Wang
Yanda Wang
Wangzi
Zhongju Wang
Wangsj
Weixuan Wang
WangHua
Wang Li
Jiuwei Wang
Wei Zheng
Wei wei
JinMingWei
Hu Weimin
Cao Weisong
Wen Qing
Wen Qingqiang
Andy Wong
Wu Chuan Ming
Wu Zhangjie
WU Xiaotian
Fang Wu
Wu Junsong
Asan
Wu Guofang
Wu Jie-ming
YongGang Wu
Jiaxiang Wu
Wu JianGuo
Wu Haiyuan
Kaixiang Wu
Wu Jianhui
Wuyina
Wu Jiuling
Wu Xuehua
Haibo Xi
Tanxi
Xi Jiannan
Xia Shiyan
Xia Yang
Meng Xiangming
Xiaoyunji
Wu Xiaoling
Zhang Xiaoyu
Xikun Liu
Xin Yi
Cheng Xin
Tang Shou Xin
Xing Guangli
Huang Xingneng
Wang Xinwei
Xu Jingxing
Xu Zhuoheng
Xu Yuanchang
Xu Kai
Gangqiang Xuan
Li Xudong
Xuening
Tu Xuli
Li Yalong
Bailiang Yan
Jing Yan
ShanliangYan
Yan Hui
Shi Yan Yan
Yan Yan
Silin Yan
Ri Yue
Bo Yang
Ningyang
Cai Yang
Yang Fawei
Yanglei
Yang Fu
Shuhuai Yang
Jianmin Yang
Channingyang
Fan Yang
Zhongmin Yang
Shaowen Yang
Yang Jihong
Wenjie Yang
Yankang Yang
Yang Shen
He Yanguang
Yao Dong
Yao Dawei
Yao Zhuang
Wang Yaxin
Zhang Yi
Yi Jin
HuangXiaoYi
Hao Yi
Fu Zhiyong
Yong Shi
Zou Yong
Zhan You Bing
Yu Haibo
Yu Wenguo
Wenhao Yu

TongYu
Yu Ming
Yujin
Yu Jianying
Han Yu Hong
Liu Yuan
Alexander F. Yuan
LiYang Yuan
Peide Yuan
Wang Dongyuan
TianYue
Jerry Lu
Yun Hongbo
Han Yun Min
Ni Yuxing
Yngsheng Zao
Zeng Junshang
Yu Zeng
Zhan Yu
Zhang Huibin
Zhang Wei
Wei Zhang
Paul Zhang
Jian Zhang
Nicky Zhang
Zhang Xiaodong
Xiao Zhang
Xiaoli Zhang
Cuncheng
Zhang Jinqi
Zhang Yan
Zhang Chengbin
Zhang Lide
Zhang Mo
Zhang Zehe
Tao
Mo Zhang
Zhang Zhiping
Wanji Zhang
Yingnanzhang
Zhang Li
Zhang Jianchun
Zhang Hongwei
Zhangxinghai
Zhao Kang
Jing Zhao
Zhaojingwei
Zhao Qin
Zhao Xuemin
Rongsheng Zhao
Zhao Guye
zwslode
Zhao Duan
Pang Zheng
Zheng Xiaoyun
Zhengzhiyao
Xiao Qun Zheng
Shi Guangzhi
Lin Zhui
Sun Zhijun
Ming Zhong
Zhong Guilin
Zhong Ruijun
Zhong Qigang
Wu Zhonglin
Tianzhongyu
Zhou Guoqiang
Zhou Xiaohui
Zhou Qingxian
Cunyun Zhou
Zhou Chao
Xin Zhou
Gukai Zhou
Zhou Lei
Zhou Haisheng
ShaoHua Zhou
Guoxian Zhou
Zhou Wei
Xiaodong Zhou
En Zhou
Zhu Jianming
Yuanbin Zhu
Danyang Zhu
Xiyong Zhu
Vego
Xiaolong Zhuang
Zhao Zhurong
Zou Hong
Zou Zheng
Zousen
Zuoqing

Colombia
Luis Acosta
Aymer Alvarez
Gabriel Aponte Salcedo
Eliana Aponte
J. M. Barrero Bueno
Fabián Bernal
Juandiegobc
Daniel Bustamante
Felipe Caicedo Chacón
Henry Agudelo
Juan Fernando Cano
Carlos Capella
Abel E. Cardenas O.
Jonathan Carvajal
Christian Castillo M.
Santiago Escobar Jaramillo
Christian Escobar Mora
César Flórez
Alvaro Barrientos
Rodolfo González
Guillermo Gonzalez
Milton Diaz
Paola Herrera
Iván Darío Herrera
Alberto Jimenez Melendez
Luis Lizaroza
William F. Martinez
Ricardo Mazalan
Omar H. Medina
Jose Miguel Gomez
Mauricio Moreno
Eduardo Munoz
JeanGenie
Jorge E. Orozco Galvis
Guillermo Ossa
Bernardo Peña
Ricardo Pinzon Hidalgo
Luis Ramirez
Federico Rios Escobar
Luis Robayo
Henry Romero
Manuel Saldarriaga
J. A. Sanchez Ocampo
Andrés Torres
Andres Valenzuela
Hernan Vanegas
Esteban Vanegas
Ricardo Vejarano
Fernando Vergara
Adriana Vergara M:
Donaldo Zuluaga Velilla

Costa Rica
Josè Campos Rojas
Jose Diaz
Alexander Otarola
Rafael Pacheco Granados
Mónica Quesada C.
Marcela Bertozzi
RobertoCarlos Sànchez
Alexander Arias Valverde

Croatia
Antonio Bat
Matko Biljak
Josip Grdan
Zeljko Hajdinjak
Fjodor Klaric
Duje Klaric
Vlado Kos
Zvonimir Krstulovic
Dragan Matic
Slavko Midzor
Marijan Murat
Barbara Saric
Josip Seri
Sanjin Strukic
Stipe Surac
Ivo Vucetic

Cuba
Daniel Anaya
Juan Pablo Carreras
Oscar Hidalgo
René Pérez Massola
Randy Rodriguez Pagés

Cyprus
Stavros Ioannides
Andreas Lazarou

Czech Republic
Jana Asenbrennerova
Tomas Bican
Michal Bílek
Radek Burda
Jan Cága
Michaela Danelova
Jiri Dolezel
Alena Dvorakova
Viktor Fischer
Hynek Glos
Lukas Houdek
Milan Jaros
Kaman Juraj
Kaifer Daniel
Radek Kalhous
Joe Klamar
Svatopluk Klesnil
Tomás Kroulík
Pavel Lisý
Veronika Lukasova
Michal Novotny
Martin Pinkas
Jiri Rezac
Jan Sibik
Filip Singer
Jan Sochor
Michaela Spurná
Frantisek Staud
Ivan Vetvicka
Dan Vojtech
Jan Zatorsky
Jan Zatorsky

Denmark
Niels Ahlmann
Christian Als
Torben Andahl
Morten Andersen
Nicolas Asfouri
Astrup
Soren Bidstrup
Jonathan Bjerg Møller
Michael Barrett Boesen
Laerke Posselt
Michael Bothager
Martin Bubandt
Finn Byrum
Klavs Bo Christensen
Fredrik Clement
Jan Dago
Casper Dalhoff
Jakob Dall
Jacob Ehrbahn
Peter Helles Eriksen
Jørgen Flemming
Mette Frandsen
Sara Galbiati
Uri Golman
Jan Grarup
Bjorn Stig Hansen
Christian Holst
Niels Hougaard
Hans Christian Jacobsen
Kasper Jensen
Martin N. Johansen
Reimar Juul
Lars Krabbe
Nanna Kreutzmann
Benjamin Kürstein
Joachim Ladefoged
Mogens Laier
Thomas Larsen
Nikolai Linares
Martin Lehmann
Thomas Lekfeldt
Bax Lindhardt
Tobias Selnaes Markussen
Morsi
Joachim Adrian
Lars Moeller
Jeppe Boje Nielsen
Mads Nissen
Peter Hove Olesen
Soren Pagter
Jeannette Pardorf
Ulrik Pedersen
Kristoffer Juel Poulsen
Lisa Pram
Kim R
Torben Raun
Pelle Rink
Asbjørrn Sand
Thomas Sjoerup
Carsten Snejbjerg
Jacob Aue Sobol
Soren Solkaer Starbird
Sisse Stroyer
Morten Germund
Martin Søby
Kristian Bertel
Gregers Tycho
Jonas Vandall
Christian Vium
Robert Wengler

Dominican Republic
Jorge Cruz
Pedro Farias-Nardi
Miguel Gomez
Miguel Pantaleon
Adriano Rosario
Pedro Sosa
Alina Vargas-Afanasieva

Ecuador
Vhasencio
Benjamín Chambers
Angel Estuardo Vera
Karla Gachet
Vicente Gaibor
Felipe Jacome
José Jácome
Amaury Martinez
Daniel Patiño Flor
Alejoreinoso
Paùl Salazar Urgilez
Fernando Sandoval Jr
Santiago Serrano
Eduardo Valenzuela

Egypt
Mohamed Abdou
Arnaud du Boistesselin
Nour El Refai
Mohamed Hossam El-Din
Nasser Ishtayeh
Khaled Kandel
Mohamed Adel
Amr Nabil
Alia (Coucla) Refaat
Ashraf Talaat
A. Tamboly
Goran Tomasevic

El Salvador
Félix Amaya
Mauro Arias
Rebeca Arias Romero
Douglas Alberto Urquilla
Claudia Castillo
Ericka Chávez
Nilton Garcia
Aaron Ganz
Oscar Leiva Marinero
Lissette Lemus
Borman Mármol
Frederick Meza
Ulises Rodriguez
Juan Carlos
Luis Angel Umaña

Estonia
Kaido Haagen
Annika Haas
Tiit Räis

Ethiopia
Eskinder Debebe
Michael Tsegaye

Faroe Islands
Benjamin Rasmussen

Finland
Mikaela Berg
Tatu Blomqvist
Jukka Gröndahl
Touko Hujanen
Esko Jämsä
Markus Jokela
Petteri Kokkonen
Meeri Koutaniemi
Tatu Lertola
Henrik Malmström
Timo Marttila
Juhani Niiranen
Timo Pyykkö
Kimmo Räisänen
Kaisa Rautaheimo
Antti Sepponen
Eetu Sillanpää
Kai Sinervo
Maija Tammi
Mikko Vähäniitty

France
Olivier Adam
Cyrille Andres
Christophe Archambault
Patrice Aroca
Serge Attal
Bruno Bade
Jerome Barbosa
Joan Bardeletti
Marie Baronnet
Martín Barzilai
Pascal Bastien
Patrick Baz
Vladimir Bazan
Arnaud Beinat
Yacine Benseddik
Alban Biaussat
Bernard Bisson
Cyril Bitton
Patrick Blanche
Romain Blanquart
Christophe Boete
Vincent Boisot
Guillaume Bonn
Régis Bonnerot
Jérôme Bonnet
Denis Boulanger
Pierre Boutier
Eric Bouvet
Philippe Brault
Fabien Breuil
Jerome Brezillon
Simon Brodbeck
Arnaud Brunet
Axelle de Russé
Christophe Calais
Thibault Camus
Francesco Carella
Sarah Caron
Fabrice Catérini
Jacques Cauda
Patrick Chapuis
Guillaume Chauvin
Olivier Chouchana
Laurent Cipriani

Lionel Cironneau
Sébastien Le Clézio
Guillaume Collanges
Yannick Cormier
Magali Corouge
Olivier Corsan
Philippe Cottin
Jean-Christophe V. Couet
Olivier Culmann
Denis Dailleux
Viviane Dalles
Julien Daniel
William Daniels
Nicolas Datiche
Hélène David
Georges Dayan
Lucie De Barbut
James Keogh
J.Debru
Louis Delavenne
Jerome Delay
Sylvain Deleu
Pascal Della Zuana
Demange-zeppelin
Mathias Depardon
Pierre-Olivier Deschamps
Benedicte Desrus
Eric Dessons
Jean Jérôme Destouches
Agnes Dherbeys
Oliver Douliery
C.Doury
Gwenn Dubourthoumieu
Camille Farges
Philippe Dupuich
Christophe Ena
Alain Ernoult
Romain Etienne
Jean-Eric Fabre
Eric Facon
Cédric Faimali
Julien Falsimagne
Gilles Favier
Olivier Fermariello
Vincent Ferrané
Bruno Fert
Julien Fitte
Corentin Fohlen
Charles Freger
Eric Gaillard
Virginie de Galzani
Guillaume Garvanèse
Bertrand Gaudillère
Beatrice de Gea
Frédéric Girou
Baptiste Giroudon
Pierre Gleizes
Julien Goldstein
Nanda Gonzague
Mathieu Grandjean
Diane Grimonet
Olivier Grunewald
Stanislas Guigui
Jean-Paul Guilloteau
Valery Hache
Eitan Haddok
Bruno Hadjih
Hervé Hamon
Christian Hartmann
Philippe Henry
Guillaume Herbaut
Gerald Holubowicz
Guillaume Horcajuelo
James
Gérard Julien
Christophe Julien
Daniel Karmann
Alain Keler
Michael Kern
Vincent Kessler
Samuel Kirszenbaum
Gregoire Korganow
Olivier Laban-Mattei
Olivier Lacour
Madame Figaro
Francis Latreille
Philippe Laurenson
Stéphane Lavoué
Martin Leers
Hughes Léglise-Bataille
Herve Lequeux
Lewkowicz
Vincent Lignier
Rene Limbourg
Philippe Lissac
Tony Lopez
Pieter-Jan Louis
Lusito
Stephane Mahe
Pierre-Philippe Marcou
Philippe Marini
Francois Xavier Marit
Jean Marmeisse
Benoît Marquet
Alexandre Martin
Valérian Mazataud
Cecile Mella

Pierre Mérimée
Isabelle Merminod
Manuel Meszarovits
Gilles Mingasson
Francois Mori
Alain Mounic
Freddy Muller
Viviane Negrotto
Roberto Neumiller
Stanley Leroux
Sebastien Nogier
Frederic Noy
Rémi Ochlik
Olivier Robin
Aude Osnowycz
Pannetier Julien
Philippe Parent
Pascarel
Christophe Petit-Tesson
Renaud Philippe
Charles Platiau
Frédéric Mery Poplimont
Agathe Poupeney
Philip Poupin
Eric Rechsteiner
Juliette Robert
Franck Robichon
Olivier Roller
Marianne Rosenstiehl
Denis Rouvre
Veronic Roux Voloir
Gilles Sabrie
Frédéric Sautereau
David Sauveur
Fabien Seguin
Jérôme Sessini
Fabrice Soulié
Jeremie Souteyrat
Guillaume Squinazi
Eleonora Strano
Frédéric Stucin
Philippe Taris
Pierre Terdjman
Ambroise Tézenas
Olivier Touron
Eric Travers
Yoan Valat
Eric Vandeville
Véronique de Viguerie
Laurent Weyl
Alain Willaume
Lucas Dolega
Stephan Zaubitzer
Zia Zeff

Georgia
Mariam Amurvelashvili
Levan Kherkheulidze
Marika Kochiashvili
Michael Korkia
Zurab Kurtsikidze
Ketevan Mgebrishvili
Dato Rostomashvili
Mzia Saganelidze
Daro Sulakauri
Niko Tarielashvili

Germany
Achenbach - Pacini
André Lützen
Dirk Anschutz
Ingo Arndt
Bernd Arnold
Frank Augstein
Thorsten Baering
Lajos-Eric Balogh
David Baltzer
Christoph Bangert
Lars Baron
Theodor Barth
Michael Bause
Siegfried Becker
Fabrizio Bensch
Jutta Benzenberg
Guido Bergmann
Toby Binder
Stefan Boness
Maik Bönisch
Wolfgang Borm
Katharina Bosse
Hermann Bredehorst
Matthias Breiter
Hansjürgen Britsch
Dominik Butzmann
Christian Charisius
Dirk Claus
Sven Creutzmann
Marcel Dahm
Peter Dammann
Reinhard Dirscherl
Sven Döring
Christopher Dömges
Winfried Eberhardt
Karl-Heinz Eiferle
Andreas Ellinger
Thomas Ernsting
Hans-Georg Esch

Daniel Etter
Enrico Fabian
Ralf Falbe
Stefan Falke
Rüdiger Fessel
Meike Fischer
Daniel Flaschar
Anke Fleig
Walter Fogel
Kai Peter Försterling
Samantha Franson
Sascha Fromm
Federico Gambarini
Maurizio Gambarini
Dirk Gebhardt
Frank Gehrmann
Guntram Gerst
Thomas Grabka
Ute Grabowsky
Marcel Grafenstein
Jens Grossmann
Gabriel Habermann
Gerald Haenel
Doerthe Hagenguth
Wolfram Hahn
Miguel Hahn
Matthias Hangst
Alfred Harder
Jan-Christoph Hartung
Benjamin Haselberger
Alexander Hassenstein
Julie Hau
Laura Hegewald
Marc Heiligenstein
Katja Heinemann
Kai-Uwe Heinrich
Dirk-Martin Heinzelmann
Katharina Hesse
Karl-Josef Hildenbrand
Benjamin Hiller
Monika Hoefler
Marc Hofer
Helge Holz
Eva Horstick-Schmitt
Sandra Hoyn
Wolfgang Huppertz
Gunther Intelmann
Malte Jäger
P. Jahn
Matthias Jung
Michael Jungblut
Susanne Junker
Kati Jurischka
Iris Kaczmarczyk
Dariusz Kantor
Marcus Kaufhold
Dagmar Kielhorn
Ben Kilb
David Klammer
Christian Klein
Herbert Knosowski
Carsten Koall
Heidi Koch
Hans-Jürgen Koch
Katrin Koenning
Bjorn Eric Kohnen
Michael Kolvenbach
Florian Kopp
Marcus Koppen
Christof Köpsel
Reinhard Krause
Gert Krautbauer
Ralf Krein
Dirk Krüll
Andrea Künzig
Christian Langbehn
Ralph Larmann
Herbert Liedel
Ralf Lienert
Jan Lieske
Ulla Lohmann
Maximilian Ludwig
Francis Malasig
Fabian Matzerath
Oliver Meckes
Andreas Meichsner
Thomas Meinicke
Martin Meissner
Dieter Menne
Jorge Marcel Mettelsiefen
Jens Meyer
Andreas Meyer
Robert Michael
Jörg Modrow
Nathalie Mohadjer
Katharina Mouratidi
Mark Mühlhaus
Cathrin Mueller
Christian Muhrbeck
Hardy Müller
Tim Müller
Florian Müller
Achim Multhaupt
Daniel Naupold
Kai Nedden
Anja Neidringhaus
Renate Niebler

Jens Nieth
Klaus Nigge
Nicole Ottawa
Ingo Otto
Jens Palme
Christoph Papsch
Michael Penner
Laci Perenyi
Thomas P. Peschak
Thomas Peter
Frank Peters
Jan Petersen
Thomas Pflaum
Herbert Piel
Thomas Rabsch
Baz Ratner
Johann Rauchensteiner
Hartmut Reeh
Markus Georg Reintgen
Pascal Amos Rest
Sascha Rheker
Astrid Riecken
Martin Rose
Daniel Rosenthal
Ekkehart Sachse
Stephan Sagurna
Eckart Schoenlau
Helena Schaetzle
Peter Schatz
Detlev Scheerbarth
Tomas Schelp
Nanni Schiffl-Deiler
Frank Schirrmeister
Roberto Schmidt
Oliver Schmieg
Harald Schmitt
Uwe Schober
Martin Schoeller
Andreas Schoelzel
Yvonne Schönherr
Matthias Schrader
Markus Schreiber
Thomas Schreyer
Annette Schreyer
Frank Schultze
Claudius Schulze
Sascha Schürmann
Marcus Schwier
Yvonne Seidel
Felix Seuffert
Markus Shimizu
Luca Siermann
Mona Simon
Patrick Sinkel
Agata Skowronek
Armin Smailovic
Florian Sonntag
Martin Specht
Alexander Spraetz
Andy Spyra
Tomas Stargardter
Sandra Stein
Kurt Steinhausen
Berthold Steinhilber
Björn Steinz
Carsten Stormer
Julian Stratenschulte
Fabian Stratenschulte
Louisa Marie Summer
Stefan Syrowatka
Uwe-S. Tautenhahn
Andreas Teichmann
Karsten Thielker
Geert Vanden Wijngaert
Uwe Weber
Mario Weigt
Oliver Weiken
Ludwig Welnicki
Gordon Welters
Silke Wernet
Kai Wiedenhöfer
Claudia Yvonne Wiens
Carsten Windhorst
Rainer Windhorst
Wim Woeber
Ann-Christine Woehrl
Michael Wolf
Peter Ulrich Zanger
Solvin Zankl
Fabian Zapatka
Sven Zellner
Fara Phoebe Zetzsche
Christian Ziegler
Marcus Zumbansen

Ghana
Emmanuel Quaye

Greece
Kostas Argyris
Dimitris Aspiotis
Yannis Behrakis
Alexandros Beltes
Yiannis Biliris
Evangelos Bougiotis
Jonnek Jonneksson
Giorgos Doganis

Apostolis Domalis
Iason Athanasiadis
Dimitris Galanakis
Vangelis
Nikolaos Giakoumidis
Petros Giannakouris
Angelos Giotopoulos
Louisa Gouliamaki
Iakovos Hatzistavrou
Thanasis Kalliaras
Yiorgos Karahalis
Yiannis Katsaris
Gerasimos Koilakos
Yannis Kolesidis
Alkis Konstantinidis
Yannis Kontos
Chris Kotsiopoulos
Stefanos Kouratzis
Maro Kouri
Costas Lakafossis
Alexandros Lamprovasilis
Yiannis Liakos
Michele A. Macrakis
Vassilis Makris
Kostas Mantziaris
Vasilis Maroukas
Dimitri Mellos
Aris Messinis
Dimitris Michalakis
Stefania Mizara
Panagiotis Moschandreou
Giorgos Moutafis
Giorgos Nissiotis
Ntamplis
Orestis Panagiotou
Myrto Papadopoulos
Konstantinos Paschalis
Nikos Pilos
Vladimir Rys
Fanny Sarri
Elias Staris
Kostas Tsironis
Angelos Tzortzinis
Aris Vafiadakis
Eirini Vourloumis

Guatemala
Jesus Alfonso
Edwin Benavente
Carlos Duarte
Luis Echeverria
Esteban Biba
Daniel LeClair
Sergio Muñoz
Johan Ordonez
Alvaro Yool

Haiti
Douglas Jean
Michou Jolissaint
Fedno Lubin
Daniel Morel

Honduras
Daniel Handal

Hong Kong
Wang Bing
Chan Wai Hing
Chau Wing Yiu Vivian
Leo Cheng
Zhang Chunxiang
Fu Chun Wai
Jinghua He
Chung Ming Ko
Lam Yik Fei
Ted Lee
Leung Cho Yi
Li Pin
Lui Siu Wai
Luo Kanglin
Ho Pak Kei
Huang Songhe
Sun Lanshan
Sunhuajin
Eric Tsang
Paul
Bobby Yip
YIP Hon Wa
Vincent Yu

Hungary
Attila Balazs
Zoltán Balogh
Szabolcs Barakonyi
Cosmicbunuel
Krisztián Bócsi
Sandor Csudai
Gyula Czimbal
Bela Doka
Gabor Dvornik
Erdélyi Gábor
Imre Foldi
Gabor Garamvari
Balazs Gardi
Hajdu Andras
Peter Hapak

Hernad Geza
Peter Kallo
Bea Kallos
Richard Kalocsi
Kerekes M. István
Peter Kohalmi
Peter Kollanyi
Szilard Koszticsak
Tamas Kovacs
Albert Kozak
Abel Krulik
Péter Lakatos
Balazs Lerner
Zoltan Madacsi
Attila Manek
Bence Máté
Mihaly Meszaros
Zoltan Molnar
Aniko Molnar
Balint Porneczi
Tamas Revesz
Zsolt Reviczky
Sánta István Csaba
Tamas Schild
János Schmidt
Segesvari Csaba
Balázs Simonyi
Lajos Soos
Gyula Sopronyi
Akos Stiller
Aron Suveg
Sandor H. Szabo
Peter Szalmas
Bela Szandelszky
Robert Szaniszlo
Lilla Szász
Joe Petersburger
Zsolt Szigetváry
Laszlo Szirtesi
Máté Tóth Ridovics
Balazs Turay
Adam Urban
Valuska Gábor

Iceland
Vilhelm Gunnarsson
Brynjar Gunnarsson
Sigtryggur Johannsson
Ingolfur Juliusson
Rakel Ósk Sigurðardóttir
Christina Simons
Pall Stefansson
Arni Torfason

India
Abhijit Addya
Piyal Adhikary
Ajay Aggarwal
Chandan Ahuja
A. Sarath Kumar
Gemunu Amarasinghe
Channi Anand
Aditya Anupkumar
Ankur Aras
Anand Bakshi
Sundeep Bali
Pritam Bandyopadhyay
Biplab Banerjee
Nilotpal Baruah
Basheer Chambal
Shome Basu
Poulomi Basu
Salil Bera
Kamalendu Bhadra
Piyal Bhattacharjee
Anup Bhattacharya
Biju Boro
Debabrota Biswas
Kishor Kumar Bolar
Ranjan Basu
Rana Chakraborty
Amit Chakravarty
Ch. Vijaya Bhaskar
Puneet Chandhok
Ganesh Chandra
Anindya Chattopadhyay
C Suresh Kumar
K.K. Choudhary
Deshakalyan Chowdhury
Vijayakumar Coimbatore
Arul Horizon
Dar Yasin
Sucheta Das
Sanjit Das
Sudipto Das
Joy Datta
Siddharth Babaji
Rajib De
Mukunda De
Uday Deolekar
Ashok Dhamija
Aniruddhasingh Dinore
Deepak Sharma
Sima Dubey
Suruchi Dumpawar

Nilayan Dutta
Subir Kumar Dutta
Santanu Dutta
Arijit Dutta
Jeevak Nana Gajbhiye
Pattabiraman
Sayatan Ghosh
Sarika Gulati
Sanjay Hadkar
Prakash Hatvalne
G.K. Hegde
Sohrab Hura
Rahul Gajjar
G.N. Jha
Yawar Nazir Kabli
Fayaz Kabli
Sanjay Kanojia
Aditya Kapoor
Sankha Kar
Soumik Kar
Harikrishna Katragadda
Bijumon Kavalloor
Farooq Khan
Praveen Khanna
Pradeep Kocharekar
Ritu Raj Konwar
Dayanand Kukkaje
Vishal Kullarwar
Pawan Kumar
Manoj Chemancheri
SL Shanth Kumar
P. Ravikumar
Ajilal
Zishaan Akbar Latif
Dilip Lokare
Atul Loke
Amit Madheshiya
Samir Madhukar Mohite
BP Maiti
Asish Maitra
Caisii Mao
Rafiq Maqbool
Javed Raja
Indranil Mukherjee
Gnanavel Murugan
Ashwani Nagpal
Rajtilak Naik
Rajen Nair
Suresh Nampoothiri
Showkat Nanda
Anupam Nath
Nathan G.
Sudharak Olwe
Gurinder Osan
Ramionder Pal Singh
P.V. Sunder Rao
Josekutty Panackal
Nagesh Panathale
Shailendra Pandey
Sandeep Pangerkar
Sathish Kumar
Altaf Qadri
Appampalli Radhakrishna
Raghu Rai
Srikanta Sharma R
Ashish Raje
B A Raju
Helena Schaetzle
Nafe Ram Yadav
Rama Madhu Gopal Rao
V. Ganesan
K. Ramesh Babu
G.N.Rao
Nishant Ratnakar
Nilanjan Ray
Sandesh Rokade
Sambit Priya Saha
Adithya Sambamurthy
M. Joy Samuel
Ravikant Sane
Kumar Sanjay
Sajeesh Sankar
Ruby Sarkar
Kausiki
Kayyur Sasi
Arijit Sen
Partha Sarathi Sengupta
KVS Giri
L.R.Shankar
Shantanu Das
Subhash Sharma
Tushar Sharma
Ashish Sharma
Jayanta Shaw
Shirish Shete
Anand Shinde
B. H. Shivakumar
S. Eshwar

Danish Siddiqui
Rajesh Kumar Singh
Dhiraj Singh
Sujan Singh
Rajib Singha
Sanat Kumar Sinha
Ashok Sinha
Anshuman Poyrekar
Shekhar Soni
Chetan Soni
R.R. Srinivasan
Anantha Subramanyam.K.
Manish Swarup
Sameer Tawde
Rohit Umrao
Ritesh R. Uttamchandani
Mthimaran
Alabhya Vaibhav
Manan Vatsyayana
Ajay Verma
Vinoth V
Robert Vinod
Keshav Vitla
Chirag Dilip Wakaskar
Danish Ismail

Indonesia
Andika Betha
Sutanta Aditya
Hero Aditya
Afriadi Hikmal
Yuniadhi Agung
Dita Alangkara
Slamet Riyadi
Allan Arthur
Binsar Bakkara
Agung Kuncahya B.
Beawiharta
Sumaryanto Bronto
Rian Afriadi
Ramdani
Johannes P. Christo
Dody Ido D
Dedy Sinuhaji
Nebula Defrien
Budi Dharmawan
Surya Efendi
Mohammad Hilmi Faiq
Iggoy el Fitra
Iwan
Junaidi Gandy
Akbar Gumay
D.P. Gunadi
Gigih M. Hanafi
Jongki Handianto
Michael Eko Hardianto
Boy T Harjanto
Tony Hartawan
Tarmizy Harva
Y.T Haryono
Raditya Helabumi
Ally
Ulet Ifansasti
Fauzan Ijazah
Mast Irham
Bay Ismoyo
Raditya Jati
Heri Juanda
Kemal Jufri
Feri Latief
P.J. Leo
Ali Lutfi
Yudhi Mahatma
Raditya Mahendra Yasa
Doni Maulistya
Prima Mulia
Irsan Mulyadi
Bayu G Murti
Mike Eng Naftali
Chalid Nasution
Yusnadi Nazar
Eka Nickmatulhuda
Gembong Nusantara
Fanny Octavianus
Crack Palinggi
Pang Hway Sheng
Rosa Panggabean
Ismar Patrizki
Yoppy Pieter
Arief Bagus
Peksi Cahyo
Boby Matanesia
Rommy Pujianto
Adam Dwi Putra
Ardiles Rante
Ferganata Indra Riatmoko
Aman Rahman
Andrea
Roy Rubianto
Toto Santiko Budi
Dwi Oblo
Sandi Jaya Saputra
Yuli Seperi
Septiawan
Hari Setianto
Ade Dani
Antonius Riva S.

Oscar Siagian
Yap Siauw Soen Gie
Simanjuntak Hotli
Fransiskus P Simbolon
Sihol Sitanggang
Slamet
Ogi Soedja
Tarko Sudiarno
Arief Suhardiman
Dedhez Anggara
Dadang Tri
Trisnadi
Donang Wahyu
Petra Wangsadihardja
Arif Wibowo
Nugroho Widagdo
Andika Wahyu
Adek Berry
Totok Wijayanto
Rony Zakaria

Iran
Golnaz Beheshti
Mehdi
Aslon Arfa
Alireza Attariani
Mohammad Babaei
Kaveh Baghdadchi
Javad Erfanian
Aalimanesh
Sara Estiri
Mirhossein Fatemi
Marjan Foroughi
Mohammad Ghadamali
Ali Ghalamsiah
Mohammad Golchin Kohi
Reza Golchin Kohi
Seyed Hossien Hadeaghi
Elaheh
Abdolrahman
Abdollah Heidari
Mahdi Jafari
Vajihe Jafari
Mehri Jamshidi
Farzaneh Khademian
Amir Hossein Khorgooei
Katayoun Massoudi
Ali Mehrabi
Sima Mehrazar
Behrouz Mehri
Ahmad Moenijam
Mehdi Monem
Mansoreh Motamedi
Sara Ahmadi Najaf Abadi
M. Nikoubazl-e Motlagh
Javid
Morteza Noormohammadi
Ebrahim Noroozi
Roshan Norouzi
Omid Omidvari
Amir Masoud Oskouilar
Javad M.Parsa
Masood
Aydin
Maryam Rahmanian
Mohammad Rezaee
Kaveh Rostamkhani
Payam Rouhani
Majid
Sajjad Safari
Hosein Saki
Niloofar Sanandjizadeh
Babak Sedighi
Ali Akbar Shirjian
Mahmoudi Soleyman
Javid Tafazoli
Mohamad Tajik
Sahar
Shahrnaz Zarkesh

Iraq
Ali Al-Kalid Yseen
Hassan Ammar
Ali Haider
Raheb Homavandi

Ireland
Carlos Benlayo
Laurence Boland
Desmond Boylan
Deirdre Brennan
Matthew Browne
Cyril Byrne
Arthur Carron
Michael Chester
Mark Condren
Aidan Crawley
Barry Cregg
Kieran Doherty
Michael Donald
Denis Doyle
Brenda Fitzsimons
David O'Flynn
Joe Fox
Kieran Galvin
David Gannon
Noel Gavin

Reg Gordon
Diarmuid Greene
Kim Haughton
Don McNeill Healy
Keith Heneghan
James Horan
Steve Humphreys
John C Kelly
Chris Kelly
Brian Lawless
Colm Lenaghan
Dan Linehan
Eric Luke
Dara Mac Dónaill
David Maher
Liam McBurney
Stephen McCarthy
Andrew McConnell
Ross McDonnell
John D McHugh
Ian McIlgorm
Ray McManus
Cathal McNaughton
Charles McQuillan
Adrian Melia
Frank Miller
Denis Minihane
Paul Mohan
Brendan Moran
Richard Mosse
Seamus Murphy
Pat Murphy
Mick O'Neill
Jeremy Nicholl
Kenneth O'Halloran
Joe O'Shaughnessy
Valerie O'Sullivan
Fergal Phillips
Ivor Prickett
Dave Ruffles
Ray Ryan
David Sleator
Morgan Treacy
Fran Veale
Domnick Walsh
Eamon Ward

Israel
Nir Alon
Miki Alon
Oded Balilty
Dan Balilty
Daniel Bar-on
Rafael Ben-Ari
Rina Castelnuovo
Gil Cohen Magen
Yori Costa
Natan Dvir
Dror Einav
Kobi Eliyahu
Michal Fattal
Eddie Gerald
Kobi Gideon
Meged Gozani
Amnon Gutman
Tomer Ifrah
Gilad Kavalerchik
Julia Komissaroff
Ziv Koren
Yoray Liberman
Amit Magal
Shay Mehalel
Moti Milrod
Lior Mizrahi
Nadav Neuhaus
Jorge Novominsky
Lior Patel
Atef Safadi
Ariel Schalit
Shaul Schwarz
Marc Israel Sellem
Ahikam Seri
Amit Sha'al
Amit Shabi
Alicia Shahaf
Nati Shohat
János
Uriel Sinai
Abir Sultan
Matanya Tausig
Daniel Tchetchik
Yuval Tebol
Gali Tibbon
David Vaaknin
Eyal Warshavsky
Pavel Wolberg
Kobi Wolf
Gili Yaari
Ilia Yefimovich
Yehoshua Yosef
Oren Ziv
Haim Ziv
Eli Zuta
Ronen Zvulun

Italy
Francesco Acerbis
Edoardo Agresti

Alessandro Albert
Gilda Louise Aloisi
Vito Amodio
Fabrizio Annibali
l'Angeloviaggiatore
Matteo Armellini
Roberto Armocida
Giampiero Assumma
Giovanni Attalmi
Michele Audisio
Tommaso Ausili
Fabiano Avancini
Martina Bacigalupo
Daniele Badolato
Diana Bagnoli
Roberto Baldassarre
Isabella Balena
Alessandro Belgiojoso
Andrea Erdna Barletta
Marco Baroncini
Andrea Barro
Nino Bartuccio
Massimo Bassano
Matteo Bastianelli
Pavlove der Visionaer
Salvatore Bello
Cristiano Bendinelli
Antonio Bergamino
Massimo Berruti
Carlo Bevilacqua
Alfredo Bini
Valerio Bispuri
Silvia Boarini
Roberto Boccaccino
Mjrka Boensch Bees
Paolo Bona
Tommaso Bonaventura
Marcello Bonfanti
Roberto Bongiorni
Federico Borella
Ugo Lucio Borga
Alberto Bortoluzzi
Michele Borzoni
Marco Bottelli
Susetta Bozzi
Roberto Brancolini
Alessandro Brasile
Giovanni Del Brenna
Leonardo Brogioni
Giacomo Brunelli
Daniele Brunetti
Luca Bruno
Grazia Bucca
Talos Buccellati
Fabio Bucciarelli
Mario Bucolo
Ms Monika Bulaj
Marco Bulgarelli
Patrizia Burra
Alberto Buzzola
Roberto Caccuri
Jean-Marc Caimi
Guy Calaf
Eleonora Calvelli
Giuliano Camarda
Andrea Camatta
Giulia Candussi
Francesca Cao
Federico Caponi
Franco Carlisi
Giuseppe Carotenuto
Davide Casella
Samantha Casolari
Eduardo Castaldo
Adriano Castelli
Luca Catalano Gonzaga
Luigi Caterino
Andrea Cattano
Gianluca Cecere
Paolo Cenciarelli
Chiara Ceolin
Luca Cepparo
Carlo Cerchioli
Simone Cerio
Daniel Chellini
János
Francesco Chiorazzi
Lara Ciarabellini
Cesare A. Cicardini
Alessandro Ciccarelli
A. Cicchini
Tiziana Cini
Giordano Cipriani
Gianni Cipriano
Pier Paolo Cito
Massimiliano Clausi
Noris Cocci
Giovanni Cocco
Giorgio Coen Cagli
Maurizio Cogliandro
Nadia Shira Cohen
Elio Colavolpe
Antonino Condorelli
Mauro Consilvio
Mauro Corinti
Matt Corner
Marilisa Cosello

Alessandro Cosmelli
Davide Cossu
Lidia Costantini
Giorgio Cosulich
Alfredo Covino
Massimo Cristaldi
Christian Cristoforetti
Marco Cristofori
Pietro Cuccia
Pierfranco Cuccuru
Laura Cusano
Fabio Cuttica
Stefano D' Amadio
Alfredo D'Amato
Cinzia D'Ambrosi
Marco D'Antonio
Alessandra d'Urso
Daniele Dainelli
Stefano Dal Pozzolo
Daniel Dal Zennaro
Fabrice Dall'Anese
Andrea Dapueto
Abramo De Licio
Nicolò Degiorgis
Luciano Del Castillo
Gibigiana
Edoardo Delille
Luca Desienna
Pietro Di Giambattista
Marco Di Lauro
Giulio Di Sturco
Giovanni Diffidenti
Nikka Dimroci
Simone Donati
Marco Dormino
Salvatore Esposito
Alfredo Falvo
Giuseppe 'Pino' Fama
Mario Farinato
Luca Ferrari
Linda Ferrari
Fabio Fiorani
Carmine Flamminio
Vincenzo Floramo
Simone Florena
Ventura Formicone
Astrid Fornetti
Luca Forno
Adolfo Franzò
Flaviana Frascogna
Andrea Frazzetta
Gabriele Galimberti
Alessandro Gandolfi
Lucia Gardin
Alessandro Garofalo
Guido Gazzill
Stephanie Gengotti
Enrico Genovesi
Simona Ghizzoni
Carlo Gianferro
Marco Giani
Antonio Gibotta
Lorenzo Giglio
Stefano Giogli
Gianni Giosue
Fabrizio Giraldi
Pino Rampolla
Francesco Giusti
Elena Givone
Chiara Goia
Matteo Gozzi
Stefano De Grandis
Paola de Grenet
Mads Greve
Eugenio Grosso
Marco Gualazzini
Gianluigi Guercia
Stefano Guindani
Daniele Gussago
Edoardo Hahn
Alessandro Imbriaco
Marina Imperi
Mattia Insolera
Luca Kleve-Ruud
Giuliano Koren
Licio La Rocca
Maila Lacovelli
Emanuele Lami
Mario Laporta
Salvatore Laporta
Emiliano Larizza
Francesco Lastrucci
Gino Lazzarin
Alessandro Lazzarin
Francesca Leonardi
Alessia Leonello
Laura Liverani
Nicola Lo Calzo
Luca Locatelli
Stefano De Luigi
Guillermo Luna
Lorenzo Maccotta
Isabella De Maddalena
Gianfranco Maggio
Giorgio Magistrelli
Alessandro Majoli
Ettore Malanca

Livio Mancini
Beatrice Mancini
Emiliano Mancuso
Katiamang
Romina Marani
Manuel Marano
Paolo Marchetti
Claudio Marcozzi
Federico Mariani
Giovanni Marino
Giovanni Marrozzini
Cesare Martucci
Enrico Mascheroni
Bob Masi
Massimo Mastrorillo
Pietro Masturzo
Daniele Mattioli
Antonio Mazzarella
Antonello Mazzei
Myriam Meloni
Giovanni Mereghetti
Gabriele Micalizzi
Sara Minelli
MiniCri
Chiara Mirelli
Giovanni Miserocchi
Marina Misiti
Pierpaolo Mittica
Giuseppe Moccia
Laura Montanari
Guido Montani
Davide Monteleone
Antonella Monzoni
Vittorio Morelli
Alberto Moretti
Walter Moretti
Michele Morosi
Lorenzo Moscia
Pietro Motisi
Franco Mottura
Sara Munari
Gianfranco Mura
Gianni Muratore
Filippo Mutani
Giulio Napolitano
Luca Nizzoli Toetti
Francesco Nonnoi
Antonello Nusca
Gianluca Oppo
Dario Orlandi
Giorgio Palmera
Danilo Palmisano
Graziano Panfili
Pietro Paolini
Massimo Paolone
Edoardo Pasero
Paolo Patrizi
Stefano G. Pavesi
Samuele Pellecchia
Paolo Pellizzari
Alessandro Penso
Carlo Perazzolo
Luciano Perbellini
Viviana Peretti Legramante
Michele Pero
Simone Perolari
Giorgio Perottino
Stefano Pesarelli
Paolo Petrignani
Christian Piana
Dario Picardi
Alessia Pierdomenico
Marco Pighin
Emiliano Pinnizzotto
Pamela Pioli
Giuseppe Pipita
Giulio Piscitelli
Paolo Poce
Antonio Politano
Francesca Pompei
Piero Pomponi
Paolo Porto
Giovanni Presutti
Ilaria Prili
Rino Pucci
Marika Puicher
Gianluca Pulcini
Maike Pullo
Ciro Quaranta
Jacopo Querci
Valentina Quintano
Marco Raccichini
Tommaso Rada
Sergio Ramazzotti
Stefano Rellandini
Letizia Reynaud
Marco Rigamonti
Lillo Rizzo
Andy Rocchelli
Renata Romagnoli
Filippo Romano
Rocco Rorandelli
Rossi Damiano
Luca Ruberti
Attilio Ruffo
Patrick Russo
Andrea Sabbadini

Francesco Dal Sacco
Ivo Saglietti
Giuseppe Salerno
Roberto Salomone
Rafael Salvatore
Luca Santese
Christian Santi
Adriana Sapone
Giulio Sarchiola
Giuseppe Giulio Sboarina
Luca Scabbìa
Claudio Schiacca
Stefano Schirato
Massimo Sciacca
Marcello Scopelliti
Federico Scoppa
Marco Secchi
Tonino Sgrò
Shobha
Christian Sinibaldi
Tano Siracusa
Massimo Siragusa
Smaldore Nicola
Luca Sola
Aldo Soligno
Luca Spano
Mauro Spanu
Gabriele Stabile
Alessandro Stellari
Marco Stoppato
Mario Taddeo
Daniele Tamagni
Bruno Tamiozzo
Alessandra Tarantino
Giuseppe Tassitano
Christian Tasso
Luigi Tazzari
E. Tidona
Silvia Tofani
Naoki Tomasini
Alessandra Tommei
Capitanbaldino
Gianfranco Tripodo
Serena Tulli
Nicola Ughi
Giuseppe Ungari
Stefano Unterthiner
Albertina d' Urso
Mattia Vacca
Federica Valabrega
Clara Vannucci
Cristina Vatielli
Alessandro Veca
Mattia Velati
Daniele Veneri
Elisa Venturelli
Riccardo Venturi
Marco Vernaschi
Paolo Verzone
Fabrizio Villa
Laura Villani
Alessandro Vincenzi
Valerio Vincenzo
Daniele Vita
Antonio Zambardino
Marco Maria Zanin
Barbara Zanon
Bruno Zanzottera
Elisabetta Zavoli
Fabio Zayed
Antonia Zennaro
Massimo Cesare Zingardi
Francesco Zizola
Dana de Luca
Mattia Zoppellaro
Paola Zorzi
Vittorio Zunino Celotto

Jamaica
Jermaine Barnaby
Norman Grindley
Makyn
Andrew P. Smith

Japan
Noriyuki Aida
Tetsuya Akiyama
Kazuyoshi Ehara
Robert Gilhooly
Masaru Goto
Toru Hanai
Chieko Hara
Yusuke Harada
Yoshi Haruyama
Naohiko Hatta
Noriko Hayashi
Yuichi Hibi
Wakako Iguchi
Itsuo Inouye
Kei Nagayoshi
Daisuke Ito
Tomonori Iwanami
Aika Kanou
Keisuke Kato
Naoko Kawamura
Yoshiki Kitaoka
Shigetaka Kodama

Koide Yohei
Yusuke Komatsu
Soichiro Koriyama
Toyokazu Kosugi
Dai Kurokawa
Ikuru Kuwajima
Naoki Maeda
Hiroko Masuike
Yuzo Uda
Tsuyoshi Matsumoto
Kazuhiko Matsumura
Fumiko Matsuyama
Dora
Shigeki Miyajima
Toru Morimoto
Koji Muto
Keisuke Nagoshi
Takuma Nakamura
Motoya Nakamura
Tomofumi Nakano
Tatewaki Nio
Shiro Nishihata
TJ
Takeshi Ogura
Yusuke Okada
Kosuke Okahara
Shinobu Onodera
Yasuo Ota
Takashi Ozaki
Q. Sakamaki
Kei Sato
Shuzo Shikano
Hloto Skiguchi
Akira Suemori
Dai Sugano
Ryuzo Suzuki
Michi Suzuki
Takagi Tadatomo
Kuni Takahashi
Satoshi Takahashi
Atsushi Taketazu
Piko
Terazawa Masayuki
Tetsuya Higashikawa
Takeshi Tokitsu
Umemura Naotsune
Yoichi Watanabe
Takaaki Yagisawa
Shin Yahiro
Gen Yamaguchi
Kazuhiko Yamashita
Hiroshi Yamauchi
Kazuhiro Yokozeki

Jordan
Ammar Awad
Tanya Habjouqa
Salah Malkawi
Jamal Nasrallah
Mohamed A.A. Salamah

Kazakhstan
Grigoriy Bedenko
Dmitriy Kuzmichev
Aziz Mamirov
Vladimir Sheshukov
Vladimir Zaikin

Kenya
Eric Bosire
Tobin Jones
Antony Kaminju
Stephen Mudiari
Mbugua
Charles Kimani
Tom Maruko
Thomas Mukoya
David Mutua
Boniface Mwangi
Thomas Omondi
Boniface Okendo Otieno
Stafford Ondego
Jennifer Muiruri

Kosovo
Laura Boushnak

Kuwait
Bahaadeen M. Al Qazwini

Kyrgyzstan
Arthur Boljurov
Igor Kovalenko

Latvia
Valdis Brauns
Reinis Hofmanis
Sergej Samulenkov
Andrei Shapran
Alnis Stakle

Lebanon
Mustafa Elakhal
Bilal Jawich
Haytham Moussawi
Marwan Tahtah

Liechtenstein
Peter Klaunzer

Lithuania
Joey Abrait
A. Algimantas
Vidmantas Balkunas
Robertas Dackus
Ramunas Danisevicius
Vladimiras Ivanovas
Kazimieras Linkevicius
Herkus Milasevicius
Romualdas Vaitkus

Luxembourg
Claude Diderich

Macedonia
Tomislav Georgiev

Madagascar
Riana Randrianarisoa

Malawi
Amos Gumulira
Emmanuel Simpokolwe

Malaysia
Syahrin Aziz
Azman Ghani
Tan Chee Hon
Tim Chong
Stefen Chow
Lee Geok Cheng
Glenn Guan
Bob Lee Keng Siang
James Tseu
Lai Seng Sin
Lee Chee Keong
Suzanne Lee
Shang Leo
Jeffry Lim Chee Yong
Ahmad Y. Mohammad Said
Bazuki Muhammad
Pan Kah Vee
Azhar A Rahim
Rahman Roslan
Aizuddin Saad
Samsul Said
Mazlan Samion
Kamal Sellehuddin
Art Chen
Sang Tan
Tan Ee Long
Teoh Jit Khiam
FL Wong
Marcus Yam
Yau Choon Hiam
Yang Zixiong

Malta
Domenic Aquilina
Stephen Busuttil
Matthew Mirabelli
Reuben Piscopo
Darrin Zammit Lupi

Mauritius
George Michel
Bouck Pillay
Ally Soobye

Mexico
Octavio Aburto
Alejandro Acosta
Daniel Aguilar
Julio C. Aguilar
Raul Aguilar Sibaja
Jesus Alcazar
Enrique Alvarez del Castillo
Jorge Carlos Alvarez Diaz
Guillermo Arias
Armando Arorizo
Daniel "Lupeto"
Jesus Ballesteros
Vidal Berrones Murillo
Tomas Bravo
Fernando Brito
Hebert Camacho
Germán Canseco
Fer Carranza
Carlos Cazalis
Rafael del Rio
Danilo Amilcar
Alejandro Cossío Borboa
Juan Carlos Cruz
Rodrigo Cruz
Agustín Cuevas
Jorge Dueñes
Yolanda Escobar
Isaac Esquivel
Carlos Figueroa Ramírez
Gerardo Flores
Alex Espinosa
Gonzalo Fuentes
José Luis Salmerón
Susana Gonzalez

Mónica González
Claudia Guadarrama
Fernando Gutiérrez-Juárez
Guillermo Perea
G. D. De Huerta Patiño
Rodrigo Jardon
Jose Manuel Jiménez
Alejandro Juarez
Miguel Juarez
Israel Leal
G. Arturo Limon D.
Angel Llamas
Raul Lodoza
Jorge Dan Lopez
Giorgio Viera
Luis Cortes
Jose Luis Magana
R. Maldonado Garduno
Mayra Martell
Imelda Medina
David de la Paz
Gilberto Meza
Carlos Milanés
Alberto Millares
Bernardo Montoya
Jesus Montoya
Elizabeth Moreno
Joel Merino
Margarito Perez Retana
Luis Quiroz
Fernando Ramírez Novoa
Pablo Ramos García
Arturo Ramos Guerrero
James Rodriguez
Cristopher Rogel
Pablo Salazar Solis
Ricardo Vargas
Oswaldo Ramirez
Antonio Sierra
Diego R. Sierra Moreno
Ariel Silva
Christian Torres
Luis Torres Ruiz
Miguel Tovar
Jesus Garcia Trigo
Marco Urgante
Federico Vargas Somoza
Irving Villegas
Adam Wiseman
Antonio Zazueta Olmos

Mongolia
Rentsendorj

Montenegro
Bojan Mihajlovic

Mozambique
Mario Macilau
Joel Chiziane
Carlos Litulo
Antonio Muchave

Myanmar (Burma)
Nyein Chan Naing
GiGi

Nepal
Nabin Baral
Bijay
Bijay Gajmer
Bimal Gautam
Rajesh Gurung
Sailendra Kharel
Bhaswor Ojha
Bibi Funyal
Kishor K. Sharma
Naresh Shrestha
Prasant Shrestha
Narenda Shrestha
Bal Krishna Thapa

Netherlands Antilles
Gromyko Wilson

The Netherlands
Marc van der Aa
Marijn Alders
Jaap Arriens
Michael Ballak
Jan Banning
Amit Bar
Gerlo Beernink
Marcel van den Bergh
Hugo Bes
Chris de Bode
M.K. Boersema
Marjan Borsjes
Theo Bosboom
Henk Bothof
Joost van den Broek
Dominique Brozek
Gitta van Buuren
Rachel Corner
Sanne Couprie
Roger Cremers
Helen de Vries

Max Dereta
Joep Derksen
Marten van Dijl
Rogér van Domburg
Kjeld Duits
Mathilde Dusol
Taco van der Eb
Karoly Effenberger
Ilse Frech
Lucia Ganieva
Maartje Geels
Annie van Gemert
Brian George
Mathilde Groenveld
Olaf Hartong
Chantal Heijnen
Roderik Henderson
Ton Hendriks
Sarah Mei Herman
Piet Hermans
Maaike Hermes
Thijs Heslenfeld
Gerrit de Heus
Harry Heuts
Erik Hijweege
Mathilde Hoekstra
Dick Hogewoning
Ronald de Hommel
Pieter ten Hoopen
Hans Hordijk
Rob Hornstra
Jeroen Jansen
Saad Jasim
Jasper Juinen
Jeroen Jumelet
Hendrik Kerstens
Chris Keulen
Arie Kievit
Paulien Kluver
Ton Koene
Hans Kreutzer
Co de Kruijf
John Lambrichts
Jerry Lampen
Gé-Jan van Leeuwen
Floris Leeuwenberg
Suzanne Liem
Kadir van Lohuizen
Fulco Lorenzo
Bas Losekoot
Emile Luider
Marrigje de Maar
Bas de Meijer
Vincent Mentzel
Lucienne Van der Mijle
Frank Muller
Vesselina Nikolaeva
Steven van Noort
Eppo Wim Notenboom
Jeroen Oerlemans
Marco Okhuizen
Erik-Jan Ouwerkerk
Mardoe Painter
Liepke Plancke
Daphne Plomp
Willem Poelstra
Patrick Post
Pavel Prokopchik
Stephan Raaijmakers
Pim Ras
Arnold Reyneveld
Paul van Riel
Elske Riemersma
Martin Roemers
Albert Roosenburg
Michiel de Ruiter
Marja Scholten
Roderick Lloyd
Nicole Segers
Ruben Smit
Corné Sparidaens
Friso Spoelstra
Mark van der Zouw
Corné van der Stelt
Jan-Joseph Stok
Larissa Strating
Yee Ling Tang
Roy Tee
Andreas Terlaak
Marie Cécile Thijs
Ruben Timman
Jeroen Toirkens
Su Tomesen
Frank Trimbos
Monne Tuinhout
Marielle van Uitert
Bas Uterwijk
Robin Utrecht
Kees van de Veen
Marieke van der Velden
Anoushka van Velzen
Anne-Marie Vermaat
Jan Vermeer
Dirk-Jan Visser
Teun Voeten
Vincent de Vries
Richard Wareham

Koen van Weel
Eddy van Wessel
Emily Wiessner
Sander F de Wilde
Robert van Willigenburg
Edwin Winkels
Daimon Xanthopoulos
Mark van der Zouw

New Zealand
Martyn Aim
Mark Baker
Scott Barbour
Kent Blechynden
Greg Bowker
Mr Andrew Cornaga
Braden Fastier
Robin Hammond
Joe Harrison
Alan Knowles
Babiche Martens
Iain McGregor
Mike Millett
Brett Phibbs
Dean Purcell
Phil Reid
Richard Robinson
Martin de Ruyter
Natalie Slade
Jason Paul South
Paul Thomas
Dean Treml

Nicaragua
Esteban Felix
Oswaldo Rivas

Nigeria
Immanuel Afolabi
Sunday Aghaeze
Ademola Akinlabi
Akintunde Akinleye
Will
Babasola Bamiro
Kingston O. Daniel
Pius Utomi Ekpei
Andrew Esiebo
Nnamdi Charles Ijiomah
Nkemakonam
Emeke Obanor
Tony Afam Onwuemene
Opara Adolphus
Muyiwa Osifuye
Tom Saater
Nwankpa Chijioke Samuel
Zamwawosai Tarachi
Julius Umogbai

Norway
Paul S. Amundsen
Paal Audestad
Jon-Are Berg-Jacobsen
Tom Henning Bratlie
Tonje Eliasson
Tommy Ellingsen
L. Bournane Engelberth
André Liohn
Johnny Haglund
Pal Christopher Hansen
Thomas Haugersveen
Pål Hermansen
Kristian Jacobsen
Jan Johannessen
Adrian Øhrn Johansen
Sigurd Fandango
Hilde Mesics Kleven
Otto von Münchow
Eivind H. Natvig
Fredrik Naumann
Aleksander Nordahl
Kristine Nyborg
Kim Nygård
Ken Opprann
Espen Rasmussen
Espen Røst
Rune Saevig
Siv Johanne Seglem
Terje Sorgjerd
Jo Straube
Solve Sundsbo
Trond Soras
Signe Christine Urdal
Lars Idar Waage
Sveinung Ystad

Pakistan
Naveed Ali
Arshad Arbab
Arshad Butt
Waheed Khan
Shabbir Hussien Imam
Hussain Jan
Arif Mahmood
Ijaz Mohammed
Nasiruddin Mughal
Rizwan Saeed
Mohammed Sajjad

Akhtar Soomro
Asim Tanveer

Palestinian Territories
Ibraheem Abu Mustafa
Mahfouz Abu Turk
Abed Al Hashlamoun
Fadi Arouri
Muhammed Muheisen
Ali Nureldine
Yasser Fatehi
Suhaib Salem
Mohammed Salem
Osama Silwadi
Mohamad Torokman

Panama
Alexander Arosemena
Eric Batista
Davis Mesa
Essdras M Suarez

Peru
Eitan Abramovich
Pedro acosta
Gladys Alvarado Jourde
Jorge Armestar M.
Mariana Bazo
Manuel Berrios
Daniel Caceres
Sebastian Castaneda
Ana M. Castañeda
Omar Lucas
Rafael Cornejo V.
Ricardo
Carlos Garcia Granthon
Marco Garro
Ana Cecilia Gonzales-Vigil
Silvia Izquierdo
César Fajardo
Alfredo Velarde
Martin Mejia
Vanessa Montero
Miriam P. Moreno Serpa
J. C. Guzmàn Negrini
Lenin Nolly
Musuk Nolte
Martin Pauca
Jair Ramirez
G. San Miguel Carrasco
Leslie Searles
Luis Sergio
Giancarlo Shibayama
Daniel Silva Yoshisato
Manuel Milko
Gihan Tubbeh
Carlos Vargas
Jose Vidal Jordan

The Philippines
Jes Aznar
Mark Balmores
Maciej Biedrzycki
Estan Cabigas
Hersley Casero
Noel Celis
KC Cruz
Tammy David
Roland dela Pena
Linus Guardian Escandor II
Aaron Favila
Romeo Gacad
Hadrian N. Hernandez
Victor Kintanar
Bullit Marquez
Kat Palasi
Bj. A. Patino
KJ Rosales
Dennis Sabangan
Luis Sinco
Gigie Cruz
Michael D Varcas
Aaron R. Vicencio
Ali Vicoy
VJ Villafranca
Chari Villegas

Poland
Peter Andrews
Agnieszka Arlukiewicz
Dorota Awiorko-Klimek
Pawel Bachanowski
Pawel Bajerski
Krzysztof Baranowski
Marek M. Berezowski
Krystian Bielatowicz
Marcin Bielecki
Bartosz Bobkowski
Wojciech Borkowski
Jan Brykczynski
Katarzyna Ceglowska
Davido Chalimoniuk
Roman Chelmowski
Filip Cwik
Kuba Dabrowski
Maciej Dakowicz
Dariusz Delmanowicz

Grzegorz Dembinski
Tomasz Desperak
Marcin Dobas
Natalia Dobryszycka
Irek Dorozanski
Slawoj Dubiel
Aleksander Duraj
Piotr Dyba
Artur Fizyczak
Dominik Gajda
Grzegorz Galezia
Lukasz Gdak
Lukasz Glowala
Arkadiusz Gola
Dominik Golenia
Michal Grocholski
Wojciech Grzedzinski
Tomasz Grzyb
Piotr Grzybowski
Tomasz Gudzowaty
Rafal Guz
Michal Gwozdzik
Christopher Gretkus
Przemyslaw Jendroska
Maciej Jeziorek
Tomasz Jodlowski
Maciej Kaczanowski
Jakub Kaminski
Mariusz Kapala
Patryk Karbowski
Maciej Kielbowicz
Tech.Ks
Grzegorz Klatka
Filip Klimaszewski
Monika Kokoszynska
Grzegorz Komar
Tytus Kondracki
Grzegorz Kosmala
Roman Koszowski
Kacper Kowalski
Agata Kozicka
Hesja
Damian Kramski
Witold Krassowski
Przemek K
Bartlomiej Kudowicz
Maciej Kujawa
Adam Lach
Pawel Laczny
Arkadiusz Lawrywianiec
Anna Lewanska
Marcin Lobaczewski
Michal Luczak
Aga Luczakowska
Aleksander Majdanski
Grazyna Makara
Katarzyna Mala
Piotr Malecki
Bogumila Maleszewska
Rafal Malko
Boguslaw Maslak
Pawel Matyka
Franciszek Mazur
Rafal Michalowski
Justyna Mielnikiewicz
Rafal Milach
Grzegorz Momot
Robert Mordal
Wojtek Moskwa
Maciek Nabrdalik
Borys Niespielak
Piotr Nowak
Rafal Nowakowski
Jakub Ochnio
Jakub Ociepa
Wojciech Oksztol
Slawomir Olzacki
Zbigniew Osiowy
Marek Paluch
Adam Panczuk
Krzysztof Patrycy
Janczaruk Pawel
Mieczyslaw Pawlowicz
Lukasz Pienkowski
Agata Pietron
Robert Pipala
Dominik Pisarek
Maciej Pisuk
Piotr Piwowarski
Przemyslaw P. Pokrycki
Ryszard Poprawski
Tomasz Raczynski
Artur Radecki
Agnieszka Rayss
Piotr Redinski
Maksymilian Rigamonti
Grzegorz Roginski
Jocher Roman
Kuba Rubaj
Olgierd Rudak
Bartek Sadowski
Mateusz Sarello
Rafal Siderski
Maciej Skawinski
Mateusz Skwarczek
Tobiasz Skwarzynski
Julian Sojka

Lukasz Sokol
Mariusz Soroka
Waldemar Sosnowski
Adam Stepien
Mikolaj Suchan
Lukasz Szelemej
Andrzej Szkocki
Michal Szlaga
Natalia Szulc
Tomasz Szustek
Jacek Szydlowski
Maciej Gadek
Mateusz Torbus
Lukasz Trzcinski
Adam Tuchlinski
Vado
Lukasz Warzecha
Grzegorz Welnicki
Zdzislaw Wichlacz
Tomasz Wiech
Andrzej Wiktor
Rafal Witczak
Tomasz Wozny
Bartek Wrzesniowski
Marek Zakrzewski
Wiktor Zakrzewski
Albert Zawada
Lukasz Zielonka
Grzegorz Ziemianski
Marek Zmudzki
Marta Zubrzycka

Portugal
Nelson d'Aires
Ricardo Almeida
Luis Barbosa
Schwantz
Carlos Barroso
Júlio Barulho
Rodrigo Cabrita
Mário Caldeira
Paulo Duarte
José Carlos Carvalho
Bruno Colaço
Luis António Costa Rosário
Rui Miguel Cunha
Paulo Cunha
Gregorio Cunha
Joaquim Dâmaso
Pedro Elias
Elisabete Farinha
Nuno Ferreira Santos
Jorge Firmino
Joao F. Gaspar de Jesus
Nuno Gonçalves
Ricardo Graça
Luís Guerreiro
Pedro Noel da Luz
Miguel Barreira
Artur Machado
Tiago Machado
João Mariano
João Pedro Marnoto
Marcos Borga
Ana Brígida
Paulo Nunes dos Santos
Carlos Palma
Octavio Passos
Jorge Monteiro
Tiago Petinga
João Pina
João Silva Pinto
Ines Querido
Luís Ramos
Hugo Joel
Miguel Ribeiro Fernandes
António Rilo
Luís Rocha Graça
Gonçalo Rosa da Silva
Duarte Sá
Carlos Costa
Paulo Escoto
Francisco Pedro
Teixeira Alvaro
Raquel Wise

Puerto Rico
Xavier J. Araujo
José Jiménez Tirado
Ramón Tonito Zayas

Romania
Anghel-Alexandru Ionescu
Remus Nicolae Badea
Daniel Baltat
Mihai Barbu
Emese Benko
Horia Calaceanu
Petrut Calinescu
Andreea Campeanu
Leonard Chioveanu
Andrei Ciocarlan
Octavian Cocolos
Bogdan Cristel
Bogdan Danescu
Simona Barbu
Florin Gabor

Octav Ganea
Robert Ghement
Vlad Gherman
Vadim Ghirda
Henning Janos
Dorothea Kettler
Kristo Robert
Laurentiu Nica
Lucian Mihai
Nagy Melinda
Ovidiu Micsik
Daniel Mihailescu
Andrei Alex. Moise
Cosmin Motei
Andrei Nacu
Radu Padurean
Stefan Jora
Andrei Pungovschi
Razvan Bibire
Sebastian Sascau
Dragos Savu
Bogdan Stamatin
Vlad Stanescu
Dragos Stoica
Mugur Varzariu
Mihai Vasile
Boldir C. Victor
Tudor Vintiloiu

Russia
Fail Absatarov
Anna Akelyeva
Mitya Aleshkovsky
Andrey Arkhipov
Maltsev Artem
Armen Asratyan
Alexandre Astafiev
Max Avdeev
Dmitry Azarov
Matvey Bayguzin
Chaplinsky
Philip Beloborodoff
Dimytri Beliakov
Alexander Bendyukov
Dmitry Berkut
Alexei Boitsov
Roman Brygin
Viacheslav Buharev
Oleg Burnaev
Alexey Bushov
Andrey Chepakin
Tatiana Cherkezyan
Julia Chernova
Davidyuk Alexander
Alexandra Demenkova
Misha Dom
Misha Japaridze
Igor Egorov
Vadim Elistratov
Sergey Ermokhin
Ershova Inna
Vladimir Fedorenko
Alexander Fedotov
Dmitriy Fomichev
Mikhail Fomichev
Vlad Galenko
Igor Gavrilov
Pavel Godyaev
Serge Golovach
Pavel Golovkin
Grigory Golyshev
Dima Gomberg
Ilona Gribovskaya
Yuri Gripas
Sergei Guneev
Elena Ignatyeva
Tatiana Ilina
Sergei Ilnitsky
Vasily Ilyinsky
Pavel Iva-Nov
Victoria Ivleva
Dmitri Izosimov
Vaga Karabashyan
Boris Karulin
Pavel Kashaev
Gulnara Khamatova
Igor Kharitonov
Valeriy Klamm
Yury Kochetkov
Denis Kojevnikov
Sergey A. Kompaniychenko
Alexey Kompaniychenko
Sasha Krasnov
Igor Kravchenko
Olga Kravets
Ruslan Krivobok
Aleksandr Kryazhev
Hramovnick Roman
Alex Kudenko
Vladkulikov
Misha Kultyapin
Alexey Kunilov
Evgeniy Kuzmin
Vladimir Larionov
Oleg Lastochkin
Vladimir Lavrov
Kirill Lebedev

Konstantin Leifer
Elena Lelikova
Sergei L. Loiko
Dmitry Lovetsky
Lukin Andrey
Marina Makovetskaya
Anatoly Maltsev
Anton Malykhin
Sergey Maximishin
Vasily Maximov
Sergey Melikhov
Valery Melnikov
Marianna Melnikova
Vlad Meytin
Sergey Mikheyev
Mikhail Mironov
Mikhail Mordasov
Maria Morina
Boris Mukhamedzyanov
Anton Mukhametchin
Aleksey Myakishev
Anatoliy Nasonov
Ilya Naymushin
Tatiana Nazarova
Alexander Nemenov
Arseniy Neskhodimov
Xenia Nikolskaya
Nikolskiy Alexey
Max Novikov
Oxana Onipko
Natalya Onishchenko
Kirill Ovchinnikov
Alexander Paniotov
Tatiana Parfishina
Valentinas Pecininas
Vladimir Pirogov
Ilya Pitalev
Anna Piunova
Tatiana Plotnikova
Maria Plotnikova
Igor Podgorny
Alexandr Polyakov
Vova Pomortzeff
Sergey Ponomarev
Slava
Pronin Andrei
Sergei Pyatakov
Rassanov
Jana Romanova
Andrey Rudakov
AnaStasia Rudenko
Evgeniy Rysikov
Salavat Safiullin
Dmitry Saltykovsky
Vitaly Savelyev
Sergey Savostyanov
Alexey Sazonov
Ivan Sekretarev
Vladimir Syomin
Alexander Chernavskiy
Oleg J Shashkov
Sergei Shchekotov
Maxim Shipenkov
Nikita Shokhov
Denis Sinyakov
Vadim Sishikov
Andrey Sladkov
Vlad Sokhin
Stanislav Solntsev
Andrei Stenin
Alexander Stepanenko
Evgeny Stetsko
Dmitry Sobolev
Grigory Sysoev
Alexander Taran
Denis Tarasov
Alexey Tikhonov
Andrey Tkachenko
Natasha Tsioma
Maria Turchenkova
Yuri Tutov
Sergey Uzakov
Viktor Vasenin
Vladimir Velengurin
Sergei Vinogradov
Georgy Vinogradov
Wishnewetz
Gontar Nikolai
Yuri Vorontsov
Vladimir Vyatkin
Mark Lyalin
Grigoriy Yaroshenko
Yufa Natalya
Victor Yuliev
Oksana Yushko
Konstantin Zavrazhin
A. Zemlianichenko Jr
Alexander Zemlyanichenko
Ksenia Zienowska
Vladimir Zharikov
Anatoly Zhdanov
Lyudmila Zinchenko

Saudi Arabia
Rania Alfardan

153

Senegal
Djibril Sy
Mamadou Touré

Serbia
Sasha Colic
Aleksandar Dimitrijevic
Marko Djurica
Darko Dozet
Andrija Ilic
Nemanja Jovanovic
Sanja Knezevic
Petar Kujundzic
Nemanja Pancic
Janko Petkovic
Marko Rupena
Branislav Strugar
Dusan Vranic

Singapore
Michael Chan
Alphonsus Chern
Chin Fook Chew
Chwee Hua Choo
Chua Chin Hon
Er Kian Peng
Joyce Fang
Gavin Foo
Young How Hwee
Zann Huizhen Huang
Kelvin Kian Han
Ray Ray Tan
Edwin Koo
Kua Kua Chee Siong
Jonathon Kwok Kwong
Sean Lee
Lim Wui Liang
Kevin Lim
Nicky Loh
Low Kai Seng Patrick
Joseph Nair
Ng Sor Luan
Ooi Boon Keong
Leonard Phuah Hong Guan
Seah Kwang Peng
Benjamin Seng
Terence Tan
Trevor Tan
Wang Hui Fen
Teck Hian Wee
Maye-E Wong
Woo Fook Leong
Jonathan Yeap

Slovakia
Andrej Balco
Martin Bandzak
Gabriela Bulisova
Rene Fabini
Jozef Fabo
Dusan Hein
Maros Herc
Ol'ga Pohanková
Vladimir Simicek
Pavel Maria Smejkal
Michal Svítok
Vaculikova Silvia
Matus Zajac

Slovenia
Jaka Adamic
Vanja Bucan
Luka Cjuha
Luka Dakskobler
Jaka Gasar
Maja Hitij
Arne Hodalic
Manca Juvan
Matjaz Kacicnik
Mirko Kunsic
Matej Leskovsek
Mitja Licar
Matej Povse
Matjaz Rust
Matej Sitar
Tadej Znidarcic

Somalia
Omar Feisal
Sunni Said Salah

South Africa
Adrian Bailey
Pieter Bauermeister
Michel Bega
Jodi Bieber
Daniel Born
Rodger Bosch
Paul Botes
Nic Bothma
Theana Breugem
Jennifer Bruce
Sam Clark
Wayne Coetzee
Denvor de Wee
Otmar Dresel
Thys Dullaart

Jillian Edelstein
Brett Eloff
Brenton Geach
Louise Gubb
Cornél van Heerden
Brian Hendler
Jon Hrusa
Mike Hutchings
Matthew Jordaan
Adrian de Kock
Christiaan Kotze
Halden Krog
Francisco Little
Masi
Kim Ludbrook
Greg Marinovich
Bongiwe
Gideon Mendel
Lucky Mofokeng
Katherine Muick-Mere
Craig Nieuwenhuizen
Oupa Nkosi
James Oatway
Alet Pretorius
Antoine de Ras
Samantha Reinders
Nikki Rixon
Shayne Robinson
Mujahid Safodien
Karin Schermbrucker
Simone Scholtz
Marc Shoul
Siphiwe Sibeko
Joao Silva
Alon Skuy
Brent Stirton
Caroline Suzman
Paballo
Herman Verwey
Deaan Vivier
Michael Walker
Wessels

South Korea
Seungwoo Chae
Woohae Cho
Hyungrak, Choi
Jean Chung
Ji Yoon Ha
Han Myung-Gu
Jae Hong
Jinhwon Hong
Hae-in Hong
Eunsoon Hur
Moo
Jea Uk Kang
Hung Ku Kim
Tae Hyeong Kim
Hyunsoo Leo Kim
Kim Hong Ji
Oksun Kim
Ryong-soo Kim
Kim Seong-Ryong
Koo Sung-Chan
Daesung Lee
Chi Yeol Lee
Lee Yu-Kyung
Lee, Seung hoon
Park Jong-Keun
Park Mo
Park, Min hyeok
Soo Hyun Park
Jungmin Park
Kim Kyung Sang
Shin InSeop
Sung Nam-Hun
yooHd
Seo Young Hee
Ahn Young-joon

Spain
Laia Abril
Alfredo Aguilar
Susana Girón
Luis Alcala Del Olmo
Delmi Alvarez
David Aprea Navarrete
Javier Aramburu
Samuel Aranda
Javier Arcenillas
Xoan A. Soler
Bernat Armangue
Cristina Balcells
JC Barberá
Daniel Beltrá
Toni Amengual
Roger Lleixá
E. Blanco Mendizabal
Pep Bonet
Domingo Botan
Jordi Busque
Alfredo Caliz
Enrique Calvo
Nano Calvo
Olmo Calvo Rodríguez
Jordi Camí
Salva Campillo

Bernat Camps Parera
Cristina Candel
Raul Carbonell Rodriguez
Juan Carlos Cárdenas
Sergio Caro
Andres Carrasco Ragel
Agustin Orduña
Castro Prieto
Agustin Catalan
Arantxa Cedillo
José Cendón
Guillermo Cervera
Xavier Cervera Vallve
Patricio Conde
Joan Pujol-Creus
Jose Luis Cuesta
Gustavo Cuevas
Alvaro DePrit
Miquel Dewever
Alberto Di Lolli
Eduardo Diaz
Javo D.
E. D. de San Bernardo
Quico Garcia
Miguel Diez Perez
Nacho Doce
Sergio Enríquez
Tomeu Coll
Ramon Espinosa
Oscar Espinosa
Patricia Esteve
Javier Etxezarreta
Quim Farrero
Erasmo Fenoy Nuñez
Manu Fernandez
Claudio de la Cal
Miguel A. Fonta
Paco Campos
Jota
Zacarias Garcia
Xoan Garcia Huguet
Ricardo Garcia Vilanova
Héctor Garrido
Jesùs Garzaron
Juli Garzon
Eugeni Gay Marín
Rafa Arjones
Joaquin Gomez Sastre
Albert Gonzalez Farran
Olmo Gonzalez
Luis M. Gonzalez Ramos
Pedro Armestre
César Sánchez
Maysun
Francisco Mingorance
Tarek Halabi
Jose Haro
Francisco de las Heras
Antonio Heredia
Nacho Hernandez
Sergio Hdez-Ranera
Angel Herrero de Frutos
Lucía Herrero
Diego Ibarra
Tono Arias
Josep Lago
Álvaro Laiz
Aitor Lara
Celestino Arce
Fernando Lazaro Quintela
Gorka Lejarcegi
Sebastian Liste
Jorge López Barredo
Angel Lopez Soto
Núria López Torres
Villar López
Carlos Luján
Hermes Luppi Maragall
Pedro Madueno
Ferrán Mallol Lerín
César Manso
Rafael Marchante
Tino Soriano
Xurde Margaride
F. Márquez Sánchez
Jonathan González
Andrés Martinez Casares
Nuria Martinez Seguer
Andres Martinez Sutil
Héctor Mediavilla
Salvy Mendoza
Fernando Moleres
Oscar Monzón
Alfonso Moral Rodriguez
Eva Morales Vallecillo
Emilio Morenatti
Marcos Moreno
Xavier P. Moure
Pedro Martínez
Angel Navarrete
Daniel Ochoa de Olza
Felix Ordoñez
Ofelia de Pablo
Benito Pajares
Vicente Paredes
Pere Pascual
Luis Camacho

Jose P. Gegundez
Juan Antonio Perez Vela
Enrique Pimoulier
Oscar Pinal
Jordi Pizarro
Ferran Sendra
Jose Haya
Inigo Plaza Cano
Alvaro Postigo
Oscar del Pozo
Marcelo Del Pozo Perez
Luis Quintanal
David Ramos
Markel Redondo Larrea
Eli Regueira
David Rengel
Miguel Riopa
Eva Ripoll
Rafa Rivas
Nando Rivero
Angel Rivero
Alejandro Zapico
José Luis Roca
José Ángel Rodríguez
Paco Rodríguez
Arturo Rodriguez Castillo
David Rodríguez
Alfons Rodríguez
Arturo Rodríguez
Daniel Casares Román
Manuel Romarís
Víctor Romero
Ruesga Bono
A. Ruiz de León Trespando
Manuel Sagues
Javier Roldan
Lluís Salvadó
Jesus F. Salvadores
Moises Saman
Edu Leon
Rafael S. Fabrés
José Antonio De Lamadrid
Cristobal Manuel
Chico Sanchez
Ervin Sarkisov
Fransisco Seco
Lourdes Segade
Alberto Simon
Carlos Spottorno
Carlos Folgoso
Kike Taberner Tarazona
Llibert Teixidó
Luis Tejido
Tifas Vh
Gabriel Tizón
Miguel Toran
Xavier Torres Bachetta
Enrique Truchuelo Ramirez
Felipe Trueba Garcia
Josu Trueba Leiva
Raúl Urbina
Patxi Uriz
Carmen Valiño
Guillem Valle
Lucas Vallecillos
Yedra Vargas M.
Valentín Vegara
Susana Vera
Jose Vicente
Pelu Vidal
Enric Vives-Rubio
Alvaro Ybarra Zavala
Ana Yturralde
Miguel Zavala
Alejandro Zerolo
Javier Zurita

Sri Lanka
Ananda S. Fernando
Buddhika Weerasinghe

Sudan
Md. Nureldin Abdallah

Surinam
Ertugrul Kilic
Roy Ritfeld

Sweden
Urban Andersson
Anders Andersson
Anna Bank
Andreas Bardell
Johan Bävman
Roland Bengtsson
Kenny Bengtsson
Mathias Bergeld
Stefan Bladh
M. Bloom Sandebäck
Sophie Brandstrom
Henrik Brunnsgard
Maja Daniels
Carl de Souza
Alexander Donka
Martin Edström
Hussein El-Alawi
Åke Ericson

Magnus Eriksson
Jonas Eriksson
Jan Fleischmann
Anders Forngren
Linda Forsell
Serkan Günes
Mark Hanlon
Paul Hansen
Krister Hansson
Anders Hansson
Casper Hedberg
Mikael Hellsten
Niklas Henrikczon
Robert Henriksson
Christoffer Hjalmarsson
Martina Holmberg
Jerker Ivarsson
Torbjörn Jakobsson
Nils Jakobsson
Eva-Lotta Jansson
Ann Johansson
Jörgen Johansson
Simon Johansson
Martin V. Johansson
Mia Karlsvärd
Annika af Klercker
Martin Von Krogh
Peter Krüger
Roger Larsson
Niklas Larsson
Johannes Liljeson
Jonas Lindkvist
Lars Lindqvist
Joachim Lundgren
David Magnusson
Emil Malmborg
Chris Maluszynski
Joel Marklund
Karl Melander
Henrik Montgomery
Anette Nantell
Thomas Nilsson
Daniel Nilsson
Axel Oberg
Johan Persson
Per-Anders Pettersson
Lennart Rehnman
Håkan Röjder
Simon Rydén
Kristofer Sandberg
Sebastian Sardi
Torbjörn Selander
Lisa Selin
Marie Sjöberg
Kajsa Sjolander
Sjöström
Sanna Sjöswärd
Patrick Sörquist
Sara Strandlund
Linus Sundahl-Djerf
Ralph David Thornell
Pontus Tideman
Ann Tornkvist
Lars Tunbjork
Roger Turesson
Joachim Wall
Åsa Wallin
Magnus Wennman
Asa Westerlund
Jan Wiridén
Karl-Göran Z. Fougstedt
Jacob Zocherman

Switzerland
Zalmaï
Fabian Biasio
Mathias Braschler
Markus Bühler-Rasom
Michael Buholzer
Laurent Burst
Pavel Cugini
Alessandro Della Bella
Ladislav Drezdowicz
Philippe Dudouit
Monika Fischer
Marco Frauchiger
Florian Froschmayer
Andreas Frossard
Yvain Genevay
Laurent Gilliéron
Michael Greub
Marco Grob
Boris Heger
Julien Heimann
Alan Humerose
Vincent Jendly
Georgios Kefalas
Daniel Kellenberger
Thomas Kern
Reza Khatir
Patrick B. Kraemer
Christian Lutz
Fred Merz
Pascal Mora
Dominic Nahr
Marco Paoluzzo
Jacek Piotr Pulawski

Jean Revillard
Romano P. Riedo
Nicolas Righetti
Didier Ruef
Meinrad Schade
Roland Schmid
Andreas Seibert
Yan Seiler
Lazar Simeonov
Hansueli Trachsel
Stefan Wermuth
Luca Zanetti
Michael Zumstein

Syria
Carole AlFarah
Thanaa Arnaout
Mohammad Haj kab
Ali Jarekji
Waseem Khrait
Fadi Saliba
Hisham Zaweet

Taiwan
Wei-Long Chai
Chang Tien Hsiung
Keye Chang
Shen Chao-Liang
Boheng Chen
Nana Chen
Chen, Zhen-Tang
Cheng-Tao Chen
Chi Chih-Hsiang
Yi-Jin Hsieh
Chuang-Kun-Ju
Pan Kan Jun
Kao Cheng Chun
Pinyuan.Kao
Tzu Cheng Liu
Shen Chun-Fan
Wang Fei Hwa
Chih-Wei Yu

Thailand
Piti Anchaleesahakorn
Mr. Bundit Chotsuwan
Agron Dragaj
Songwut In-Em
Suthep Kritsanavarin
Jetjaras Na Ranong
Suchat Pederson
Athit Perawongmetha
Ohm Phanphiroj
Korbphuk Phromrekha
Aphiluck Puangkaew
Ekkarat Punyatara
Rungroj Yongrit

Tunisia
Ons Abid

Turkey
Tolga Adanali
Aytunc Akad
Arif Akdogan
Kursat Bayhan
Sinan Cakmak
Necdet Canaran
Yildirim Celik
Onur Coban
Mehmet Demirci
Sefik Dinç
Alper Apito Dutkin
Sezayi Erken
Hatice Ezgi Özçelik
Murat Germen
Kenan Gürbüz
Mühenna Kahveci
Aytac Onay
Cem Ozdel
Riza Ozel
Mehmet Ali Poyraz
Kerem Saltuk
Murad Sezer
Isa Simsek
Emre
Mustafa Yalcin
Niko Guido
Yildirim Sugoze

Turkmenistan
Aman Geld Mehinli

Uganda
James Akena

Ukraine
Leyla Akhunovda
Bochek
Arthur Bondar
Igor Bulgarin
Mike Chernichkin
Konstantin Chernichkin
Aleks Demidoff
Andrii Derkach
Sergey Dolzhenko
Maxim Dondyuk

Yuriy Dyachyshyn
Evgen Gapych
Gleb Garanich
Kirill Golovchenko
Gurniak Viktor
Oleksandr Klymenko
Gryshyn Kostyantyn
Dmytro Kupriyan
Efrem Lukatsky
Nataliya Masharova
Maxim Marusenko
Kadnikov Oleksandr
Stepan Rudik
Genya Saviliov
Sergei Shtepa
Sodel Vlad
Anatoliy Stepanov
Sergei Supinsky
Olexandr Techynskyy
Mila Teshaieva
Ganna Trepalyuk
Ivan Tykhyi
Anna Voitenko
Emine Ziyatdinova

United Kingdom
James Abbott
Julian Anderson
Brian Anderson
Platon
Marc Atkins
Thomas Ball
Jane Barlow
Guy Bell
Colin Bell
Andrew Bennison
James Benwell
Charlie Bibby
Mark Bickerdike
Marcus Bleasdale
Will Boase
James Bollen
Chris Booth
Shaun Botterill
Stuart Boulton
Simon Brown
Henry Browne
Jonathan Browning
Clive Brunskill
Jason Bryant
Tessa Bunney
Mark Burton
André Camara
Briony Campbell
Richard Cannon
Ben Cawthra
David Chancellor
Dan Charity
William Cherry
Wattie Cheung
Carlo Chinca
Musa Chowdhury
Edmund Clark
Bethany J Clarke
Phil Clarke-Hill
Araminta de Clermont
Rose Clive
Nick Cobbing
Holly Cocker
Christian Cooksey
Phil Coomes
Vicki Couchman
Helen Couchman
Damon Coulter
Tricia de Courcy Ling
Michael Craig
David Cruickshanks
Simon Dack
Mohamed Dahir
Nick Danziger
Prodeepta Das
Alan Davidson
Fabio De Paola
Adam Dean
Peter Dench
Chloe Dewe Mathews
Alexander Dias
Francis Dias
Nigel Dickinson
James dodd
Kieran Dodds
Ross Domoney
Luke Duggleby
Matt Dunham
Nic Dunlop
Stuart Dunn
Jeremy Edwards
Mike Egerton
Kirk G. Ellingham
Sam Faulkner
Alixandra Fazzina
Sally Fear
Tristan Fewings
Roderick Field
Rick Findler
Julian Finney
Stuart Forster

Ian Forsyth
Stuart Freedman
Sam Frost
James Robert Fuller
Christopher Furlong
Robert Gallagher
Sean Gallagher
Andrew Garbutt
Stephen Garnett
George Georgiou
Dan Giannopoulos
Jeff Gilbert
John Giles
Paul Gilham
David Gillanders
Trevor Gliddon
Martin Godwin
Jonathan Goldberg
Lydia Goldblatt
Noah Goodrich
David Graham
Charlie Gray
Johnny Green
Laurence Griffiths
James Gunn
Paul Hackett
Andy Hall
Neil Hall
Rosie Hallam
Daniel Hambury
Gary Hampton
Sara Hannant
Paul Harding
Pip Harrigan
David Harriman
Marcus Harris
Mark Harrison
Richard Heathcote
Mark Henley
Mishka Henner
Mike Hewitt
Cliff Hide
Andrew Higgins
James Hill
Jack Hill
Adam Hinton
Neil Hodge
Alex Hodgkinson
David Hoffman
Dave Hogan
Emile Holba
Jim Holden
Kate Holt
Andrew Hone
Harvey Hook
Rip Hopkins
Scott Hornby
Michael Hughes
Jeremy Hunter
Tim Ireland
Tom Jenkins
Spike Johnson
Richard Jones
Hannah Jones
Robin Jones
Nadav Kander
Sonal Kantaria
Simon Keitch
Jon Kent
Eddie Keogh
Mike King
Ian Kington
Glyn Kirk
Dan Kitwood
David Klein
Colin Lane
Ian Langsdon
Jason Larkin
Kalpesh Lathigra
Stephen D. Lawrence
Mark Leech
David Levene
Zute Lightfoot
Dominic Lipinski
Michael Lishman
Alex Livesey
Matthew LLoyd
Liz Lock
Sharron Lovell
Mikal Ludlow
Amy Lyne
Peter Macdiarmid
Ian MacNicol
Robin Maddock
Leo Maguire
David Maitland
Peter Marshall
Bob Martin
Dylan Martinez
Leo Mason
Clive Mason
Jenny Matthews
Stuart Matthews
John McIntyre
Andrew McLeish
Ian McVea
Jamie James Medina

Toby Melville
Kois Miah
Jane Mingay
Jeff Mitchell
Asef Ali Mohammad
Doug Moir
Clara Molden
James Mollison
Pramod Mondhe
Jeff Moore
James Morgan
Eddie Mulholland
Rebecca Naden
Simon Norfolk
Zed Nelson
Peter Nicholls
Lucy Nicholson
Ian Nicholson
Phil Noble
Charles Ommanney
Robert Ormerod
Jeff Overs
Steve Pace
Mark Pain
Laura Pannack
Esper
Peter Parks
Lindsey Parnaby
Gavin Parsons
Brijesh
Adam Patterson
Sam Pearce
Richard Pelham
John Perkins
Robert Perry
Charles Pertwee
Kate Peters
Tom Pilston
Olivier Pin-Fat
Richard Pohle
Louis Quail
Andy Rain
Carl Recine
Max Reeves
Michael Regan
Vaughn Ridley
Lorna Roach
Paul Roberts
Stuart Robinson
Ian Robinson
Nigel Roddis
Paul Rogers
Will Rose
David Rowland
Dan Rowley
Mark David Runnacles
David Sandison
Oli Scarff
Michael Schofield
Mark Seager
John Sibley
Paul Smith
Russell Gray Sneddon
Lalage Snow
Anthony Stanley
Jerome Starkey
Wayne Starr
Craig Stennett
Nick Stern
Tom Stoddart
Chris Stowers
Colin Summers
Jon Super
Mark Sutton
Sean Sutton
Jeremy Sutton-Hibbert
Bran Symondson
Justin Tallis
Jason Tanner
Mark Parren Taylor
Aaron Taylor
Anastasia Taylor-Lind
Grahame Tearle
Edmond Terakopian
Andrew Testa
Hazel Thompson
Edward Thompson
Abbie Trayler-Smith
Alex Treadway
Joanna Vestey
David Vintiner
Aubrey Wade
Jenny Lynn Walker
John Walmsley
James Wardell
Barrie Watts
Andy Weekes
Bella West
Edward Whitaker
David White
Neil White
Paul White
Lewis Whyld
Barney Wilczak
Jim Wileman
Hot Dog
Gari Wyn Williams

James Williamson
Philip Wolmuth
Andrew S.T. Wong
Chris Young
Sean Dufrene
Lisa O'Connor
Kurt Roy

Uruguay
Leo Barizzoni
Martin Cerchiari
Gabriel A. Cusmir Cúneo
Julio Etchart
Quique Kierszenbaum
Pablo Porciúncula
Armando Sartorotti
Nicolás Scafiezzo Porcelli
Andres Stapff

USA
Anonymous
Mustafah Abdulaziz
Evan Abramson
Jenn Ackerman
Lynsey Addario
Lola Akinmade
Alaa al-Marjani
Maya Alleruzzo
Kainaz Amaria
Elise Amendola
Scott Anderson
Daniel Anderson
Jason Andrew
Johnny Andrews
Drew Angerer
Bryan Anselm
Jeff Antebi
Jessica Antola
Ron Antonelli
Michael Appleton
Charled Rex Arbogast
Timothy Archibald
Ricardo Arduengo
Nathan W. Armes
Kristen Ashburn
Jonathan Lucas Auch
Moammar Awwad
Kim Badawi
James Balog
David Walter Banks
Jeffrey Barbee
Michael Barkin
Nancie Battaglia
Kurt Bauer
Will Baxter
Liz O. Baylen
Loulou Beavers
Max Becherer
Robert Beck
Mike Behr
Natalie Behring
Mike Belleme
Al Bello
Nicole Bengiveno
Rob Bennett
David Bergman
Ruediger Bergmann
Christopher Berkey
Emily Berl
Lauren Berley
Nina Berman
Alan Berner
John Biever
Keith Birmingham
Josh Birnbaum
Rebecca Blackwell
Gregg Bleakney
Gene Blevins
Victor J. Blue
John Boal
Antonio Bolfo
Karen T. Borchers
Scott M Bort
Mark Boster
Bie Bostrom
Samantha Box
Thomas Boyd
Zach Boyden-Holmes
Anna Boyiazis
Dominic Bracco II
Brian Branch-Price
M. Scott Brauer
Isaac Brekken
William Bretzger
Kendrick Brinson
Dan Britt
Ben Brody
Paula Bronstein
Kate Brooks
Richard A. Brooks
Nathaniel Brooks
Milbert O. Brown Jr.
Frederic J. Brown
Thomas Brown
Simon Bruty
James Bryant
Paul Buck

Joe Buglewicz
Gregory Bull
Andrew Burton
Elyse Butler
Renée C. Byer
Ty Cacek
Cairnduff Cairnduff
Mary Calvert
Hong Cao
Christopher Capozziello
Don Carpenter
Matt Carr
Darren Carroll
J. Pat Carter
Antrim Caskey
Marco Castro
Joe Cavaretta
Dominic Chavez
Ray Chavez
Barry Chin
Debbie Egan-Chin
LiPo Ching
Paul Chinn
Daniel Cima
John Clark
Jay Clendenin
Carolyn Cole
Jed Conklin
Michael Conti
Thomas R. Cordova
Ron Cortes
Don Couch
Andrew Craft
Stephen Crowley
Anne Cusack
Scott Dalton
Russel A. Daniels
Linda Davidson
Mike Davis
Sam Dean
David Degner
Lou Dematteis
Bryan Denton
Bryan Derballa
Julie Dermansky
Chris Detrick
Peter DiCampo
Kenneth Dickerman
Karly Domb Sadof
Larry Downing
Craig Downing
Carolyn Drake
Dick Druckman
Rian Dundon
Melanie Dunea
Keith Dunlop
Michael Eckels
Charles Eckert
Aristide Economopoulos
Matt Eich
Sarah Elliott
Bruce Ely
Peter Essick
Josh Estey
James Estrin
Allen L. Eyestone
Gary Fabiano
Rich-Joseph Facun
Timothy Fadek
Steven M. Falk
Katie Falkenberg
Christopher Farber
Gina Ferazzi
Stephen Ferry
Gaialight
Brian Finke
Peter Foley
Michael Forster Rothbart
Tom Fox
Bill Frakes
Ric Francis
Jamie Francis
Michelle Frankfurter
Danny Wilcox Frazier
Ruth Fremson
Gary Friedman
Misha Friedman
Hector Gabino
Phyllis Galembo
Preston Gannaway
Alex Garcia
Marco Garcia
Micah Garen
Mark Garfinkel
Kenneth Garrett
Mark Garten
Morry Gash
Robert Gauthier
Eric Gay
Jim Gehrz
Sharon Gekoski-Kimmel
Danny Ghitis
David Gilkey
Thomas E. Gilpin
Julie Glassberg
Sarah J. Glover
Melissa Golden

David Goldman
Andrew Gombert
Andres Gonzalez
Chet Gordon
Steven Greaves
Kyle Green
Bill Greene
Stanley Greene
Lauren Greenfield
Mike Greenlar
David I. Gross
Djamila Grossman
Tim Gruber
Adrienne Grunwald
Roberto (Bear) Guerra
CJ Gunther
David Guttenfelder
Carol Guzy
Rachelle Hacmac
Robert Hallinen
Mark M. Hancock
Andrew Hancock
Jonathan Hanson
Mark Edward Harris
Jerod Harris
Bret Hartman
Valerie Hayken
Laura Heald
Sonya N. Hebert
James Heil
Todd Heisler
Andrew Henderson
Mark Henle
Ryan Henriksen
Gerald Herbert
Lauren Hermele
Tyler Hicks
Michael Hicks
Erik Hill
Jessica Hill
Shoun A. Hill
Ed Hille
Matthew Hinton
Lawrence K. Ho
Eros Hoagland
Evelyn Hockstein
Brendan Hoffman
Jeremy Hogan
Michael Holahan
Peter Holderness
Jim Hollander
Mark Holtzman
Chris Hondros
Erin Hooley
Aaron Huey
Jeff Hutchens
Achmad Ibrahim
Walter Iooss Jr.
Lucas Jackson
Jed Jacobsohn
Julie Jacobson
Terrence Antonio James
Jay Janner
Krisanne Johnson
Eric Michael Johnson
Marvin Fredrick Joseph
Allison Joyce
Jen Judge
Nikki Kahn
Greg Kahn
Michael Kamber
Kang Hyungwon
Anthony Karen
Ed Kashi
Ivan Kashinsky
Karen Kasmauski
Carolyn Kaster
Scott Keeler
James Keivom
Mark W Kelley
Mike Kepka
Laurence Kesterson
Natalie Keyssar
Carl Kiilsgaard
Yunghi Kim
John J. Kim
John Kimmich-Javier
Paul Kitagaki Jr
Torsten Kjellstrand
Stephanie Klein-Davis
David E. Klutho
Bevil Knapp
Meridith Kohut
J. A. Koscielniak-Woolf
Daniel Kramer
Stacy Kranitz
Lisa Krantz
Daniel Krauss
Suzanne Kreiter
Andy Kropa
Brandon Kruse
Amelia Kunhardt
Karna Kurata
Jack Kurtz
Srinivas Kuruganti
Steve Labadessa
Sakchai Lalit

Lauren Lancaster
Nancy Lane
Justin Lane
Jeremy M. Lange
Chris Langer
Louis Lanzano
Jerry Lara
Erika Larsen
Jensen Larson
Tim Larson
Adrees Latif
Adam Lau
Gillian Laub
Amy Leang
Streeter Lecka
George LeClaire
Chang W. Lee
Matthew J. Lee
Brian Lehmann
Josie Lepe
Erik Lesser
Andy Levin
Heidi Levine
William Wilson Lewis III
David Liittschwager
Annie Ling
Brennan Linsley
Edward Linsmier
David Lisenby
Jim Lo Scalzo
Karen Quincy Loberg
Jeremy Lock
Rick Loomis
Dario Lopez Mills
Jon Lowenstein
Benjamin Lowy
Robin Loznak
Kirsten Luce
Amanda Lucidon
Amanda Lucier
Charles Ludeke
Erik Lunsford
Patsy Lynch
Tom Lynn
John G. Mabanglo
Michael Macor
Chris Maddaloni
Narayan Mahon
Charlie Mahoney
David Maialetti
Matt Mallams
Sheri Manson
Javier Manzano
James Y.R.Mao
Melina Mara
Tiana Markova-Gold
Dan Marschka
Liz Martin
Dave Martin
Joel Martinez
Saul Martinez
Ronald Martinez
Pablo Martinez Monsivais
Matt Marton
A.J. Mast
Tim Matsui
David Maung
Justin Maxon
Dania Patricia Maxwell
Leslie Mazoch
Peter McBride
Patrick McCarthy
Matt McClain
Nicholas Hegel McClelland
Peter Earl McCollough
Michael McCollum
Matthew McDermott
John W. McDonough
Michael Francis McElroy
Maddie McGarvey
Ryan McGinley
Scott McIntyre
Kirk McKoy
Joseph McNally
Win McNamee
Mary Beth Meehan
Eli Meir Kaplan
Eric Mencher
Jim Mendenhall
Alex Menendez
Peter J. Menzel
Justin Merriman
Rory Merry
Nhat V. Meyer
Sebastian Meyer
RJ Mickelson
Bob Miller
Lester J. Millman
Doug Mills
Stew Milne
Donald Miralle, Jr.
Karen Miranda-Rivadeneira
Logan Mock-Bunting
Genaro Molina
M. Scott Moon

John Moore
Andrea Morales
Karsten Moran
P. Kevin Morley
Mike Morones
Peter Morrison
Laura Morton
Ozier Muhammad
Peter Muhly
Michael Mullady
Pete Muller
Rachel Mummey
C.S. Muncy
Edward J. Murray
Karla L. Murray
Clem Murray
Mark C. Murrmann
Vincent J Musi
James Nachtwey
Adam Nadel
Matt Nager
Michael Nagle
Leila Navidi
Sol Neelman
Jesse Neider
Wally Nell
Gregg Newton
Jonathan A. Newton
Jehad Nga
Shawn Long Nguyen
Robert Nickelsberg
Matthew Niederhauser
James Nielsen
Landon Nordeman
John Nowak
Chris O'Meara
Michael O'Neill
Scott Olson
Katie Orlinsky
Francine E. Orr
KC Ortiz
Kevin Oules
Nick Oza
Darcy Padilla
Joel Page
Sophie Paris
Nigel Parry
Yana Paskova
Nancy Pastor
Willow Ulani Paule
John Pendygraft
Lucian Perkins
Corey Perrine
Richard Perry
John Francis Peters
Mark Peterson
Shane Peterson
Daryl Mr. Peveto
Abigail Pheiffer
Melissa Phillip
Terry Pierson
Julie Platner
Spencer Platt
James Pomerantz
Jessica Pons
Smiley Pool
John Poole
Gary Porter
Mike Powell
Brian Powers
Joshua Prezant
Jake Price
Joe Pugliese
Eddie Quinones
Susana Raab
Joe Raedle
Randy L. Rasmussen
Patrick Raycraft
Jerry Redfern
Ryan Spencer Reed
Jim Reed
Mona Reeder
Tom Reese
Andrea Star Reese
Damaso Reyes
Gary Reyes
Michael Reynolds
Andy Richter
Phil Rider
Charlie Riedel
Jessica Rinaldi
Steve Ringman
Amanda Rivkin
Larry Roberts
Julia L. Robinson
Michael Robinson Chávez
David Rochkind
Joseph Rodriguez
Dana Romanoff
Calixtro Romias, Jr.
David Root
Bob Rosato
Aaron Rosenblatt
Lance Rosenfeld
ShimonRothstein
TammarRothstein
Raul Rubiera

Dina Rudick
Raechel Running
Benjamin Rusnak
J.B. Russell
Eva Russo
Robert Sabo
Paul Sakuma
Jeffery Salter
Adrian Sanchez-Gonzalez
David Lougheed Sanders
Jo Ann Santangelo
Joel Sartore
Howard Schatz
Lucas Schifres
Kristen Schmid Schurter
Bastienne Schmidt
Claire E Schneider
Jake Schoellkopf
Susan Schulman
Patrick Semansky
Scott Serio
Rick Sforza
Ezra Shaw
Callie Shell
Allison Shelley
Brian Shumway
Benny Sieu
Sam Simmonds
Denny Simmons
Stephanie Sinclair
Wally Skalij
Brian Skerry
Laurie Skrivan
Matt Slaby
Lynne Sladky
Matt Slocum
Brendan Smialowski
Bryan Smith
Larry Smith
Juliana Irene Smith
Patrick Smith
Drew Anthony Smith
Michael Kirby Smith
Brian Snyder
Jared Soares
Michael Sohn
H. Connor Bailey
Magdalena Solé
Armando Solares
Lara Solt
Chip Somodevilla
Jan Sonnenmair
J.L. Sousa
Andrew Spear
Jamie Squire
John Stanmeyer
Julia Staples
Shannon Stapleton
Susan Stava
Jordan Stead
Maggie Steber
Haraldur Stefansson
George Steinmetz
Lezlie Sterling
John F. Stevenson
Thomas C. Stewart
Sean Stipp
Robert Stolarik
Gigi Stoll
Carol Allen Storey
Scott Strazzante
Damian Strohmeyer
Bob Strong
Theo Stroomer
Anthony Suau
Justin Sullivan
Andrew Sullivan
Lea Suzuki
Chitose Suzuki
David Robert Swanson
Chris Sweda
Joseph Sywenkyj
Marcin Szczepanski
Kayana Szymczak
Kevin Tachman
Ramin Talaie
Mario Tama
Andri Tambunan
Ross Taylor
Patrick Tehan
Mark J. Terrill
Sara Terry
Mike Terry
Shmuel Thaler
Eric Thayer
Shawn Thew
Bryan Thomas
Jeffrey Thompson
Al Tielemans
Bill Tiernan
Maisie Todd
Tara Todras-Whitehill
S. Tomada Piccolomini
Billy Tompkins
Jonathan Torgovnik
Erin Grace Trieb
Linda Troeller

Scout Tufankjian
Tyrone Turner
Peter Turnley
Jane Tyska
Gregory Urquiaga
Chris Usher
Alexandra Vainshtein
Vicki Valerio
Alicia Vera
Brad Vest
Stephen Voss
Evan Vucci
Bill Wade
Devin Wagner
Craig F. Walker
Vaughn Wallace
Robert Wallis
Amy Wang
Craig Warga
Steve Warmowski
Jenn Warren
David M. Warren
Guy Wathen
Nathan Weber
Billy Weeks
Taylor Weidman
Steven Weinberg
Carol Weinberg
Laura Weisman
David H. Wells
Kristyna Wentz-Graff
Jim West
Dan Westergren
Nick Whalen
James Whitlow Delano
Jonathan L. Wiggs
Rick T. Wilking
Gary Williams
Michael Williamson
Lisa Wiltse
Steve Winter
Damon Winter
Dan Winters
Michael S. Wirtz
Ed Wray
Alison Wright
Ty Wright
Julia Xanthos
Mark Zaleski
Ariel Zambelich
Matthew Ziegler
Andrew Zuckerman
Chris Zuppa

Uzbekistan
Anzor Salidjanov

Venezuela
Gustavo Bandres
Juan Barreto
Miguel Castillo
Ariana Cubillos
Carlos Garcia Rawlins
Marienna García-Gallo
Mike Gonzalez
Miguel Gutierrez Gutierrez
Alvaro Hernandez
Nilo R. Jiménez Barrozzi
Leo Liberman
Fernando Llano
Jose Lobo
Juan Carlos Lopez V.
Alvaro Camacho M
Gil Montaño
Edsau Olivares
Jacinto Oliveros
Leo Ramirez
Cecilia Rodriguez
Aaron Sosa
Jimmy Villalta

Vietnam
Hoang Quoc Tuan
Tran van Hung
Dan Huynh
Lai Khanh
Trung Nguyen Ngoc
Na Son Nguyen
Dzung Nguyen
Maika Elan
Nam Du
Pham Ngoc Lan
Luong Thai Linh
Tran Viet Van
Trung Nghia
Vu Anh Tuan

Yemen
Mustafa Al-Ezzi Naji

Zimbabwe
Davison Mudzingwa
Tsvangirayi Mukwazhi

A great story is expertly told.

www.canon-europe.com/eos1dmk4

While deep in the Balinese jungle shooting a story on the Macaque monkeys, professional photographer and Canon Ambassador Thorsten Milse needs a camera he can rely on: the Canon EOS-1D Mark IV. Its 16MP CMOS sensor and 45 point AF system combine to capture every detail in outstanding clarity. And with 10fps up to ISO 102.400 this camera ensures that whatever story he's telling, he never misses a shot. Discover why the EOS-1D Mark IV is the professionals' choice.

EOS-1D
Mark IV

take more than pictures.
take stories.

Canon Professional Network

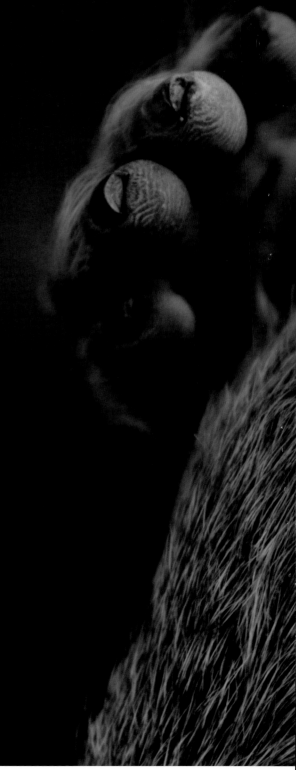